Lacan at the Scene

Short Circuits, Slavoj Žižek, editor

Lacan at the Scene **HENRY BOND**

THE MIT PRESS
CAMBRIDGE, MASSACHUSETTS
LONDON, ENGLAND

MIT Press books may be purchased at special
quantity discounts for business or sales promotional
use. For information, please email special_sales@
mitpress.mit.edu or write to Special Sales Department,
The MIT Press, 55 Hayward Street, Cambridge,
MA 02142.

This book was set in Filosofia and Univers by
Graphic Composition. Printed and bound in Spain.

Library of Congress Cataloging-in-Publication Data
Bond, Henry, 1966–
Lacan at the scene / Henry Bond ; foreword by
Slavoj Žižek.
p. cm.—(Short circuits)
Includes bibliographical references and index.
ISBN 978-0-262-01342-0 (hardcover : alk. paper)
1. Legal photography—Psychological aspects.
2. Photographic criticism. 3. Murder victims—
Pictorial works. 4. Crime scene searches—
Psychological aspects. 5. Criminal psychology.
6. Psychoanalysis. 7. Lacan, Jacques, 1901–1981.
I. Title.
TR822.B66 2009
363.25022'2—dc22

2008054758

10 9 8 7 6 5 4 3 2 1

A sad thing it was, no doubt, very sad;
but we can't mend it. Therefore let us make the
best of a bad matter; and as it is impossible
to hammer anything out of it for moral purposes,
let us treat it aesthetically, and see if it will
turn to account in that way.

Thomas De Quincey,
On Murder Considered as One of the Fine Arts

CONTENTS

A short circuit occurs when there is a faulty connection in the network—faulty, of course, from the standpoint of the network's smooth functioning. Is not the shock of short-circuiting, therefore, one of the best metaphors for a critical reading? Is not one of the most effective critical procedures to cross wires that don't usually touch: to take a major classic (text, author, notion) and read it in a short-circuiting way, through the lens of a "minor" author, text, or conceptual apparatus ("minor" should be understood here in Deleuze's sense: not "of lesser quality," but marginalized, disavowed by the hegemonic ideology, or dealing with "lower," less dignified topic)? If the minor reference is well chosen, such a procedure can lead to insights which completely shatter and undermine our common perceptions. This is what Marx, among others, did with philosophy and religion (short-circuiting philosophical speculation through the lens of political economy, that is to say, economic speculation); this is what Freud and Nietzsche did with morality (short-circuiting the highest ethical notions through the lens of the unconscious libidinal economy). What such a reading achieves is not a simple "desublimation," a reduction of the higher intellectual content to its lower economic or libidinal cause; the aim of such an approach is, rather, the inherent decentering of the interpreted text, which brings to light its "unthought," its disavowed presuppositions and consequences.

And this is what "Short Circuits" wants to do, again and again. The underlying premise of the series is that Lacanian psychoanalysis is a privileged instrument of such an approach, whose purpose is to illuminate a standard text or ideological formation, making it readable in a totally new way—the long history of Lacanian interventions in philosophy, religion, the arts (from the visual arts to the cinema, music, and literature), ideology, and politics justifies this premise. This, then, is not a new series of books on psychoanalysis, but a series of "connections in the Freudian field"—of short Lacanian interventions in art, philosophy, theology, and ideology.

"Short Circuits" wants to revive a practice of reading which confronts a classic text, author, or notion with its own hidden presuppositions, and thus reveals its disavowed truth. The basic criterion for the texts that will be published is that they effectuate such a theoretical short circuit. After reading a book in this series, the reader should not simply have learned something new: the point is, rather, to make him or her aware of another—disturbing—side of something he or she knew all the time.

FOREWORD: THE CAMERA'S POSTHUMAN EYE
Slavoj Žižek

The only thing I feel qualified to add to Henry Bond's outstanding book is what I see as its philosophical presupposition: the weird status of the camera's eye. In order to grasp this status, one should begin with Marcel Proust's *The Guermantes Way*, a novel which is part of his *In Search of Lost Time*.[1] Toward the end of the first chapter, there is a memorable scene in which, using the phone for the first time, Marcel (the narrator of the novel) talks to his grandmother:

> After a few seconds of silence, suddenly I heard that voice which I supposed myself, mistakenly, to know so well; for always until then, every time that my grandmother had talked to me, I had been accustomed to follow what she was saying on the open score of her face, in which the eyes figured so largely; but her voice itself I was hearing this afternoon for the first time. And because that voice appeared to me to have altered in its proportions from the moment that it was a whole, and reached me in this way alone and without the accompaniment of her face and features, I discovered for the first time how sweet that voice was. . . . It was sweet, but also how sad it was, first of all on account of its very sweetness, a sweetness drained almost—more than any but a few human voices can ever have been—of every element of resistance to others, of all selfishness; fragile by reason of its delicacy it seemed at every moment ready to break, to expire in a pure flow of tears; then, too, having it alone beside me, seen, without the mask of her face, I noticed for the first time the sorrows that had scarred it in the course of a lifetime.

What happens here is described by Proust in very precise terms which uncannily point forward to Lacanian theory: the voice is subtracted from its "natural" totality of the body to which it belongs, out of which it emerges as an autonomous partial object, an organ which can magically survive without the body whose organ it is—it is as if it stands "alone beside me, seen, without the mask of her face." This subtraction withdraws it from (our ordinary) reality into the virtual domain of the real, where it persists as an undead specter haunting the subject: "'Granny!' I cried to her, 'Granny!' and would have kissed her, but I had beside me only that voice, a phantom, as impalpable as that which would come perhaps to revisit me when my grandmother was dead." As such, this voice signals simultaneously a distance (Granny is not here) and an obscene overproximity, a presence more intimate, more penetrating, than that of an external body in front of us:

> A real presence indeed that voice so near—in actual separation. But a premonition also of an eternal separation! Over and again, as I listened in this way, without see-ing her who spoke to me from so far away, it has seemed to me that the voice was crying to me from depths out of which one does not rise again, and I have known the anxiety that was one day to wring my heart when a voice should thus return (alone, and attached no longer to a body which I was never more to see).

The term "anxiety" is to be read in the precise Lacanian way: for Lacan, anxiety does not signal the loss of the object, but, on the contrary, its overproximity. Anxiety arises when the *objet a* directly falls into reality, appears in it—which is precisely what happens when Marcel hears his granny's voice separated from her body, and discovers "for the first time how sweet that voice was": this sweetness is, of course, the extracted quintessence which made Granny so heavily libidinally invested. This, incidentally, is how psychoanalysis approaches the libidinal-subjective impact of new technological inventions: "technology is a catalyzer, it enlarges and enhances something which is already here"[2]—in this case, a fantasmatic virtual fact, like that of a partial object. (Something like this happens in a psychoanalytic session where, precisely, the patient is reduced to a voice: "psychoanalysis makes out of the ordinary voice a telephone voice.")[3] And, of course, this realization changes the entire constellation: once a fantasy is realized, once a fantasmatic object directly appears in reality, reality is no longer the same. Take the sex gadgets industry: on the market today is a so-called "Stamina Training Unit," a masturbatory device which resembles a battery light (so that, when we carry it around, we are not embarrassed): you put the erect penis into the opening at the top and move the thing up and down until satisfaction is achieved. The product is available in different colors, tightnesses, and textures to imitate the three main openings for sexual penetration (mouth, vagina, anus).

What one buys is simply the partial object (erogenous zone), deprived of the embarrassing additional burden of the entire person. The fantasy (of reducing the sexual partner to a prosthesis) is here directly realized, and this changes the entire libidinal economy of sexual relations.

This brings us to the key question: what happens to the body when it is separated from its voice, when the voice is subtracted from the wholeness of the person? For a brief moment, we see "a world robbed of fantasy, of the affective frame and sense, a world out of joint."[4] Grandmother appears to Marcel outside the fantasmatic horizon of meaning, the rich texture of his previous long experience of her, which up till now made her a warm, charming person—all of a sudden, he sees her "red-faced, heavy and common, sick, lost in thought, following the lines of a book with eyes that seemed hardly sane, a dejected old woman whom I did not know." Perhaps the best metaphor here is that of a squid which moves elegantly in water, but turns into a disgusting helpless piece of slimy meat once out of water: seen after the fateful phone conversation, deprived of her fantasy frame, Granny is like a squid out of water, on dry land—here is Proust's precise description of this effect:

... when, entering the drawing-room before my grandmother had been told of my return, I found her there, reading. I was in the room, or rather I was not yet in the room since she was not aware of my presence, and, like a woman whom one surprises at a piece of work which she will lay aside if anyone comes in, she had abandoned herself to a train of thoughts which she had never allowed to be visible by me. Of myself—thanks to that privilege which does not last but which one enjoys during the brief moment of return, the faculty of being a spectator, so to speak, of one's own absence,—there was present only the witness, the observer, with a hat and traveling coat, the stranger who does not belong to the house, the photographer who has called

to take a photograph of places which one will never see again. The process that mechanically occurred in my eyes when I caught sight of my grandmother was indeed a photograph. We never see the people who are dear to us save in the animated system, the perpetual motion of our incessant love for them, which before allowing the images that their faces present to reach us catches them in its vortex, flings them back upon the idea that we have always had of them, makes them adhere to it, coincide with it. . . . But if, in place of our eye, it should be a purely material object, a photographic plate, that has watched the action, then what we shall see, in the courtyard of the Institute, for example, will be, instead of the dignified emergence of an Academician who is going to hail a cab, his staggering gait, his precautions to avoid tumbling upon his back, the parabola of his fall, as though he were drunk, or the ground frozen over. So is it when some casual sport of chance prevents our intelligent and pious affection from coming forward in time to hide from our eyes what they ought never to behold, when it is forestalled by our eyes, and they, arising first in the field and having it to themselves, set to work mechanically, like films, and show us, in place of the loved friend who has long ago ceased to exist but whose death our affection has always hitherto kept concealed from us, the new person whom a hundred times daily that affection has clothed with a dear and cheating likeness. . . . I, for whom my grandmother was still myself, I who had never seen her save in my own soul, always at the same place in the past, through the transparent sheets of contiguous, overlapping memories, suddenly in our drawing-room which formed part of a new world, that of time, that in which dwell the strangers of whom we say "He's begun to age a good deal," for the first time and for a moment only, since she vanished at once, I saw, sitting on the sofa, beneath the lamp, red-faced, heavy and common, sick, lost in thought, following the lines of a book with eyes that seemed hardly sane, a dejected old woman whom I did not know.

One should read this passage against its implicit Kantian background: a network screens our raw perceptions of beloved persons, that is to say, "before allowing the images that their faces present to reach us catches them in its vortex, [it] flings them back upon the idea that we have always had of them, makes them adhere to it, coincide with it"; this network—the complex web of past experiences, affections, and so on, which colors our raw perceptions—plays exactly the role of a transcendental horizon which makes our reality meaningful. When we are deprived of this transcendental network, that is, of the fantasmatic coordinates of meaning, we are no longer engaged participants in the world, we find ourselves confronted with things in their *noumenal* dimension: for a moment, we see them the way they are "in themselves," independently of us—or, as Proust puts it in a wonderful formula, the spectator becomes "a spectator, so to speak, of one's own absence." What this means is that, once the fantasy object is subtracted from reality, it is not only the observed reality which changes, but also the observing subject himself: he is reduced to a gaze observing how things look in his own absence (recall the old Tom-Sawyer-and-Huck-Finn fantasy of being present at one's own funeral). And is this, precisely, not the feature which makes the photographic camera so uncanny? Is a camera not our eye separated from our body, drifting around and recording how things look in our absence?

What we encounter here is the gaze as object, free from the strings which attach it to a particular subject—no wonder that *Kino-Eye* [*Kino-glaz*], Dziga Vertov's Soviet silent classic from 1924 (one of the high points of revolutionary cinema), takes as its emblem precisely the eye (of the camera) as an "autonomous organ" which wanders around in the early 1920s, giving us snippets of the NEP ("new economic politics") reality of the Soviet Union. Recall the common expression "to cast an eye over something," with its literal implication of picking the eye out of its socket and throwing it around. Martin, the legendary idiot from French fairy tales, does exactly this when his mother, worried that he will never find a wife, tells him to go to church and cast an eye over the girls there. What he does is go to the butcher first, purchase a pig eye, and then, in the church, throw this eye around over the girls at prayer—no wonder he later reports to his mother that the girls were not too impressed by his behavior. This, precisely, is what revolutionary cinema should be doing: using the camera as a partial object, as an "eye" torn from the subject and freely thrown around—or, to quote Vertov himself: "*The film camera drags the eyes of the audience* from the hands to the feet, from the feet to the eyes and so on in the most profitable order, and it organises the details into a regular montage exercise."[5]

We all know the uncanny moments in our everyday lives when we catch sight of our own image and this image is *not* looking back at us. I remember once trying to inspect a strange growth on the side of my head using a double mirror, when, all of a sudden, I caught a glimpse of my face in profile. The image replicated all my gestures, but in a weird uncoordinated way. In such a situation, "our specular image is torn away from us and, crucially, our look is no longer looking at ourselves."[6] It is in such weird experiences that one catches what Lacan called gaze as *objet petit a*, the part of our image which eludes the mirror-like symmetrical relationship. When we see ourselves "from outside," from this impossible point, the traumatic feature is not that I am objectivized, reduced to an external object for the gaze, but, rather, that *it is my gaze itself which is objectivized*, which observes me from the outside; which, precisely, means that my gaze is no longer mine, that it is stolen from me.

Deleuze often varies the theme of how, in becoming posthuman, we should learn to practice "a perception as it was before men (or after) . . . released from their human coordinates":[7] those who fully endorse the Nietzschean "return of the same" are strong enough to sustain the vision of the "iridescent chaos of a world before man."[8] Although Deleuze resorts here openly to Kant's language, talking about direct access to "things (the way they are) in themselves," his point is precisely that one should subtract the opposition between phenomena and things-in-themselves, between the phenomenal and the noumenal level, from its Kantian functioning, where noumena are transcendent things that forever elude our grasp. What Deleuze refers to as "things in themselves" is in a way *even more phenomenal* than our shared phenomenal reality: it is the impossible phenomenon, the phenomenon that is excluded from our symbolically constituted reality. The gap that separates us from noumena is thus primarily not epistemological, but practico-ethical and libidinal: there is no "true reality" behind or beneath phenomena, noumena are phenomenal things which are "too strong," too intens(iv)e, for our perceptual apparatus attuned to constituted reality—epistemological failure is a secondary effect of libidinal terror, that is to say, the underlying logic is a reversal of Kant's "You

can, because you must!": "You cannot (know noumena), because you must not!" Imagine someone being forced to witness a terrifying torture: in a way, the monstrosity of what he sees would make this an experience of the noumenal impossible-real that would shatter the coordinates of our common reality. (The same holds for witnessing an intense sexual activity.) In this sense, if we were to discover films shot in a concentration camp among the *Musulmannen*, showing scenes from their daily life, how they are systematically mistreated and deprived of all dignity, we would have "seen too much," the prohibited, we would have entered a forbidden territory of what should have remained unseen. (One can well understand Claude Lanzmann who said that, if he were to stumble upon such a film, he would destroy it immediately.) This is also what makes it so unbearable to witness the last moments of people who know they are shortly going to die and are in this sense already living-dead—again, imagine that we had discovered, among the ruins of the Twin Towers, a video camera which magically survived the crash intact and is full of shots of what went on among the passengers on the plane in the minutes before it crashed into one of the Towers. In all these cases, it is that, effectively, we would have seen things as they are "in themselves," outside human coordinates, outside our human reality—we would have seen the world with inhuman eyes. (Maybe the US authorities do possess such shots and, for understandable reasons, are keeping them secret.)

This, then, is the background of what Bond describes: although the shots of the crime scene do not directly present the noumenal scene of a crime too intensive for our eyes, they evoke it—what makes them so unsettling is that they record traces of something we cannot really accept as an actual event, or grasp how it could have happened.

ACKNOWLEDGMENTS

Many thanks are due to the following for their contributions—guidance, advice, encouragement—toward the successful completion of this manuscript. I gladly and warmly acknowledge: Emily Tsingou, Sharon Harper, Ros Jennings, Alison Scott-Baumann, Nick Sargeant, David Bate, Mandy Merck, Darian Leader, Julian Stallabrass, Bruce Fink, Dylan Evans, Luc Sante, Urs Stahel, Bernard Burgoyne, Nicholas Royle, Douglas Gordon, Lindsay Watson, Dominic Palfreyman, Brian Voce, Russell Roberts, Michael Pinfold.

All images are reproduced with permission of The National Archive, Kew.

Special thanks to Roger Conover at MIT and, of course, to Gospod Žižek: who could frame his fearful—Balzacian—symmetry?

Lacan at the Scene

I begin with a novel and engaging premise: what if Jacques Lacan—the brilliant and eccentric Parisian psychoanalyst—had left his home in the early 1950s in order to travel to England and work as a police detective? How might he have applied his theories in order to solve crime? A "what if . . . ?" that conjures up images of this most unusual personage: on the cross-Channel ferry swaying in the drizzling rain next to an ageing Citroën DS; being met in Dover by a steaming Jaguar filled with gruff chain-smoking cops. In my mental film clip Lacan's *Frenchness* is amplified, highlighting the incongruity of the effete intellectual as he greets his new colleagues.[1]

But beyond this flippant or comedic starting point is a serious enough proposition: an attempt to put Lacan's tripartite model of human mental functioning to use in the service of crime investigation—particularly through a consideration of visual evidence present at scenes of murders. In order to follow up on this proposal—or question—I began to make regular visits to the National Archive, requesting whatever material I could find on murders that took place in England between 1955 and 1970. Each bulky, dusty box file contained essential original documents pertaining to the crime—the Senior Investigating Officer's (SIO's) report to the Director of Public Prosecutions (DPP), numerous witness statements, press clippings, and, decisively, copies of the original crime scene photographs: I had enough information to research and propose a series of *Lacanian* readings. And set out below are the results of my three-year-long inquiry.

Police photographs of a murder scene do not ordinarily capture the aggressive actions that Lacan characterized as "moments, similar in strangeness to the faces of actors when a film is suddenly stopped in mid-frame [a freeze-frame]."[2] Always arriving *too late*, the forensic photographer must depict instead only what is residual. The presence of Scenes of Crime Officers (SOCO) or Crime Scene Investigators (CSI)[3] is menacing—or ominous—and immediately obvious through their distinctive regulation attire: single-use Tyvek brilliant white polyethylene hooded forensic scene anticontamination one-piece coveralls, nitrile gloves, and a face mask, or even a respirator.[4]

The term *forensic*, as is well known, refers to a context: work that is being carried out for legal purposes. As part of the "apparatus of the prosecution," any evidence collected by these men and women may ultimately be produced and admitted as exhibits by the crown/prosecuting counsel in any future trial. Perhaps the most desirable type of forensic evidence is recovered material that includes a sample of a suspect's—more or less unique—DNA; a single hair or saliva residue preserved on a glass is sufficient, and will more or less incontestably connect that suspect to the scene. Samples of clothing fibers, or even pollen, may be recovered. Possible fingerprint evidence is

also photographed and documented, as well as the patterns and formations of any blood residues. Such evidence will be photographed and enlarged by up to 1000x magnification.[5]

Yet, in addition to these highly technical materials and records, the CSIs will also make an extensive series of *normal* photographs, images that usually include diverse general photographic views of the scene taken from various perspectives and angles, often made using the same kind of familiar camera equipment that a wedding photographer might use—and it is examples of these more prosaic or workaday records that I have relied upon in this study.[6]

The *Federal Bureau of Investigation Handbook of Forensic Services* provides a comprehensive picture of the meticulousness that is essential to success in this demanding field. In the USA, a copy of that handbook is given to all law enforcement professionals including part-time staff, county sheriffs, and so forth, as decisions made by the first officer to arrive at a crime scene will be crucial—important forensic evidence is often destroyed or recovered inappropriately by nonspecialists long before the CSIs arrive. In the mêlée that often commences upon the discovery of violent death, appropriate procedure is not always followed, and the first priority of any law enforcement officer is to secure the scene: that is, to stop anyone but the CSIs from approaching or entering.[7] In high contrast to the drama and excitement that such an event will provoke in the layman, the specialist CSIs seem to carry on their methodical, reflective work with an apparent nonchalance that often appears to be awkwardly respectful of the traumatizing events: for them it is just another day at the office. Indeed, for these experts the crime scene *is* their typical—but always temporary—workplace, and, in common with those attending many much less challenging working environments, they proceed with a confident familiarity.

Considering this dichotomy of performance versus reflection in terms of the *photographic*, there is an immediate resonance with the critical assertion made by the French theorist and philosopher Roland Barthes, who noted that "the filmic, very paradoxically, cannot be grasped in the film 'in situation,' 'in movement,' 'in its natural state,' but only in that major artefact, the still."[8] Deferring to the residual, Barthes argued, is probably essential in order to comprehend cinematic action.[9] The author William Burroughs also recognized that the *affect* connected to an event or activity might be revealed—grasped—only through documentation, observing that "you may not experience shame during defecation and intercourse, but you may well experience shame when recordings are played back to a disapproving audience. *Shame is* playback: exposure to disapproval."[10] There is an idea advanced that remote documents may hold the key to comprehending human actions, events, and so on: a belief (or fascination) that may be traced back

through the advances and discoveries made—in the late nineteenth and early twentieth century—in the domain of photography technology.

In 1924, the Hungarian photographer and writer László Moholy-Nagy noted how the photographic camera "makes visible existences which cannot be perceived or taken in by our optical instrument, the eye: i.e., the photographic camera can either complete or supplement our optical instrument, the eye. . . . This principle has already been applied in a few scientific experiments, as in the study of movements—walking, jumping, galloping—and of zoological, botanical and mineral forms—enlargements, microscopic photographs—and other investigations into natural history; but these experiments have remained isolated phenomena, the *inter-connections* of which have not been established."[11] And Moholy-Nagy's exhortation to recognize the potential significance of the connections and links between data provided from diverse photo sources seems to precisely foreshadow the development of the modern forensic services laboratory, which is a contemporary instance *par excellence* of this proposition: a place where every possible use is made of diverse technologically advanced lens-based equipment, and where a single unifying purpose remains primary—the possible *interconnections* that might effectively incriminate a suspect.

The inventions and discoveries to which Moholy-Nagy alludes include the development of photomicrography (taking photographs through a microscope), an invention attributed to Reginald Fessenden in 1876; the high-speed camera shutter (stop-motion photography) attributed to Eadweard Muybridge in 1878, and Röntgen ray imaging (x-ray images) attributed to Wilhelm Röntgen in 1895.[12] A common purpose shared by each of these pioneers was the desire to use science in order to reveal hitherto unseen worlds—to go deeper, further, and so on. And this attitude was shared, of course, by the Austrian neurologist Sigmund Freud, who formulated his initial theory of the unconscious during precisely the years that these photo discoveries were also announced—*The Interpretation of Dreams* was finally published in 1899.

It was the philosopher Walter Benjamin who—almost thirty years later—first proposed a direct parallel between inventions such as photomicrography, Röntgen ray imaging, or the high-speed camera shutter and the theory of psychoanalysis. Benjamin—now famously—commented that "photography, with its devices of slow motion and enlargement, reveals the secret. It is through photography that we first discover the existence of this optical unconscious, just as we discover the instinctual unconscious through psychoanalysis."[13] Benjamin's assertion of a parallel with Freud's proposition is instantly compelling, but if we take his proposal literally and relate it back to the analytic setting—"the session"—it can be noted that traces—evidence—of the unconscious are not wholly imperceptible, only

disguised. The hidden metanarrative—of the dynamic unconscious—emerges from the analysand's discourse: the *real* story is not the one that the patient carefully relates, but is often located in seemingly incidental details such as denials, repetitions, hesitation, slips, and so on. The primacy of the analysand's discourse has been qualified by the psychoanalyst Jacques-Alain Miller: "[Lacan emphasizes] the internal coherence of the patient's discourse, that is, of what he or she says . . . you simply check whether his or her discourse is consistent . . . you look for discrepancies within the discourse itself."[14]

This theme also underpins the process that modern crime investigators follow: their basic procedure is to rule out or *eliminate* each suspect from the inquiry—a methodology that remains unaltered since Poe's fictional detective M. Dupin observed that "they [the detective and his team] had fallen into the gross but common error of confounding the unusual with the abstruse. But it is by these deviations from the plane of the ordinary, that reason feels its way, if at all, in its search for the true. In investigations such as we are now pursuing, it should not be so much asked 'what has occurred,' as 'what has occurred that has never occurred before.'"[15]

And when this method of alighting upon inconsistency is applied to interpreting, for example, crime scene photographs, Benjamin's parallel with the clinical setting is sustained: just as the privileged space of the psychoanalytic session enables an ordinarily dismissible instance of speech to be highlighted, here too all that was once incidental or unremarkable cannot be (must not be) ignored or *overlooked*. The scene of a murder is a rarefied space in which the banal is almost completely eradicated (or annihilated). Commenting on the power that a dead body has to alter the status of objects surrounding it, the French philosopher Maurice Blanchot noted: "even though the cadaver is tranquilly lying in state on its bier, it is also everywhere in the room, in the house."[16] And this factor is decisive—whether a violent death or otherwise—as it is the presence of a body that redefines the space and reconfigures the status of everything—or, everything *else*—in the room.[17] As a consequence of that presence, every formerly mundane object must now be documented and *scrutinized*.[18]

In order to capture—privilege—such details in the primary material that I consulted—crime scene images from the DPP archive—I worked with a macro or "close-up" lens at around three centimeters from the surface of the original photographs, using a technique known as photomacrography.[19] Commenting on his use of a similar setup, the artist Richard Prince wrote: "I thought of the camera [copy stand] as an electronic scissor,"[20] and so, too, my rostrum-like movements over the image surface (the lens moving slowly across the ageing black-and-white photos) were made in order to seek out and alight upon (in the familiar clutter of the everyday) elements which

were recognizable as *symptomatic*.[21] Immersed in the angle of view offered by my camera's viewfinder, I "reentered" each of these scenes, and often the effect *was* as if I were physically present—cautiously (guiltily) creeping around, capturing my own evidence: a single high-heeled shoe on a kitchen table; some carefully folded clothes placed over the back of a chair; a plate of chocolate biscuits on a dinner table; a lewd graffiti inscribed into a train carriage door; an arrangement of workman's tools in a forest clearing.[22]

In *The Optical Unconscious*, Rosalind Krauss asks: "What can we speak of in the visual field that will be an analogue of the 'unconscious' itself, a structure that presupposes first a sentient being within which it operates, and second a structure that only makes sense insofar as it is conflict with that being's consciousness? Can this optical field—the world of visual phenomena: clouds, sea, sky, forest—*have* an unconscious?"[23] And in answer to Krauss's vexed question, it may simply be asserted that the (supposed) unconscious of "clouds, sea, sky, forest," are—at least in this study—irrelevant: the *clues* that I interrogate below are simply proposed as *indexical*—visual evidence that is always related back to (possible) human actions and behavior.[24] Following Barthes's terminology, the *studium* of murder scene photographs—insofar as I have worked with them—is always the depiction of a violent death (the corpse). Barthes characterized this element as "the general, cultural . . . interest one has in a photograph [that which] corresponds to the photographer's work."[25] However, as the author Jim Ballard has observed, "cruel and violent images which elicit pity one day have by the next afternoon been stylised into media emblems."[26] Thus, the Barthesian *studium* may actually seem banal, repetitive, and empty, communicating only an emblem which is restricted, closed.[27] Equally, the Barthesian *punctum*, "the detail that captivated me, surprised and awakened me . . . a kind of point, a sting, that touches me sharply," seems to also depend—as do Miller's and Poe's—upon the notion of a discrepancy.[28]

For example, of the fifteen paintings by the German artist Gerhard Richter which depict—almost grandiosely—the much-disputed "suicides" of Andreas Baader, Gudrun Ensslin, and Jan-Carl Raspe in the early hours of the morning of October 18, 1977 (while inmates of Stammheim Prison), it is a "subsidiary" painting that is not derived from the sensational press images of the harrowing cadavers, but merely depicts a secondary detail of a record (a vinyl LP) on a cheap record player which "touches me sharply," that is, seems to be the most revealing—and poignant—image.[29] The depressing futility of the RAF's eleven-year campaign of violence and murder that was designed to achieve freedom from so-called Imperialist Forces is not implicit in the "heroic" images of their cadavers—which do seem to present them as martyrs in a "just cause" of the complete destruction of Capitalism—but might be glimpsed somehow in the record player: the

stirring revolutionary and anti establishment sentiment of late-1960s rock and pop music must have been *how it all began*. An example of the phenomenon that Luc Sante alluded to when he observed: "The fact that every life is a chaos of incidentals ensures that sudden death will magnify disorder; any ridiculous moment might be the last moment, any insignificant object might be forever associated with you through some terminal juxtaposition."[30] And it is precisely some instances of these "terminal juxtapositions" that I evaluate in this book—the detail that is usually glimpsed only at the edges of an otherwise lurid photo.

Hard Evidence

IN *THE NEW HISTORY OF PHOTOGRAPHY*, EDITOR MICHEL FRIZOT CLAIMS THAT HIS APPRAISAL OF PHOTO HISTORY IS ONE WHICH DEMOCRATICALLY INCLUDES HITHERTO IGNORED APPLICATIONS OF THE MEDIUM—A HISTORY NOT SOLELY BASED ON THE *OEUVRES* OF THE TRADITIONAL CANON OF GREAT MASTER PRACTITIONERS. THERE ARE ARTICLES ON SCIENTIFIC PHOTOGRAPHY AND ON THE HISTORY OF THE SNAPSHOT ("UNIVERSAL PHOTOGRAPHY"), BUT NOTHING REALLY ON CRIME SCENE PHOTOGRAPHY (THE HARD-TO-IGNORE HISTORY OF PORNOGRAPHY IS ALSO CONVENIENTLY SIDESTEPPED).[1]

The photography historian Dr. Ian Jeffrey has recently proposed a new and revised history of photography—*Revisions: An Alternative History of Photography*—a study that recognizes the centrality of utility to photography's development.[2] Dr. Jeffrey offers chapters on military photography, celestial photography, and x-ray imaging. However, it is not surprising to note that even in a book on "overlooked" genres of photography, the crime scene photograph is not considered.[3]

This was the first compelling *clue* that I was confronted with when I began researching crime scene photography: the shortage of any sustained *critical* writing (or other presentation) on the subject—it seemed that for some possibly significant reason, an adequate discourse had failed to evolve.

Certain publications available on this topic deal quite generally with the relationship between photography and law enforcement—these are essentially picture books that normally feature copious reproductions of crime-related images presented as they stand, or accompanied by a series of terse commentaries, and include those edited by Buckland, Hannigan, and Aaronson.[4] I think it is fair to assert that some of these additions to the literature are not intended to be academic studies, and—as with many such "coffee table" books—they tend to be designed and presented in a manner that seems to promote only a brief perusal. The written contributions often include tossed-off generalized statements that are sometimes poorly considered; others echo a prevalent tendency—when confronted with the crime scene photograph—to descend into a prose style that is a parody of *hard-boiled* crime fiction, such as this annotation of a photograph made by Arthur Fellig ("Weegee"), a photographer whose pictures are *de rigueur* in these books: "Roy Bennett, twenty-seven years old, had come from Texas by bus and immediately tried his hand at big city crime. His first attempt at a stickup was his last: detectives shot him dead as he tried to escape on August 11, 1941."[5]

Another regularly encountered theme is a response that relies upon a heartfelt or personal reaction to the imagery; writing in Mandel and Sultan's *Evidence*, Sandra Phillips comments: "Recently, there has been an interest in seeing evidentiary photography, such as police pictures made as evidence [for use] in court, aesthetically, a phenomenon probably linked to reality TV and a certain anxiety about reality itself. Photographs of early twentieth-century murders in New York City, published in a book called *Evidence* [Sante, 1999], are pictures of social phenomena compelling and beautiful.

Because of their fascinated regard for violent death [that] . . . volume is really about rapture, the mysterious sacredness of life, and provides . . . an acknowledgment of photography's power."[6] Phillips's notes—on a collection of photographs selected from the archives of the NYPD—are extravagantly wide-ranging (reality TV, global anxiety, mysterious sacredness) but are clearly not based on any relevant academic argument, relying instead on bland casual opinion.[7]

In the literature accompanying a recent exhibition of crime scene photographs (at a well-known US photography center), it is asserted that "some of these images are downright shocking in their detailed depictions of grim homicides. Yet many also have a picturesque beauty verging on the cinematic. Some of the more evocative scenes even come perilously close to resembling stills from film noir classics."[8] Equally, Gail Buckland writes: "We are all wildly ambivalent about crime photographs. We want to look, and we want to look away. Our response to many images of violence is the same as it is to a terrifying scene in a movie: we cover our eyes but leave our fingers just a little apart."[9] The crime scene photograph is often characterized as both picturesque/cinematic and shocking/grim (that paradox *is* noted); however, it is elementary that looking at crime scene photographs can often be vexatious and troubling to the viewer—such images do seem to often provoke mixed feelings. What is lacking is any psychological explanation (or exploration) of the reasons for such a paradox.[10]

Furthermore, when I made a request to the leading English photography historian Mark Haworth-Booth (who for many years, until his recent retirement, was curator of photography at the Victoria and Albert Museum, London) to conduct an e-mail interview on the subject of crime scene photography, I received only the following terse reply: "Sorry, but I find the whole subject of crime scene photo so unsympathetic."[11]

As these examples perhaps begin to reveal, crime scene photography has not been particularly well served by academic inquiry from within the discipline of photo history. However, several authors working in other allied fields have made important contributions to the production of a basic critical context. Particularly cogent are several studies concerned with documents of trauma, disaster, or war, in which the emphasis is often on a broad social context/reception and includes such works as those by Taylor; Baer; Lesser; Azoulay; and (the difficult to find) Ruby.[12] The art historian Sue Taylor's study of the photographer Hans Bellmer is Freudian in its orientation, and there are also some other highly original studies that cut across the boundaries of literature, art, and art criticism, including those by Parry, Sante, Sternfeld, and Rugoff.[13]

Peter Wollen's text in Rugoff's *Scene of the Crime*, in particular, encompasses a consideration of the major themes that seem relevant to this field of

inquiry, and my research in this volume might be reasonably characterized as a response to—or a sustained elaboration of—his all too brief essay.

In attempting to extend the discourse in this field, the emphasis of my attack has been to pursue a critical engagement with my primary material whereby I have sought, above all, to go beyond readings of murder scene photography that propose to invoke poetic rapture—the mysterious and unknowable. But also those in which the critical challenge posed is diffused and sanitized by rendering the themes under consideration as distinctly separated from the present (the everyday), thus inoculating the viewer/reader against the potentially threatening, distressing, psychological dimension. In this respect I note an affinity with the unflinching and insightful biographies of certain notorious murderers written by Ward Jouve, Masters, and Burn; these exemplary studies undoubtedly remain key texts in this field. [14]

The discovered murder scene is a location that exists primarily as a myth, that which is "close to what Durkheimian sociology calls a 'collective representation,' [and] can be read in the anonymous utterances of the press, advertising, mass consumer goods; it is something socially determined, a 'reflection.'"[15] Crime scenes are frequently depicted across the formats of the mass media, but rarely—for the majority—is such a place ever actually *experienced*.[16] A defining aspect of the murder scene is that it is a privileged place that is inaccessible to all but a few professionals. Even the press photographer is denied access by the Police Line—the ubiquitous yellow-and-black or blue-and-white polythene tape, emblazoned with the injunction: CRIME SCENE DO NOT CROSS—and is confronted by a situation where the scene itself cannot be depicted. The tape defines a specific area that is temporarily subject to extraordinary regulation. Due to the presence of this barrier the photojournalist may turn instead to suggestion and implication, the lack of access ultimately prompting documents of the familiar coming and going at the perimeter boundary: they may point their lenses at a circling helicopter, or at the police and medical support vehicles which slow to a crawl at the threshold, then abruptly accelerate away.

The press photographer's pictures are often defined by their distance from the site itself, and such images are precisely those that propagate myth or cliché: the inherent lack of specificity finally supporting their function, that is, their vagueness and generic quality, actually creates a useful space from where the news *story*—in the form of speculation and journalistic musings—can emerge.[17]

Conversely, the Scenes of Crime Officer—whose photographic records are the subject of this inquiry—works *beyond* myth. Such a photographer is not expected to produce a neat story. Instead their task is to photograph *everything*—anything present may be of significance. In the current FBI field manual it is stated that "Nothing is insignificant to record if it catches one's

attention."[18] When the (artistic) photographer Garry Winogrand asserted: "I photograph to find out what something will look like photographed," he also came near to elucidating a sensibility closely allied to the forensic brief, which presumes that *we do not yet know what is important or significant*: that is something which will be considered—or understood—only later.[19]

Practitioners involved in these two equally important disciplines are seemingly polarized: they are literally either side of a (polythene) line.[20] For the first there is a lack or gap: the photographer cannot actually gain access to their supposed subject at all. Whereas the latter is vexed by an excess: there is a seemingly unlimited quantity of material which must be documented.[21] And this is the basic challenge with which the Scenes of Crime Officer is presented upon arriving at such a place. Indeed, the soco's role is now so well known that dominant film language, for instance, has produced no more effective—or simpler—means of introducing a location as a *discovered* crime scene than to portray the act of it being photographed and documented.[22]

Numerous practical handbooks exist to guide the practitioner through the process of photographing a crime scene, including those authored by Siljander, Saferstein, and Redsicker.[23] Each of them reconfirms the point made—somewhat extravagantly—by the technician Kraszna-Krausz, who notes that "photographic coverage [must be] made from several angles to meet *all eventualities*."[24] A recent FBI briefing document asserts that "the aim should be to record a maximum of useful information," and includes the following examples of potentially relevant subject material: "cigarette butts, tool marks and impressions of shoe prints . . . [a] telephone receiver off the hook or wires cut, playing cards orderly stacked or scattered, TV and lights turned on, food in cooking stages, coffee cups, drinking glasses or liquor bottles."[25]

The above directive confirms that a basic paradigm of the csi's procedure is to place no greater emphasis on what appears to be striking or spectacular (a bloody corpse, for instance) than on any of the other ordinary, unspectacular, or banal elements present (coffee cups or food in cooking stages), an approach that may be described as one which *democratizes* the subject matter.

This essential requirement or *sine qua non* of the crime scene document has been redeployed by numerous photographers in a fine-art context, including William Eggleston, Keith Arnatt, Boris Mikhailov, and Georg Philipp Pezold.[26] Documenting *the everyday* has also been a concern in my own research/practice since 1988.[27] Such photographers have often depicted— and published images of—familiar objects that are encountered daily: milk bottles, saucepans, shoes, folded newspapers, or the contents of a fridge. This approach to subject matter is more or less opposed to the aims of many others who seek to photograph the exotic/the spectacular, and so on. Characterizing his approach to his daily activity of photo-making with a straightforward clarity, William Eggleston commented: "the word [snapshot] has

never had any meaning [for me]. I am at war with the obvious."[28] For Eggleston and some others, the everyday is often recorded without a preconceived notion of what might be (or *has* to be) coded as interesting or beautiful. This approach also has parallels in literature—for example, the painstaking evaluations and descriptions of the ordinary supplied by Georges Perec in *La Vie mode d'emploi* [*Life: A User's Manual*].[29] Or Daniel Spoerri's *An Annotated Topography of Chance*, which is constructed using a device that the author describes as the "technique of Sherlock Holmes . . . [who] starting out with a single object could solve a crime."[30] Spoerri highlighted the mundane objects on his studio table—an egg cup, matches, a piece of baguette—and derived his enthralling text exclusively from associations, memories, and anecdotes relating to them.[31]

For the Swiss photographer Olivier Richon, depicting mundanity is also proposed as a challenge to the traditional hierarchy of fine-art subject matter: "[The everyday is] an aesthetic category based upon the repudiation of the classical regime of representation that assigns a hierarchy to different genres and subjects. The banal and the ordinary raise things to the dignity of objects and the technique of photography enables us to read signs on the photographed body of things and people."[32] This classical regimentation of representation is not only present in historical fine-art painting, but is also generally determining. For instance, when the French sociologist Pierre Bourdieu asked a group of survey respondents to consider certain photographs and give each a percentage score based on a perception of how "interesting or beautiful" it appeared to be, he drew the following overall results:

A sunset: 78%, a landscape: 76%, a little girl playing with a cat: 56%, a woman breast-feeding: 54%, a folk dance: 46%, a weaver at work: 39%, a still life: 38%, an old master: 37%, the bark of a tree: 35%, a famous monument: 27%, a first communion: 26%, a snake: 20%, a rope: 16%, a metal frame: 15%, cabbages: 12%, a butcher's stall: 9% . . . a car accident: 1%.[33]

According to Bourdieu's research results, there emerges a broadly agreed sense that—for many people—certain photographic subjects are simply more worthwhile than others: there is a consciously asserted typical hierarchy of agreeable subject matter. And it is this often unspoken proposition (assertion) of a sliding scale that many of the pioneers of twentieth-century photography sought to challenge. Characterizing precisely this inclusive democracy of vision, Walker Evans invoked a passage written by his contemporary, the Russian author Vladimir Nabokov: "Vasili Ivanovich would look at the configurations of some entirely insignificant objects—a smear on the platform, a cherry stone, a cigarette butt—and would say to himself that never, never would he remember these three little things here in that

particular interrelation, this pattern, which he could now see with such death-less precision. . . . Nabokov might be describing a photograph in a current exhibition at the Museum of Modern Art."[34] And beyond Evans's recognition of a parallel with fine-art photography there is also, again, a correlation with the forensic work that the SOCO is tasked to carry out: recording spatial rela-tionships between objects; documenting the exact angle at which an object came to rest; the precise distance of one object from another; and so on.[35]

An insight into this seemingly too inclusive mode of visual inquiry may be gained by comparing it with another approach to representing the-world-around-us to which it is also antagonistic: the stock or library photograph—such as those huge commercial collections held by Getty Images, Corbis Corp., or Fotosearch, for example. Typical examples of this genre include many depictions that seem to be intent upon only reiterating a well-known visual motif—a worker at a desk in shirt sleeves, surrounded by several stacks of papers; a smiling couple hand in hand at sunset; dad greets his child, offering a new teddy bear; a smile on the telephone; weary shoppers step out of a New York taxicab. The primary purpose of this—often tedious—photographic language is to close down ambiguity in order that the denotative function remains secure, thus enabling the image to communicate—telegraphically—a preferred connotation, which also very often reconfirms—automaton-like—a well-known theme: happy-in-love; healthy free time; busy at the office; and so on. In terms of technical pro-duction, though, the essential factor is the necessity to constantly marshal a *correct* interpretation, and in order to achieve this aim all insignificant, unnecessary, or unusual detail is carefully avoided and removed from the frame by the photographer and art directors. In the stock photograph, daily life is depicted without the leaks, blemishes, stains, pauses, and stumbling that actually characterize it.[36] Most importantly, elements that communicate *nothing really* (Nabokov's cherry stone and cigarette end) are removed on the basis that inclusion would limit the efficiency of the image to make its point. In the Barthesian sense, the stock photo is designed and executed with all possibility of *punctum* wiped out.[37] And it is precisely because such images are sanitized, highly intentional, and predictable that they exist only as banal generic clichés.[38]

In order to develop an explanation for this ongoing dichotomy between the warts-and-all, humdrum depiction and an alternative *more polished version*, it seems plausible, or even essential, to introduce a psychoanalytic frame-work, and in particular the concept of repression.[39]

Just as the scientific/forensic photographer gains nothing from ide-alization, the psychoanalyst has no purpose in prioritizing "interesting and beautiful" utterances, and will usually be equally interested in nongeneric and less art-directed phenomena. A slip of the tongue, mispronunciation,

repetition, or a hesitation—like the bits and pieces of detritus noticed on a station platform—may be of as much value as any carefully worked, consciously controlled speech. In order to apprehend material that is marked, distorted, or altered by the unconscious, the analyst declines to insert or impose any thematic hierarchy on the incoming data. Indeed, this strategy, first elucidated by Sigmund Freud, remains the basic analytic rule—the *golden* rule. Stating the analysand's (some use patient or even client these days, in order to avoid this semi-antiquated term) obligations in the session, Freud pronounced: "For the purpose of self-observation with concentrated attention it is advantageous that the patient should take up a restful position and close his eyes; he must be explicitly instructed to renounce all criticism of the thought formations which he may perceive. He must also be told that the success of the psychoanalysis depends upon his noting and communicating everything that passes through his mind, and that he must not allow himself to suppress one idea because it seems to him unimportant or irrelevant to the subject, or another because it seems nonsensical."[40]

The stock photography picture—indeed, promotional imagery in general—might be described as a corollary to the Freudian concept of justification: a presentation that is idealized and artificial.[41] Richard Prince, for example, describes such pages as "too good to be true. Unbelievable. Overdetermined."[42] Equally, a photo strategy that tends to highlight what is "unremarkable, forgotten, cast adrift" does not simply offer up an alternative or antidote to the familiar banality of myth, but, in capturing the incidental, an equalitarian directive is activated with the underlying proposition (or implication) that *all* subjects, views, objects become part of a nonjudgmental continuity—just as in the session it will be for the psychoanalyst to differentiate and select what is to be regarded as significant, by attending to the logic of the unconscious.

The overt hierarchy of photographic subject that Pierre Bourdieu's respondents proposed as "interesting or beautiful" may thus be contrasted—or even replaced—with one that is more open-ended and less restricted by what Freud called the "psychical dams of disgust, shame, and morality."[43] Just such an alternative taxonomy was proposed in a phantasmagoric sequence of images compiled by the French writer and philosopher Georges Bataille:[44]

An abandoned shoe, a rotten tooth, a snub nose, the cook spitting in the soup of his masters . . . an umbrella, a sexagenarian, a seminarian . . . the hollow eyes of judges . . . a dog devouring the stomach of a goose, a drunken vomiting woman, a sobbing accountant, a jar of mustard represent the confusion that serves as the vehicle of love. . . . The Jesuve [a Bataillian neologism] is thus the image of an erotic movement that burglarizes the ideas contained in the mind, *giving them the force of a scandalous eruption.*[45]

Bataille includes images that are tawdry or intentionally distressing, but crucially, he also adds several that are entirely unclear or ambiguous in their connotation—a jar of mustard, a snub nose, an umbrella—and it is this movement away from relentlessly identifiable hierarchies and logical groupings that is compelling. Bataille refuses to exclude elements that *do not seem to fit*; his images are provocative—and richly associative—precisely because some of their connotations are opaque.[46]

The creative decision to explore the visual *beyond myth* is, in any case, a strategy that has been sustained since the invention of photography—as long ago as 1839.[47] Edgar Allan Poe, for example, described the initial announcement of the daguerreotype (the forerunner of modern photographic processes) as "the most important and perhaps the most extraordinary triumph of modern science,"[48] and in the tale *The Mystery of Marie Rogêt*, written the following year, he pieces together the probable events of an unsolved murder case (a thinly veiled commentary on the unsolved murder of the cigar vendor Mary Rogers in New York).[49] Poe's prose seems to be, if not directly dependent on photographs, then at least *photographically informed*; his literary reconstruction foreshadows a slow low-angle camera pan across the murder scene.[50] Poe's device is to consider certain details *as if he were referring back to a series of photographic images* of the crime scene, and his meticulous appraisal reveals the significance of a hitherto overlooked detail—some torn strips of fabric which had been carefully removed from the deceased's skirt.[51]

Geoffrey Batchen has noted that "the photograph exercised a hallucinatory presence well before its official invention, being conceived by at least twenty different individuals between 1790 and 1839"; for Poe, however, it seems, photography remained a "hallucinatory presence" even *after* its invention.[52] Reiterating his interest in the mundane—and now foreshadowing Freud—Poe's M. Dupin reminds his colleagues: "Experience has shown that a vast, perhaps the larger, portion of truth arises from the seemingly irrelevant."[53]

Many decades later, yet directly influenced by both Freud and Poe, the surrealists—a group of artists, writers, and provocateurs based mainly in Paris—reengaged with this *larger portion of truth*. John Roberts has commented: "[For Breton] Freud produced not just a new diagnostics, but a new hermeneutics of the everyday. The possible truth of things and events lay beyond the initial moment of empirical verification in their unconscious significance. As a consequence, everyday life became filled with motives and intentions whose meaning lay beyond the consciousness of their agents."[54] Breton himself asserted, for instance: "We have said nothing about [Giorgio de] Chirico until we take into account his most personal views about the artichoke, the glove, the biscuit, or the spool."[55] Recognizing this phenomenon in the work of the French photographer Eugène Atget, Walter

Benjamin observed that "Atget almost always passed by the 'great sights and so called landmarks.' What he did not pass by was a long row of boot lasts; or the Paris courtyards, where from night to morning the handcarts stand in serried ranks; or the tables after people have finished eating and left, the dishes not yet cleared away—as they exist by the hundreds of thousands at the same hour; or the brothel at No. 5, Rue———, whose street number appears, gigantic, at four different places on the building's façade"[56]—that is to say, Atget often avoided the overdetermined and spectacular views that had already become the photo clichés of Paris, and instead chose to highlight elements from a seemingly mundane reality, such as grilles, banisters, grates, shop window displays, and so on. More recently, the curator and writer John Szarkowski—also a significant contributor to the study of Atget—has proposed that a central preoccupation for the photographic practitioner has been to record, or "point at [that which] was unseen before, or seen dumbly, without comprehension."[57] Thus, finally, the interpretive work laid out below may be contextualized as a further contribution to a critical trajectory which began with Poe, and has been incrementally evolved through the contributions of Atget, Chirico, Evans, Spoerri, Perec, Nabokov, Eggleston, and so on.[58]

A second theme that is worth reviewing in the context of this study is that of the *photograph of a photograph*—the macro details that I created/worked from are *pictures of pictures*—rephotographed fragments.[59] In a rephotograph the subject matter selected by the photographer is *already* a photograph, and the fundamental signification implicit in the use of this technique ("strategy") is that—in depicting and re-presenting a preexisting photograph—there is an emphasis placed upon the materiality and processes of photography as media/medium.[60] Michel de Certeau, writing in the 1970s, considers appropriation—in the activity of reading—as unintentional, unavoidable: "[The reader/viewer] insinuates into another person's text the ruses of pleasure and appropriation: he poaches on it [steals from it], is transported into it, pluralizes himself in it like the internal rumblings of one's own body. Ruse, metaphor, arrangement, this production is also an 'invention' of the memory."[61] In the 1980s the focus moved away from the whimsical—personalizing—appropriation, and was concentrated instead on highly intentional *theft* and the explicit use of *duplication*; this prompted some commentators—particularly in relation to fine-art practice in 1980s New York—to suppose that photographers/artists involved with rephotography were signaling a failure of originality: the use of rephotography—particularly as it was offered by, say, Richard Prince or Sherrie Levine—was promoted as being redolent of a hastening endgame in which image-making was rapidly becoming limited and repetitive. Andy Grundberg's critical commentary, for example,

which is predicated on a thematic of finality, now looks, in retrospect, overly dramatic: "[Richard Prince's] art is troubling because it implies the exhaustion of the image universe; it suggests that a photographer can find more than enough pictures already present in the world without the bother of making new ones. It is a strategy of wide appeal to a generation brought up in an environment saturated with images."[62] For Grundberg, photographic subject matter is proposed, quite preposterously, as a commodity; one which—much like oil or coal reserves—is presumed to be running out, or becoming used up. And this theme of a "connotation exhaustion" (as depletion) or a even a feared photo saturation was a pervasive attitude in the fine arts at that time: a recognition that it was "Game Over," that artists were now operating only in the (bombed-out) ruins of art history—the death of art, and so on. More recently those "postmodernist" themes have been forgotten, and attention has been on the so-called "Greater New York" scene of artists, including Wade Guyton, Kelley Walker, and Nate Lowman—a loose quasi-group of rephotographers and appropriationists whose exuberance is not at all in question.

Indeed, it seems not only elementary but essential that an inquiry into the nature of photographic representation is actually enriched through an a priori acceptance of the photographer's *alienation* from their subject.[63] And it is alienation (which begins with/in the lens itself) which is, for Lacan, implicit to the imposition of language—the fundamental consequence of the subject's entry into the *Symbolic Order*.[64] This theme of the subject's alienation—which is the basic paradigm of Lacan's conceptualization of Oedipus—has been eloquently described by the psychoanalyst Dr. Darian Leader, who recently noted that "we are all immersed in the register of signs. Language is pulverized. The phrase 'I love you' is already pulverized. Each [visual] artist creates their own pulverized signs. We struggle to convey intimacy in language: it is already pulverized. We can only get to the *real* feeling through the artificial. The realm of language inherently produces distance."[65] This factor, that we are doomed to "get to the real feeling [only] through the artificial," is precisely what the rephotograph highlights: rephotography may be conceptualized/recognized as a useful means with which to emphasize the fundamentally *mediated* quality of subjectivity itself. And Richard Prince—writing in a personal artist's statement—communicates something of this sensibility; in an explanation of his decision to utilize that technique, he notes how "his own desires had very little to do with what came from himself because what he put out (at least in part) had already been out. His way to make it new was to *make it again*, and making it again was enough for him certainly, personally speaking, *almost* him."[66] As Douglas Crimp has reflected: "[these photographers are] showing photography to be always a representation, always-already-seen."[67]

This potentially debilitating pulverization of the sign prompted Roland Barthes (attempting to summarize his theory of photography) to state: "I think that we are victimized by cultural stereotypes."[68] Barthes is not defeatist in delivering this observation, but this state of affairs does seem to demand a response from (create a challenge for) the author, the artist, the poet. Highlighting the work of Gustave Flaubert, he continues: "[Flaubert] also came to grips with cultural codes; he was truly bogged down in them, and he tried . . . to free himself from them through ambiguous attitudes, irony, plagiarism, simulation; as a result we have that vertiginous book, so amazingly modern, *Bouvard et Pécuchet*."[69] Thus—as with the theme of the mundane detail that I have also outlined above—the trajectory curve of the *creative* use of plagiarism, simulation, and so forth may be traced back at least a century to Flaubert's 1881 novel, evolving through, for example, the work of Francis Picabia, the phenomenon of pop art, and the films Jean-Luc Godard (Wollen highlights, for instance, Godard's use of "multiple diegesis, open-endedness, overspill, intertextuality, allusion, quotation, and parody"), before arriving at the "[Metro] Pictures" scene of the 1980s and beyond.[70]

One of the earliest examples of creative appropriation or quotation in so-called *straight* photography can be seen in Walker Evans's notorious image, often referred to simply as *Studio*: a photograph that depicts the window of a commercial photo-portrait studio where rows of photo booth images have been placed.[71] In this image, and others such as *Minstrel Handbill* or *Torn Cinema Poster*, Evans simply re-presents photographic images that were already on display, with no further intervention.[72] Once again Evans's experiments dispose of any argument that the use of appropriation in photography is an explicitly "postmodern" phenomenon. As the art historian Douglas Fogle has recently noted, while also reconsidering some of the grandiose claims made in the 1980s: "One starts to think that the last picture might not have come yet, let alone the last picture show, which today seems like a distant dream."[73]

Equally, Jacqueline Rose, commenting from an overtly Freudian perspective, does not emphasize any end-of-epoch stagnation or desolation of image production, but the fact that "[a psychoanalytic approach] gives back to repetition its proper meaning and status: not lack of originality or something merely derived, nor the more recent practice of appropriating artistic and photographic images in order to undermine their previous status; but repetition as insistence, that is, as the constant pressure of something hidden but not forgotten."[74] Rose's conceptualization of repetition as pressure (being brought to bear on the image) seems cogent: in her reading, repetition actually becomes a valuable tool that can act to intensify and illuminate precisely through re-presentation—pressure—which returns the reader/viewer to some element that has been repressed, removed, rejected.

An alternative—and useful—approach to locating the rephotograph is to completely remove any connotation (context) of artistic practice altogether, and recognize it instead as a technique that has been an important utility since the earliest years of the medium's history: a technique that has always been used to simply enable the duplication of an important document—like the modern (recently antiquated) photocopy. In the 1840s, during the era of the daguerreotype process, taking a photograph of a photograph was actually the only way a reproduction could be made of an existing image, since the daguerreotype produced only originals and no negative. And that procedure has been paradigmatic—embedded—during the *analogue* era, as the basic mechanism whereby an image, a text, a film, a television program, or an audio recording has been copied. The process of making an analogue copy produces a *next-generation* copy where, crucially, the newer version is always marked by the process: a consequence of making the copy is that the new image is *degraded*. Analogue duplication processes (in photography the jargon is "making dupes") *always also* produce a loss of clarity when compared to the original. In transfers of audio recording (magnetic tape) this marking of the copy is manifest in increased "noise" or audible hiss, for example, and in the photocopy or dupe photograph evidence of the copying process is often recognizable in a narrowing of the original color gamut that is manifested in a loss of detail in shadow areas, and other often unwanted alterations such as color balance shifts that can render the image as unnatural or unrealistic.

The inherent degradation of analogue reproduction may be contrasted with the typical contemporary means of copying that is achieved through the use of *digital* processing. Of course, the trace (clue, evidence) of the digital process is that it actually *improves* on the original—through techniques such as digital restoration, remastering, image enhancement, image cleaning, noise removal—the object is often returned as better than it ever was before.

The process of digital restoration of antique films, photographs, and audio recordings often reveals extra detail that was not previously visible/audible. Recently, new digital versions have been made from the negatives of several early classic films—including, notably, Fritz Lang's *M*. As a consequence of these processes, much detail often literally *comes to light* that was present on the original camera negative, but was not actually visible in the early theatrical (analogue) positive prints: the film negative stored these levels of detail which would be seen only decades later.[75] Another—regularly cited—instance of just such a phenomenon is portrayed in the classic sci-fi film *Blade Runner*: the detective Deckard uses an *Esper* workstation to magnify and enhance a photograph, revealing details that were previously hidden in areas of shadow.[76] And although that film is set in the year 2019, much of the functionality of the fictional *Esper* machine actually became commercially available with the introduction of Adobe's Photoshop computer software

application in 1991.[77] My activity actually paralleled quite precisely the process carried out by Deckard—with his barked voice recognition instructions replaced in my setup by a computer mouse and the digital tools of *curves, saturation, skew, distort, perspective, warp, threshold*, and so on.[78]

Yet equally, I have also allowed included/incorporated the visible evidence of rephotographing as an analogue process in the illustrations included here. I have, for example, made no effort to disguise any evidence of my intervention—indexed through "errors" such as inconsistent color temperature, visible surface reflections, and even lens-based distortions. That is to say, the images reproduced do not escape also being instances of what Walter Benjamin memorably described—and appositely here—as being "like the bloody fingerprint of a murderer on the page of a book [which] says more than the text."[79] An observation that parallels, for example, the approach taken by conservators and restorers of photography: these professionals, who are constantly in contact with the *materiality* of the image, do not tend to describe a photograph as "a picture" or "an image" (as I am so tediously obliged to) but as *an object* (e.g., "I am working on a very challenging object at the moment," or "I am still working on that object"). The simple point being that in their line of business a photograph is three-dimensional: it has a back, a front, and (usually) four (very thin) *sides*. For those carrying out such forensic-type activities, commonly held presumptions are often replaced by others that are more specific/specialized. A complete comprehension as to how a particular photograph has been constructed—the condition of each of the layers of substrate, the photosensitive layer, the protective laminate, etc.—may be vital in determining the appropriate method of restoration.

Police photographers document and record scenes of crimes in a manner that is assumed to be scientific. The general approach is to work toward some kind of supposed neutrality; any photographic *effect* produced by the lens—such as foreshortening or the typical stretching caused by wide angles of view—is recognized as a distortion, and dismissed as potentially confusing or even misleading. As the current FBI handbook of guidelines recommends: "Photograph from eye-level to represent the normal view."[80] Summarizing the purpose of these expectations, Raymond Siljander, a law enforcement professional involved with training such photographers—whose guide to this type of work is a classic desk reference on the subject—qualifies this instruction: "Be sure to always use the camera to document things rather than attempt to create photographs that offer little more than a pleasing artistic quality. . . . The forensic photographer must seek evidence, not a creative work of art."[81] For those who are on the *other side* of the yellow-and-black-striped tape, the dichotomy between their documentary work and *art* is surely explicit.[82] But the basis for Siljander's binary opposition is not a traditional antagonism between art (considered highly subjective) and

science (considered highly objective); the true motivation for prioritizing objectivity is simply that such photographs must remain admissible as evidence in court. As they are produced, stored, and referred to, the status of crime scene photographs is seemingly constant: a legal document and a vital visual resource which must never appear to include any element that might be interpreted as exhibiting a bias, nor incorporate anything that a hostile defense lawyer might seize upon in an attempt to discredit the credibility of the forensic evidence—regularly during jury trial proceedings a judge will hear legal argument that a photograph provisionally admitted as evidence is, in fact, prejudicial, that is, not neutral enough, and will therefore rule that it cannot be presented to a jury.

Within fine-art photography, the motif of this "image without a personality," that is blank, transparent, and reliable, has been extensively utilized, particularly by, for example, the so-called Düsseldorf School of photographers such as Bernd and Hiller Becher or Thomas Struth. Elsewhere, other so-called conceptual artists have emphasized the role of photography as a utility that can be used simply to record a preconceived action or an event (tossing colored balls in the air; photographing every garment of clothing owned; documenting every building on a given street), as in some works of art made by John Baldessari, Bruce Nauman, Edward Ruscha, or Christian Boltanski.[83] In such instances, the idea that the resultant pictures provide documentary evidence is often assumed—or utilized—as a given. However, those who are engaged with a critical approach to photography (and do not actually need to complete the important work of documenting a crime) cannot so easily enter a supposedly binary debate such as the one Siljander proposes between artists and CSIs.[84] For those involved with the philosophy of *the photographic*, it is an established axiom that all images are coded, derived: as Barthes states, a document that is intended to be "a purely mechanical and exact transcription of reality [always] implies some consideration, some ideology behind the shot."[85] And certain artists—and visual researchers— have responded to this inherent ideological factor which (always) underpins "exact transcription" by reproblematizing any simplistic—and potentially complacent—reading of the forensic evidence photograph as merely (and exclusively) a reliable document.

In order to produce the series *Evidence*, Mike Mandel and Larry Sultan selected and exhibited a selection of photographs from various archival sources, including records of industrial trials and documentation of experiments/field research at organizations such as the United States Department of Transportation or U.S. Food and Drug Administration, as well as images produced by the National Semiconductor Association.[86] The selected photographs were removed from any forensic context and placed into the artistic/reflective context of an art gallery. The artist's Duchamp-like act of appropriation

allowed a series of initially bland scientific documents to resonate in quite unexpected ways.[87] The original intended *purpose* of each photograph is not revealed—it often remains unclear which compositional element is even primary. The photographs are freed from their rigid *raison d'être* and may—in the cultivated, reflective setting of the art space—resonate enigmatically in a similar way to the deliberately open-ended visual images in Morgan and Murray's TAT (Thematic Apperception Test), sparking off diverse associative, interpretive possibilities.[88] And through this process a more or less complete inversion of the original scientific purpose is achieved.[89]

In the exhibited series of photographic works *L'Hôtel*—and a subsequent publication—the French artist Sophie Calle re-presented photographs taken in various occupied hotel rooms.[90] Her images were made using the same "dispassionate" approach as the one that the CSI is also taught to adopt/appropriate. Calle's photographs record and document such incidental details as a winter coat laid on a bed, a cluttered desktop, a pair of shoes carefully placed, or a toothbrush in a glass next to a few coins. In photographing the objects in each of the rooms *as if it were a crime scene*, the artist also challenges the too simple expectation that a supposedly neutral photograph is also a generally reliable image: her pictures *do*—in fact—accurately record the interiors of certain hotel rooms, but Calle's intervention is also an inversion—or short-circuiting—of the viewer's expectations that have been raised and deceived through the use of *the code of objectivity*, that is, the artist records copious evidence of incidental bric-à-brac that has been observed in some entirely arbitrary hotel rooms—these are evidence photos that *lack a crime*. Calle's challenge is to propose evidence in the *absence* of a crime—in spite of no crime; her images function to reaffirm Benjamin's now mantra-like assertion: "It is no accident that Atget's photographs have been likened to those of a crime scene. But isn't every square inch of our cities a crime scene? Every passer-by a culprit? Isn't it the task of the photographer to reveal guilt and point out the guilty in his pictures?"[91]

And these examples of artistic research or experimentation—along with many others—have tested the long-ago-abandoned notion that "the camera never lies." But the specific appropriation that is going on in *L'Hôtel* and *Evidence* is not of any individual image in particular, but a more generalized *appropriation of context*.[92] Simplifying Barthes's observation that there is an implicit ideology behind every photograph, it is possible to assert an even more compact truism: in photography, ideology *is* context.

Very often murder scene photographs are difficult to access. Those held by individual police forces such as those in London (Metropolitan Police Authority) or Manchester (Greater Manchester Police) are never made available to researchers or any other interested individual; even those that are eventually passed to the National Archive are often censored for various

given reasons, including any ruling a judge may have made during a trial—such as a recognition that making the images public may cause distress to surviving relatives. Similarly, explicitly violent material recorded in the process of news-gathering remains unbroadcast or printed—newspapers and broadcasters in England adhere to a code that allows some limited depictions of death (as a consequence of war, bomb blasts, or natural disaster) but outlaws the depiction of severe injury, suffering, severed body parts, and so on.[93] The material is essentially sanitized, and—in the case of broadcast news—often emerges with an entirely misleading narrative: if the truly harrowing elements are removed, a dangerously disjointed continuity remains, one that is unrealistic because (as with, say, the Hollywood sex scene) it misses/excludes the supposed subject, showing only a rendition that highlights *before* and *after*—a narrative that incorporates repression.[94]

Crime scene photographs are surrounded by taboo—my inquiries as to the possibilities of sustained access for research were often met with a distinctly discouraging tone by those tasked to curate such objects; there was a discernible resistance to making this type of material available.[95] It was as if it had been hidden away in the same manner that psychoanalytic theory proposes that hostile infantile (including murderous) thoughts become subject to the force of repression—they are hidden away because they are unbearable. The psychoanalyst Theodor Reik noted how the decision to imprison a criminal may be understood as a kind of *quarantining*.[96] In his argument, criminals are placed in prison for fear of contagion: their dangerous thoughts and actions are feared because they represent an irresistible temptation to others.[97] And, following Reik, it may be argued that photographs of the taboo of murder are also repressed or censored for the same reason: to diminish any temptation that might emanate—ooze—from them.[98] As Reik noted: "The horror of the crime, the desire for expiation, the urgent need to find the culprit, all these bear witness to a defense against repressed impulses. . . . [It is] our own hidden impulses that account for the haste with which cases [of murder] are dealt with."[99] And to this list might also be added an apparent need—or wish—to also make the photographic evidence of such crimes highly inaccessible: to forget about them—that is, to repress them.[100]

This dimension of the negative reaction to a taboo—as temptation—was often enforced while I was working at the National Archive. I was, for example, regularly asked by the patrolling guards to move to a cell-like private room designed for those working with documents that require constant invigilation. This request was apparently due to the distressing nature of my material, that is, I was asked to move in order to protect other readers (working in this open-plan setting) from the potentially harmful consequences of looking (glancing) at the images on my desk.

On one occasion I requested to see again a case file that I had previously consulted—I had already photocopied the case notes and made my own photographs from the crime scene images that the folder contained. However, when I placed my follow-up request, the screen of the document-ordering service computer terminal returned an error message: YOU DO NOT HAVE PERMISSION TO REQUEST THIS FILE.[101] I consulted the information desk, and was asked to return to my allocated study area. After fifteen minutes a man came over to me and introduced himself as a senior archivist. I was asked to follow him. We went through a set of doors that seem almost hidden in normal daily use. He led me down a long corridor, at the end of which I was asked to take a seat in a large meeting room. Three men were seated at one end of a large conference table, with the archive box that I had requested placed (tantalizingly) in front of them. As I entered, the archivist turned to me and said, "I think they are going to ask you to sign the Official Secrets Act."[102] Ultimately, the three men did not ask me to sign anything. They only indicated that this file had been inappropriately placed into the public domain, and had now been re-marked as "closed": they had simply made a mistake, the file had been opened *too early*. After this—vaguely uncomfortable—experience, I realized that much material is present at the National Archive which could easily be made available to researchers/readers, but is not. For instance, there are many case files that are physically present at the archive site but are not due to be made accessible to the public for years— or even decades—to come. Such files are ghostlike: they can be located on a specific shelf with precision; they have already been assigned a case number; but nobody may legally consult the contents until the date imposed has passed (often 80 years after the original trial). Such material is not withheld for a logistical reason—that it has not yet been fully prepared or indexed, for example—but solely because a required period of quarantine has not expired; that is—following Reik's assertion—it is simply too *contagious* to release.

Such a quality of contagion also prevails when crime scene examples are introduced into the mainstream more directly. In order to counter the negative connotations of the taboo surrounding the murder scene, general publication of such photographs is often rendered acceptable by the addition of a clearly defined *justification*. When Georges Bataille considered the reproduction of murder scene photographs for consumption by a mass-market audience, such as those that were regularly reproduced in the 1920s—and usually documented the crimes carried out during the era of Prohibition in the USA, often highlighting the gang "hits" of the black marketeers—he noted that they were usually presented in the context of a high moral tone or a specific campaign *against* violence, and the format of *X Marks the Spot* (the book that Bataille reviewed) is retained in the well-known BBC television program *Crimewatch*, in which violent armed robberies and even

murders are "re-created by actors," but only for the admirable purpose of eliciting new evidence from members of the public.[103] Contemporary book publications that incorporate a convincing justification include Hannigan, Buckland, Phillips, Sante, and Parry, with the intellectual explanations ranging across such themes as historical significance, cautionary tales, poetic value, and so on.[104]

Law enforcement officers who are involved with such gruesome material on a daily basis also retain, for example, the justification of the necessity to consult it. The studied indifference and apparently cynical hard-boiled attitude to violent crime that is so often characteristic thus becomes an index to a phenomenon Lacan also highlighted when he commented: "We have noted that manifest indifference may mask intense latent interest."[105]

Equally, if the required—and essential—dimension of justification is absent, then the use and display of such imagery is immediately recoded as merely gratuitous, and instantly becomes taboo—for example, the disgust that is reserved for Tejaratchi's highly explicit book *Death Scenes*, a publication which will be found only in a bookstore's Cult/Alternative section, often next to books on other peculiar phenomena such as spontaneous combustion or mysterious crop circles.[106] Or, equally, the internet site goregallery .com, which is typically derided as being a destination for puerile weirdos; in any case, admitting to browsing to that url will endear the internet user to few. In such contexts, curiosity—or a deficit of shame—will often prevail.

In that circumstance, as Bataille wrote, "the wish to see triumphs over disgust or terror,"[107] and this duality between (appalled) loathing and annoyance and indulgence remains a basic theme that is regularly invoked and requalified—there is a bleeding edge. But it is not a theme that any civilization can solve once and for all. As Freud qualified: "To negate something in a judgement is, at bottom, to say: 'This is something which I should prefer to repress.' A negative judgement is the intellectual substitute for repression; its 'no' is the hallmark of repression, a certificate of origin—like, let us say, 'Made in Germany.'"[108]

The taboo that surrounds this type of material may also account for the fact that as a researcher of murder case files at the National Archive (2004 through 2007) I was apparently unique: there were no others studying—in any sustained manner—the DPP files during the time I was involved with them. Indeed, each file that I requested still retained, upon my receipt of it, the unbroken seals of the Home Office (the last Government department that would have been responsible for them), that is, they had never been opened—for each of the cases annotated below, I was undoubtedly the first (and only) reader to interrogate the material since it was placed in front of a jury, more than fifty years before.[109]

Lacanian Detectives

STRUCTURALIST LINGUISTIC THEORY—AS SCHEMATIZED BY FERDINAND DE SAUSSURE—HAS REGULARLY BEEN DEPLOYED IN ORDER TO ASSERT THAT VISUAL ELEMENTS IN A PHOTOGRAPH (OR FILM FRAME) MAY BE BROKEN DOWN AND INTERPRETED THROUGH THE CONCEPTUAL FRAMEWORK OF SIGNIFIER/SIGNIFIED. CONSIDERING THE PHOTOGRAPHIC TABLEAU, BARTHES NOTES THAT "MEANING COMES FROM THE OBJECTS PHOTOGRAPHED [WHEREBY] . . . THE INTEREST LIES IN THE FACT THAT THE OBJECTS ARE ACCEPTED INDUCERS OF ASSOCIATIONS OF IDEAS—[E.G.,] BOOKCASE = INTELLECTUAL. . . . SUCH OBJECTS CONSTITUTE EXCELLENT ELEMENTS OF SIGNIFICATION . . . STABLE TO A DEGREE WHICH ALLOWS THEM TO BE READILY CONSTITUTED INTO SYNTAX."[1] AND, IF IT IS AGREED THAT THIS IS A FAIRLY TYPICAL MODE OF INTERPRETING A PHOTOGRAPHIC IMAGE, THEN IT MIGHT ALSO BE ASSERTED THAT A PSYCHOANALYTIC INTERPRETATION SEEKS TO REVEAL A FURTHER ENCRYPTED DIMENSION THAT IS ATTACHED TO THE CHOSEN SIGNIFIER: THE PATHOLOGICAL MAY BE RECOGNIZABLE IN THE VISUAL, BUT ONLY WHEN A LATENT MEANING HAS BEEN INTERPRETED CAN THIS OTHER SENSE OF SIGNIFICATION BE REVEALED.

The psychoanalyst Bruce Fink has commented that "nothing in [the clinical session of] analysis can be taken at face value."[2] And with specific reference to the crime scene, the Lacanian-oriented critical theorist Slavoj Žižek has noted that "the detective grasps the scene as a bricolage of heterogeneous elements, in which the connection between the murderer's mise-en-scène and the 'real events' corresponds exactly to that between the manifest dream content and the latent dream thought, or between the immediate figuration of the rebus and its solution. It consists solely in the 'doubly inscribed' signifying material."[3] The objects that I have rephotographed and annotated below are—as in Žižek's characterization—precisely those that are *doubly inscribed*. However, the crucial paradigm of a Freudian reading of an image is the supposition that signification is also *personalized* for each individual. It is this notion of the personal stake in signification that de Certeau, for example, was assessing when he considered how "writing becomes a movement of strata, a play of spaces. A different world (the reader's) slips into the author's place. This mutation [the reader's transformation of a text or image through personal association] makes the text habitable, like a rented apartment. It transforms another person's property into a space borrowed for a moment by a transient. Renters make comparable changes in an apartment they furnish with their acts and memories; as do speakers, in the language into which they insert both the messages of their native tongue and, through their accent, through their own 'turns of phrase,' etc., their own history; as do pedestrians, in the streets that they fill with the forests of their desires and goals."[4] And it is these—often unconscious—insertions, mutations, or *rentings* that psychoanalytic research is finally concerned with: associations that are regularly revealed to be paradoxical, contradictory, or even a *complete inversion* of the most obvious reading.[5]

This seemingly paradoxical metasignificance is also what vexed Freud's early patients, their disconcertedness often prompting him to justify his

interventions: "as soon as I had corrected his mistake I asked him to explain it, but, as is usually the case, he was surprised at my question. He wanted to know whether a person had no right to make mistakes in talking. I explained to him that there is a reason for every mistake."[6] In order to be understood, however, these hidden associations and beliefs that are attached to an object/situation must be *worked through*. And the methodology I propose depends upon a *wild* working through of certain possible interpretations of various objects, locations, elements, and so forth. The unconscious of the visual—specifically in terms of the documentation of human activity—may be recognized as a residue that is always an index to a thought or *thought pattern*—however, my annotations remain propositions only; overall they may best be read as indicative. I am not proposing to actually know the contents of another's unconscious. What I *am* asserting is that the technique—or method—that I follow is robust and coherent.

Wild psychoanalysis is the historically (technically) correct term used to describe any psychoanalytically oriented interpretation that is made outside of a clinical session. It is an activity that is often derided and discouraged by practicing psychoanalysts, who—motivated by elitist, xenophobia-like fears of erosion, pollution, or "falling standards"—dismiss the work of non-card-carrying researchers as charlatanism, and so forth. This recently prompted a colleague to characterize working on psychoanalytically oriented cultural theory/critical theory as "something like a noble shame."[7] The key point here is that any argument against wild analysis, or even the psychobiography genre—biography containing psychoanalytic propositions—inherently asks that we reserve psychoanalysis for the clinic, but this wish—exhortation—is simply too much of a luxury: psychoanalytic theory must be deployed wherever it can illuminate a dark corner, as it is (in any case) the only tool available.

The specific deciphering system I use below relies on Lacan's contribution to psychoanalytic theory, but—it may be argued—his theory does no more than schematize Freud's original theories: that is, his theories do not contradict Freud's at any point. As the psychoanalyst Dr. Mark Bracher has observed: "psychoanalytic discoveries provide the basis for a general model of subjectivity that can help us understand . . . the psychological roots of social and cultural phenomena—that is, the motives that cause humans to produce these phenomena."[8] My research has evolved out of a belief in the validity of the above assessment, of the psychoanalytic project, and is located within a resolutely Freudian discourse; thus I will confirm immediately that this text will not draw into question the historical validity of Freud's claims, nor attempt to propose that they are dated, or—the dullest of all proposals—that they are due for a "timely reappraisal."

A fundamental factor which led me to concentrate on Lacan's framework is that central to his theory is the categorization of human mental functioning as *neurotic, perverse*, or *psychotic*—a tripartite model. As Jacques-Alain Miller asserts: "Lacan forces us to ask ourselves how meaning is given to certain things by neurotics, psychotics, and perverts."[9] In opposition to the generalized myth surrounding Dr. Lacan's *oeuvre*—that it is overly complex and too *difficult*—my decision to utilize his approach is, conversely, based on my belief in its clarity, even its simplicity. Elsewhere Miller explains that "the three fundamental mechanisms found in Freud's work—neurosis, psychosis, perversion—were logicized by Lacan: repression (Verdrängung) for neurosis, foreclosure (Verwerfung) for psychosis, and Verleugnung [repudiation] for perversion."[10] The crucial point here, though, is that Lacan proposed these three categories—structures—as nonpermeable, distinct, and separate from one another: a neurotic subject cannot—suddenly—become perverse; a psychotic subject cannot become neurotic: these are mutually exclusive modalities. Thus any instance of human functioning must be an example of *only one* of the three concepts. This is the *sine qua non* of Lacanian theory. In the clinical setting the overwhelming majority of cases are neurotic, and it may be useful to note here that there is no meaningful distinction in psychoanalytic work between so-called "normal" subjects and neurotic subjects. Normal is not a technical term: in psychoanalytic theory, neurosis is the basic familiar paradigm. Joseph Wortis, for example, attributes the following to Freud: "everybody has some slight neurotic nuance or other, and as a matter of fact, a certain degree of neurosis is of inestimable value as a drive."[11] Clinical work with psychotics can be highly effective, but it is not psychoanalysis *per se*. On the other hand, clinical work with perverse subjects is rare and, in any case, most likely to be unsuccessful. This basic Lacanian framework—"technique"—is, obviously, not limited to the appraisal of the crime scene or crime scene photographs; it can (and should) be deployed to consider any phenomenon that bears the trace of human intervention.

At the heart of Lacan's work is his proposal that these different structures are the consequences of different outcomes of the Freudian Oedipus complex. As Fink has clarified in this crucial paragraph:

> The father brings about a socialization of the boy's [or girl's] sexuality: he requires the boy [or girl] to subordinate his [or her] sexuality to culturally accepted—that is to say, symbolic—norms. This occurs, Freud tells us, even in the case of perverts: their polymorphous sexuality gives way to a hierarchization of the drives, but under the dominance of a zone other than the genital zone (oral, anal, scopic, and so on). Similarly, in accordance with Lacanian criteria, the pervert's imaginary has undergone symbolic rewriting nevertheless. In psychosis this rewriting does not

occur. We can—at the theoretical level—say that this is due to the unsuccessful establishment of the ego-ideal, the non-functioning of the paternal metaphor, the non-initiation of the castration complex.[12]

Lacan restated the centrality of the Freudian Oedipus complex in instigating the subject's insertion into language: becoming literally *subject to it*. He summarizes: "One can only think of language as a network, a net over the entirety of things, over the totality of the real. It inscribes on the plane of the real this other plane, which we call here the plane of the symbolic."[13] Indeed, the essence of Lacan's theory is contained in his single bald—and boldly straightforward—assertion that "the prohibition of incest is nothing other than the *sine qua non* of speech."[14] For Lacan, the central concept that defines development is paternal triangulation, a mechanism/process that will end with a child's entry into the Symbolic Order of language. Central to Lacan's theme of Symbolic Castration is the notion that, in order to enter the realm of the Symbolic, the child also has to *give up something*. It is this factor—of alienation from some longed-for element—that remains decisive; hence the centrality of nostalgia/lack in his conceptualization.[15]

Equally, beyond my argument for Lacan's conceptual simplicity, it remains undeniable that he *did* also utilize numerous techniques, seemingly in order to derail any straightforward dissemination/application of his work.[16] Justifying his actively obfuscatory approach, Lacan stated: "I speak about [the Freudian Thing/*das Ding*] in a way that was evidently the cause of the undoubted discomfort the text provoked at the time. The fact is, I sometimes make The Thing itself speak."[17] Lacan's purpose was, it seems, to ensure that his discourse remained active—with the reader implicated in it. As Malcolm Bowie has noted: "Where other Freudians appoint themselves as explainers, emendators or continuators of the original theoretical texts, Lacan wants to keep on feeling their initial shock. The worst that could happen to psychoanalysis, for him, is not that it should be ignored or vilified but that it should be thought to be right, complete, consummated, self-subsistent or unanswerable."[18] Thus his contributions to psychoanalytic theory do not simply disclose (or transfer) an idea. In Lacan the text literally functions as an example of a proposition: the impossibility of capturing/isolating desire.[19] The reader is likely to experience his texts as evolving/collapsing, with their own personal place within them being highly significant and individualized. It might be argued that Lacan wanted a close reading of his texts to produce a similar effect to the one produced in the psychoanalytic session itself: of the subject's demands being frustrated. As Madan Sarup has maintained: "Lacan's writings are a rebus because his style mimics the subject matter. He not only explicates the unconscious but strives to imitate it."[20]

I think it is fair to assert that Dr. Lacan was unquestionably an unusual, even a bizarre, gentleman, but this assessment is partially context-driven: these days we expect a psychoanalyst to adhere to standards of professionalism similar to those offered by doctors, and so on. But Lacan did not necessarily see the evolution of psychoanalysis in this direction as a positive development. His command to "Return to Freud" was surely also a personalized response to the evolution of the discipline of analysis: he railed against the fact that the numerous unhinged and colorful personalities of the so-called first generation of analysts—think of Tausk, Rank, Ferenczi, Stekel, Brill, and even Jung (flying saucers, ESP)—were slowly and inexorably being replaced with humorless wonks and anodyne social workers.[21]

If it is broadly agreed that Lacan's work is in essence nothing more than a schematization of Freud, then evolving perceptions on the reception of Freud's work itself must also be considered an obstacle to the generation of any consensus.[22] Furthermore, any primary-level reflection on Lacan's *oeuvre* is not actually possible for the Anglophone reader: it is obscured by the fact that only seven of his twenty—year-long—seminars are available in translation. His primary texts were in German (Freud); Lacan spoke/wrote only in French; the translators must also contend with his regular use of words that are deliberately deployed to signify ambiguously.[23] Bruce Fink—Lacan's English translator—has, for example, questioned certain early English-language translations of Lacan's work, claiming that faulty translation has "contributed to Lacan's reputation as an extremely abstruse writer whose murky formulations are impenetrable to even highly motivated readers."[24]

Lacan focused only one presentation specifically on the theme of crime, a paper he prepared in collaboration with a colleague, Michel Cénac: *A Theoretical Introduction to the Functions of Psychoanalysis in Criminology.* Given that it was written in 1950, it is an example of "early Lacan," and is not a definitive commentary on the topic.[25] However, the authors do come close to asserting a grid that corresponds to his later conceptualizations—and my work here—when they state that "there is a high correlation between many perversions [of the law] and the subjects who are sent for criminological examinations, but this correlation can only be evaluated psychoanalytically as a function of fixation on an object [perversion], developmental stagnation [psychosis], the impact of ego structure and neurotic repressions [neurosis] in each individual case."[26]

Contrasting the structure of perversion with neurosis, the Slovenian psychoanalyst Renata Salecl has noted that "neurotics always *lack* satisfaction and thus go from one object to another, not knowing what they want, endlessly questioning the nature of their desire. Perverts, in contrast, are satisfied, they find the object and thus also sexual satisfaction."[27] Miller also

makes a similar point when he comments that "the pervert has found the object, that is his problem; he is certain about his ways of obtaining sexual gratification."[28] The fundamental clinical theme is of negation or repudiation: the subject attempts to evade or stage/restage a demonstration against symbolic castration. I expand upon the proposition that in perversion, *infantile* fantasy still dominates; this may be characterized by and recognized in an apparent splitting or oscillation between an image of an *idealized mother* and another that represents a *repulsive mother*. I conceptualize perversion as a continuing protest against externally applied limits and boundaries, locating the perverse subject in a socially coded context of subversion and sabotage.

Lacan characterizes psychosis as a mode of mental (non)functioning, "a disturbance that [has] occurred at the inmost juncture of the subject's sense of life."[29] And, as with each of his three classifications, the source of psychosis is not rooted in the physical structural deficit—gray-matter abnormality—proposed by modern psychology, but in the subject's *experience* of the Oedipus complex. In psychosis there is a fundamental malfunction of an assumed trajectory. It is, as Lacan notes, "the foreclosure of the Name-of-the-Father in the place of the Other and the failure of the paternal metaphor [that] I designate as the defect that gives psychosis its essential condition."[30] Insofar as psychoanalysis is defined as the study of the unconscious, one can say that the essential quality of a psychosis is that the unconscious—as it is configured in neurosis—is simply nonexistent. The psychoanalyst Bernard Burgoyne has described how, in his understanding of psychotic mental functioning, "certain elements will have no representation whatsoever in the mind."[31] There are two key themes that I develop in order to apprehend evidence of psychosis. First, I propose that visual evidence of fragmentation and chaos may be interpreted as a consequence of *foreclosure*. And secondly, that visual evidence of a bizarre or incomprehensible organizing logic may imply the presence of a—protective—delusional metaphor. Lastly, my annotations on the *neurotic crime scene* follow Lacan's assertion that "the unconscious is the chapter of my history that is marked by a blank or occupied by a lie: it is the censored chapter. But the truth can be refound; most often it has already been written elsewhere."[32] And visual evidence of the mechanism of repression (*Verdrängung*) is what I attempt to apprehend in the photographs. I follow Freud in arguing that "repressed, psychic material, [which] though pushed away from consciousness is nevertheless not robbed of all capacity to express itself."[33] Hence, I reveal the return of the repressed, in what I assert to be visual evidence of each of three elements of a Freudian trajectory: obsessional behavior, reaction formation, and acting out.

The above outlines may seem reasonable enough, but to gain a more complete context it is also essential to compare this outlook with what

actually happens in the real world of law enforcement. The most influential text in this field is the *Crime Classification Manual* (CCM), an approach to crime developed in the USA by the FBI, and the basis of what is also referred to as offender psychological profiling.[34] There are many parallels between the criminal types that the CCM offers and the Lacanian propositions that I espouse. Parallels can be noted, for example, within the designated CCM indicators for an organized killer/sexual murderer, that echo the Lacanian paradigm of perversion (disavowal), while the designated CCM indicators for a disorganized killer often mirror the Lacanian framework of psychosis (foreclosure). For Robert Ressler, one of the editors of the CCM, "the organized versus disorganized distinction became the great divide [in forensic profiling], a fundamental way of separating two quite different types of personalities who commit murder."[35] And these basic distinctions are wholly in agreement with my psychoanalytic approach.[36] Indeed, it may be argued that CCM is practically—if not intentionally—Lacanian. This was (and remains) a thrilling discovery: a Lacanian model can be mapped over the FBI's approach without the need for revision of either theory—and as these two techniques evolved out of very different firmaments, this factor seems to offer reassuring corroboration on both sides. Most importantly, a Lacanian interpretive model does not need to be proposed as an alternative to or a replacement for existing research on murder; on the contrary, it is complementary. In essence, the psychoanalytic grid offers an explanation of the possible (unconscious) motivations that lie behind/beneath criminal acts—even behind consciously asserted fantasy, and so forth.

Because of these important parallels, I include some references to the FBI approach in the text. I also make several references to the *Diagnostic and Statistical Manual of Mental Disorders IV-TR* (DSM). The relevance of DSM—proposed as a comprehensive annotation of all mental health *disorders*—is that the psychiatric approach (which it encyclopedically defines and refines) is predominantly used throughout the British NHS (National Health Service): more bluntly, it is the approach to mental functioning that is accepted by the state, and is often discernible in the wording of statutes, for example the Mental Health Act (1959, 1983, 2007).[37]

And, although it is unlikely to become a reality, I shall also stress here that the most *relevant* readership for my annotations below would actually be the various employees of the state ("the apparatus of the prosecution") who are involved—day to day—with the crime of murder, and are currently using CCM and DSM.[38] For, despite the seemingly flippant title of this book, the following assessments are in no way proposed as merely a fascinating ruse or what have you.[39]

The commentaries below are *clinically* informed; thus there is a subtle, but important, differentiation between this approach and some other

psychoanalytically informed, but less clinically oriented, articulations which have been published recently. Victor Burgin once commented: "In the 1970s psychoanalytic theory came to be imported into cultural studies. Psychoanalytic terms (such as 'scopophilia'), and pseudo-psychoanalytic expressions (such as 'male gaze'), have since become commonplace in the study of visual culture. . . . [However,] if psychoanalytic theory is to be meaningfully employed in cultural studies, then it is essential that psychoanalytic concepts be employed in their psychoanalytic sense, as a means of getting *access to phenomena which we would not have access to in another way*."[40] And I confidently reconfirm Burgin's timely assertion. My interpretive work is intended to be distinct from any approach that might be characterized as more broadly psychoanalytic, such as those offered by, say, Griselda Pollock or Parveen Adams.[41] My concern is that in some critical theory there emerges an almost *painterly* approach to psychoanalytic concepts. In a recent example of this tendency, Annette Kuhn introduces a theory developed by psychoanalysts Michael Balint and Donald Winnicott, utilizing it in order to consider certain classic films, yet her exposition on the concept of the "transitional object" is not allied to a more basic assertion of the primacy of the Freudian unconscious.[42] Another example of this sensibility can be found in, for example, Michelle Henning's contribution to the widely used *Photography: A Critical Introduction*, in which the commentaries on *fetishism*, *voyeurism*, and *scopophilia* are all completed without a single mention of the unconscious, and my concern is that the author defines these concepts as stand-alone ideas that may be utilized *without recourse to basic Freudian theory*.[43] Often in such texts there is an apparent wish (or need) to be inclusive, and avoid possible accusations of determinism or absolutism, but it is this mentality of overweening political correctness that—as ideology—also presumes a creeping plurality, which, while limiting any offense caused to those with, say, diverse religious views, can equally be guilty of causing intellectual offense: diluting the essence of the Freudian project and rendering psychoanalytic theory quite meaningless.[44] It was, after all, just such a tendency in clinical psychoanalytic technique—proposed by Anna Freud and the so-called ego psychology movement—that prompted Lacan's enraged exhortation to "Return to Freud."[45] It seems that some commentators fail to accept the radical quality of Freud's ideas, which they are often prepared to deploy (even apologetically) as only a tentative discursive strand: an approach that is—when considered in terms of methodology—not only irritatingly timid, but a betrayal.[46]

The visual material that is reproduced in the second half of this book may cause distress to the viewer.[47] I also recognize that disseminating this kind of material may potentially enable the imagery contained within to be misused somehow, so that it might even seem to contribute further harm in some way. Considering this vexing factor, Sue Taylor—in her work

concerning the distressing images made by Hans Bellmer—noted that her response to these difficult photographs was to follow the approach asserted by the art historian and theorist Susan Rubin Suleiman, who decided "to treat these transgressive cultural products responsibly [and thus] provide a reading that 'will look at a text, or at a whole *oeuvre* if time and space allow, patiently and carefully, according the work all due respect—but also critically, not letting respect inhibit it.'"[48] Of course, it is from Bellmer's reputation as a significant contributor to surrealist art practice that any respect for the work would emanate: after all, however shocking the images, they are, in any case, still justifiable as art. The crime scene material that I worked with—some of which is reproduced below—was not validated (or encumbered) by any inhibiting established reputation that could simply be bolstered or denigrated as appropriate. Yet, Taylor continues: "my mission [has been] not to denounce Bellmer's sometimes vicious fantasies or his 'sexism' . . . rather, I want to ask, of him, and his troubling works of art, the probing question formulated by Spivak: 'what is man that the itinerary of his desire creates such a text?'"[49] And it is thus Gayatri Chakravorty Spivak's maxim that I sought to incorporate into my annotations: to—also—place the theme of the itinerary of (unconscious) desire centrally.[50]

A specific quality of the visual material presented throughout this book is the repetitive imagery of mutilated and defiled women—that is, evidence of violence toward women as opposed to men. When I originally set the parameters for gathering primary material for this research, I had no gender-based agenda (I had sought to collate *all* material from an archive of murder scene photographs in which a dead body was depicted). The material with which I was finally confronted recorded many more examples of men killing women than the seemingly less common instance of a woman killing a man.[51] My conscious motivation to write this book was not morbid fascination or a misogynist's sensibility but was, instead, born of a wish to illuminate what I perceived to be an area of photography history that demanded further inquiry.[52] However, having turned up material that was uncomfortable to work with, I hesitated. But, after a period of reflection, I decided that I was somewhat duty-bound to proceed: I should not—must not—"turn away" simply because what I was confronted with was distressing, or seemed to imply an inherent gender bias. If I had decided to self-censor, or recoil in pity/disgust, this would have been only the response of a researcher who was cowardly and not prepared to truly engage with the issues emerging.[53] To revile and then reject such imagery would have halted and restricted what I believe to be a worthwhile inquiry.[54]

To further qualify any apparent gender bias in the imagery, I also want to note that in Lacan's theory, the perverse structure—his *Verleugnung*—is one that is characterized as an intrinsically male response to Oedipus; thus,

a perverse killer—the so-called "lust killer"—will always be exclusively male.[55] Furthermore, the symptomatic *behavior* of the hysterical neurotic—often a woman—is different to that of the obsessional neurotic—often a man. If the obsessional's behavior is underpinned or characterized by the return of the repressed in (obsessional) actions that are often indexed in the quotidian, conversely, the hysteric is often identified by symptoms in which unconscious conflict is inscribed directly onto/into the body—including continence (urine retention), sweating, vomiting, eczema, numbness, loss of sensation in the limbs, and so on. Hence, evidence of such symptoms is much less likely to be inscribed (apparent) in these documents of the quotidian.[56]

The Perverse Crime Scene

THE PRESENCE OF FANTASY IN PERVERSION IS A FACTOR THAT HAS BEEN NOTED IN NUMEROUS CONTEXTS. FOR EXAMPLE, THE FBI CRIMINOLOGIST ROY HAZELWOOD HAS COMMENTED THAT "FANTASY IS A FASCINATING AREA, AND MOST PEOPLE [IN LAW ENFORCEMENT] DON'T HAVE TIME TO LOOK AT IT. THEY SAY, WELL, THAT'S AN AREA OF MENTAL HEALTH. HOWEVER, IT'S EXTREMELY RELEVANT IN CRIMINAL INVESTIGATIONS. IT GIVES US A BETTER UNDERSTANDING OF THE OFFENDER. THAT'S WHERE IT BEGINS."[1] ROBERT RESSLER, HAZELWOOD'S PIONEERING COLLEAGUE, ASSERTS THAT "[PERVERSE OR *ORGANIZED* KILLERS] ARE MOTIVATED TO MURDER BY THEIR FANTASIES ... THEY MURDERED TO MAKE HAPPEN IN THE REAL WORLD WHAT THEY HAD SEEN OVER AND OVER AGAIN IN THEIR MINDS SINCE CHILDHOOD AND ADOLESCENCE."[2] THE PSYCHIATRIC PERSPECTIVE ESPOUSED IN DSM ALSO CLARIFIES THAT "BY DEFINITION THE FANTASIES AND URGES ASSOCIATED WITH [PARAPHILIC/PERVERSE] DISORDERS ARE RECURRENT. MANY INDIVIDUALS REPORT THAT THE FANTASIES ARE ALWAYS PRESENT."[3] EQUALLY, THE PHILOSOPHER GILLES DELEUZE HAS LIKENED THE PERVERSE—IN THIS CASE MASOCHISTIC—FANTASY TO A SERIES OF STILL IMAGES IN WHICH "THE WOMAN ... FREEZES INTO POSTURES THAT IDENTIFY HER WITH A STATUE, A PAINTING OR A PHOTOGRAPH. SHE SUSPENDS HER GESTURES IN THE ACT OF BRINGING DOWN THE WHIP OR REMOVING HER FURS; HER MOVEMENT IS ARRESTED AS SHE TURNS TO LOOK AT HERSELF IN THE MIRROR. THESE 'PHOTOGRAPHIC' SCENES, THESE REFLECTED AND ARRESTED IMAGES, ARE OF THE GREATEST SIGNIFICANCE ... THE SCENES ARE REENACTED AT VARIOUS LEVELS IN A SORT OF FROZEN PROGRESSION."[4]

It seems that there is a broad recognition of the notion that perversion is associated with *sexual* satisfaction as mannered, something preformulated.[5] The perverse crime scene might, in the light of these qualifications, be likened to a film set: a distinctively artificial place that is designed and art-directed, literally constructed; and it is to this sense of the murder scene as a site that can be crafted—artistically—that Thomas De Quincey is referring when he observes (in his notorious parody): "Something more goes to the composition of a fine murder than two blockheads to kill and be killed—a knife—a purse—and a dark lane. Design, gentleman, grouping light and shade, poetry, sentiment, are now deemed indispensable to attempts of this nature."[6] And, like film production, such killings are often carried out "on location," that is, at a space which has been selected for its appropriateness to a *script* that cannot be easily altered by contingent elements; FBI literature even highlights this phenomenon as the "staging" of the scene.[7] Following Deleuze, it may be said that the perverse crime scene has been *pictured* long before it is reified.[8]

The traditional approach to investigating crimes that indicate cruelty and violence to the victim is to highlight the perpetrator's pleasure in gaining power and control over them.[9] However, a crucial clarification must be made here between a conscious fantasy and an unconscious fantasy or phantasy—a fantasy that may not be consciously articulated at all.[10] In Lacan, the perverse fantasy is illuminated through his conceptualization of *le regard* (the gaze).

The psychoanalyst Jean Clavreul, writing in the late 1960s, observed that the Other's look "is necessary for the pervert. The look has such an importance for the pervert because it is the one that refers to the father, the one through which a relationship to the law is found."[11] For Žižek, this look is "like the impossible gaze from above for which old Aztecs created gigantic figures of birds and animals on the ground . . . the most elementary fantasmatic scene is not that of a fascinating scene to be looked at, but the notion that 'there is someone out there looking at us.'"[12] This other—Lacan's big Other—is thus posited as an onlooker, a third party experienced as an audience to be performed for. But crucially, as Clavreul clarifies, "insofar as he brings a look, the Other will be the partner, and above all the accomplice of the perverse act."[13]

In the process of seeking out evidence of this paradigm in the visual, I recognized a two-step process whereby the pervert must, seemingly, first invoke the Other before a demonstration of its supposed powerlessness can commence. The Other is located as a corrupted accomplice, a conceptualization which suggests that the crime scene photograph may be effectively reconstituted as a document of a performance, an event, or a "happening."[14]

The Lacanian perverse act—in the context of sadistic killing—can be understood as one which is actually carried out on behalf of the Other as the Law: day-to-day officers of the law are indeed locked into a vexatious relationship with the criminal—after all, without him they would not have a job to do; they *need* him to act. They depend on a crime being committed, and on the killer to supply the corpse. The perverse crime has been carried out—acted, played out—in relation to an Other that seems to coincide with "the authorities," or "the powers that be."[15]

Something of this relationship can be seen in a series of photographs which document a murder committed in Southport, Lancashire, in 1969 (photographs 3.1–3.3). Photograph 3.3 depicts what might be described as the killer's point of view of this death scene. The police photographer has captured, highly unusually, an angle which records not the typical view toward the cadaver, but instead a reverse shot. It is a photograph that documents a *look back*: the place where the criminal acted is now surrounded by the looks of the Law. And—in relation to the above point—this ramshackle group of men in overcoats, who look on (hands in pockets, or hands on hips, quietly impressed, even fascinated), do indeed seem to be looking at the exposed—alluring—body in a manner that raises the specter of guilty pleasure, or even the discovery of a dirty secret.

The key factor here is that the image provides a reification of the basic perverse theme: that the crime scene has been constructed primarily in relation to an audience; that it is *their* expectations/reactions that were privileged. And this photograph draws attention to the fact that this group of men

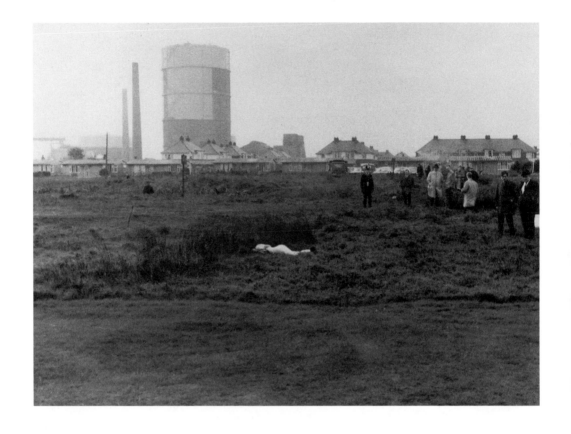

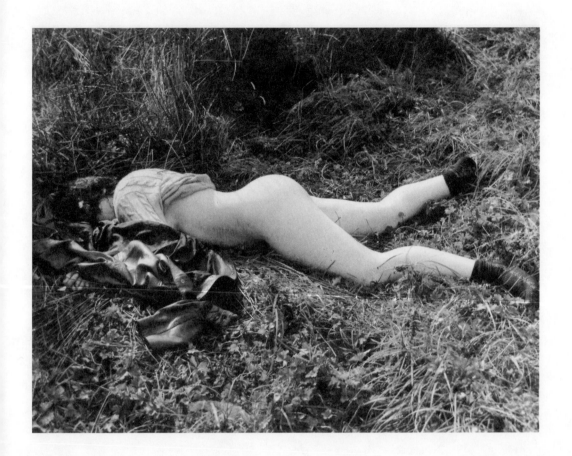

3.2

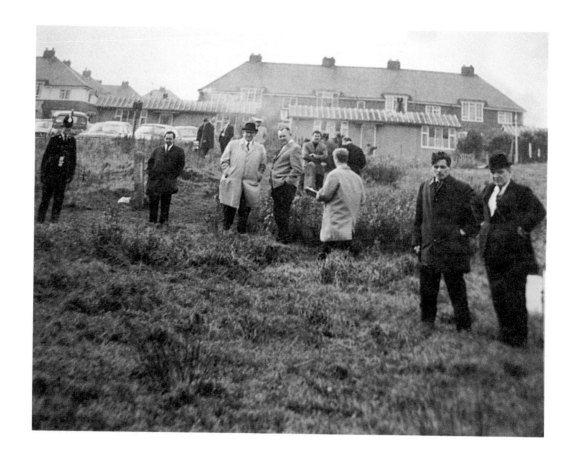

3.3

depicted now also share the killer's "guilty knowledge"—the specifics of a murder scene that are known only to the police and the criminal. It is this knowledge which also becomes a shared secret.[16] Clavreul, commenting on the significance of this factor, notes that "the perverse ceremonial is always profoundly marked with the seal of secrecy, of a secret whose fragility is the illusory guarantee."[17]

Through a series of crime scene photographs that depict a murder committed in Newcastle, Stafford, in 1960—photographs 3.4–3.7—I shall elaborate this theme further. The photographs in this series depict a crime that was perpetrated outside—out in the open—on a lawn or front garden, at night. It can be seen in photograph 3.4 that a body has been discovered more or less outside a private house. There are blown leaves on the grass and the path; without the execrable constituent it would remain a typically English suburban scene.

In several of the cases that I annotate elsewhere in the text, a cadaver has been discovered in an appropriately bleak or alienating environment like a bomb site or a gloomy textiles factory—somewhere that is, at least, a *private* place. When a murder victim is discovered in a squalid parking lot, on a strip of wasteland, or behind a motorway service area, the location is redolent ("has the fumes") of a devious criminal mind, a mind that probably selected some inconspicuous corner in order that the body might remain undiscovered (and unburied) for days, months, or longer.

Yet in this set, and by contrast, the body lies in the grass (staring up at the sky) in the middle of a pleasant enough garden, and in full view of a nearby house, a factor that also implies close proximity to numerous potential witnesses. The presence of the body seems to function as a provocation (or a lure); any assumed logic that a killer would wish to remain undisturbed and undiscovered is replaced with the apparent bravado and daring of the perpetrator: this killer carried on even with the impending prospect of being caught "red-handed," *in flagrante delicto* (literally: "while blazing").[18]

The SIO's report on this case indicates that time of death was estimated to have been before midnight. Thus, photograph 3.4 was quite probably made at dawn on the morning following the murder, while 3.6 may have been made soon after the initial discovery.[19] But when we look at these photographs more closely, we may notice that—notwithstanding the time differences—they work as a pair, again evoking the basic film syntax of shot/reverse (or reaction) shot.[20] Together they enable a reading of the scene in which spatial relationships become significant: the first image shows a house behind the body, the next shows the view to the scene taken *from the house*. And crucially, if this criminal were to have been observed, it could have been through the bay windows that are depicted in 3.5, adorned with traditional lace curtains—known also as *voiles* (veils). Such curtains protect

　　THE PERVERSE CRIME SCENE

the privacy (modesty) of the inhabitants. But they also function to disguise the outward look: any observer lurking behind them remains out of view, like the Neighbourhood Watch snoop whose "twitching" lace curtains are often associated—at least in suburban England—with the imposition of the *nosy* (supposedly lower-middle-class) neighbor, an unseen spy who is often derided as judgmental and easily offended. And this detail of a darkened window, or a *house that looks on*, has been elaborated in turn by a sequence of influential philosophers including Sartre, Merleau-Ponty, Lacan, and Žižek, each of whom has invoked it in relation to the notion of the Other's gaze—for Žižek it is Norman Bates's home in Hitchcock's *Psycho*, while for Sartre it is an—inexplicably poignant—"white farmhouse at night during war-time."[21]

In his chief commentary on the theme of the Other—in a passage from *Being and Nothingness*—Sartre offers several examples of objects that can come to embody the Other's look. He notes how "the Other's gaze will be given just as well on occasion when there is a rustling of branches, or the sound of a footstep followed by silence, or the slight opening of a shutter, or a light movement of a curtain."[22] He also observes that "[such things] only represent the eye, for the eye is not at first apprehended as a sensible organ of vision but as the support for the look. They never refer therefore to the actual eye of the watcher, hidden behind the curtain, behind a window in the farmhouse."[23] Lacan comments: "all that is necessary is for something to signify to me that there may be others there. . . . [A] window if it gets a bit dark, and if I have reasons for thinking that there is someone behind it, is straightaway a gaze. From the moment this gaze exists, I am already something other, in that I feel myself becoming an object for the gaze of others."[24] Characterizing Lacan's later formulation of the gaze, Slavoj Žižek has also isolated the motif of a *house that looks on*, asking: "Is this notion of the gaze not perfectly rendered by the exemplary Hitchcockian scene in which the subject is approaching some uncanny threatening object, usually a house? There we encounter the antimony between the eye and the gaze at its purest: the subject's eye sees the house, but the house—the object—seems somehow to return the gaze . . . this gaze is effectively missing, its status is purely fantasmatic."[25]

The window depicted in 3.4 might thus be recognized as a literal (illustrative) instance of this separation between eye and gaze: this *place from which the Other looks*—the Other's gaze reified—that is always distinct from the subject's look.

Constant observation from the watchtower guard at the center of Bentham's Panopticon—or the now ubiquitous CCTV video camera—is typically characterized as invasive, yet crucially, for the pervert (as Žižek has also recognized), the Other's gaze is actually an inversion of the one also proposed by Orwell: it is one upon which the perverse subject actually *depends*.

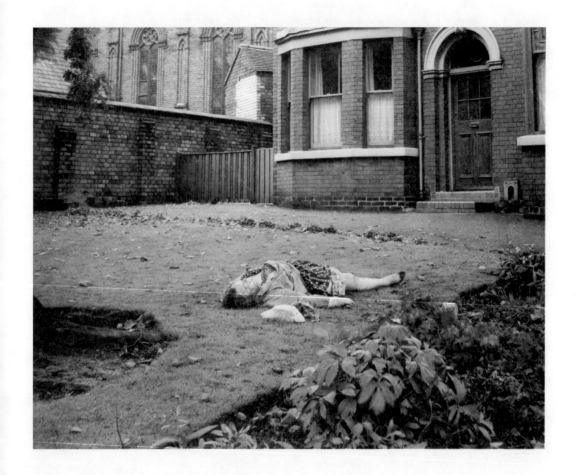

3.4

3.5

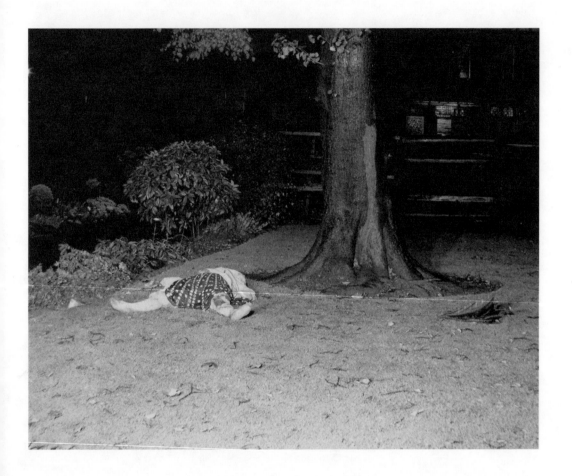

3.6

THE PERVERSE CRIME SCENE

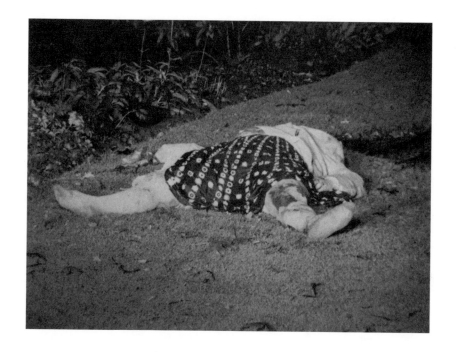

Further reference to the SIO's report to the Director of Public Prosecutions (DPP) reveals that this public place was highly specific: the building on the other side of the fence—seen at the far left corner in photograph 3.4—is actually a church, and the lawn upon which the murder was committed was that of the adjoining presbytery or vicarage.[26]

The deceased seems to parody erotic exhibitionism, with the body in an obscene position—legs spread wide apart, skirts pulled up (3.7). Here a distinctive dialogue emerges whereby the woman's exposed body functions as if it were a lewd message, one that is explicitly sexual/vulgar only *when seen from the house* and, in particular, from the darkened windows: this was the place, it seems, at which this criminal *aimed* his message. The woman as ravished-to-death introduces an iconography that is profane, carnal, and excessive; but, above all, this naked body is presented as undeniably (and unavoidably) erotic. It is an image that echoes Bataille's description of the pervert's sadistic activity, which aims at "provoking an irruption of excremental forces . . . the excessive violation of modesty."[27] This *ravishment* has taken place in the presence of a sacred (religious, pious) look, and the crime may be read as a demonstration of transgression in which the Other is implicated by the subject, who "captures us in our own trap . . . using it for his own purposes and thus assuring the inanity of our interventions."[28] That is, the power of the crime to shock and appall is redoubled by the context of the Other: as with many instances of perverse crime, the scenario can be read as a sick joke or an instance of *black* humor—the final punch line being completed only by the third party.[29] The dramatic irony, in this instance, was that the window *did* actually conceal an eyewitness behind it:

> Miss Kelly went to the front door of the presbytery, which looks out on to the lawn and drive, at the front of the house, facing Grosvenor Road. She switched on an outside electric light . . . she was suddenly startled to see a woman lying on the lawn, with a man lying down in front and on top of the woman. The man had his back towards Miss Kelly, and he at once got up and ran down the drive towards the main road . . . Miss Kelly went on to the lawn and she saw the deceased lying on her back with her legs wide apart, her clothing up to her waist and her private parts exposed. She ran back to the house, shouted to Monsignor Kelly (he is still known and referred to as Father Kelly) and then returned to the lawn and arranged the clothing on the body so as to cover the exposure of the private parts.[30]

The SIO's time line of the events of the discovery demonstrates how effective—*corrupting*—the introduction of the lewd element was: in the face of this depraved, Bataillian, admixture of sex, death, and violence, the description of Miss Kelly darting out in order to rearrange the victim's clothes becomes almost farcical, and recalls Lacan's reaction to Gustave Courbet's

1866 painting *L'Origine du monde* (the model's pubic hair and genitalia are the inescapable subject matter) which, having acquired at great expense, he decorously restored to dignity with a hand-crafted screen, "so as to cover the exposure of the private parts."[31] However, the presence—or potential distress—of the witness Miss Kelly may have been of little significance to this killer, who was perhaps drawn to this site because it allowed him to "organize" the murder around a setting that was *inherently overlooked*. Thus, an initially innocuous detail—the veiled Victorian bay windows—that seems bland enough on initial viewing, actually emerges as a key organizing factor which activates this highly specific orientation.

It is also possible to amplify this theme in relation to a series of crime scene photographs (photographs 3.8–3.10) which document a murder that took place on a train traveling from Bognor Regis in Sussex to Gatwick in Surrey, in 1965. Like the murder at the vicarage discussed above, this killing also occurred in a public place; in this case a train carriage.[32] The carriage was divided into several compartments, as we can see in 3.8—a layout that segregates small groups of travelers into two opposing groups of three, a seating arrangement that can produce (like riding in a crowded elevator) an uncomfortable quasi-intimacy that is merely a consequence of physical proximity.[33] Yet equally, the setting of a train carriage also brings to mind the romantic notion of the chance encounter with a stranger on a train as a fateful meeting.[34] However, the scenario that seems to have been played out in this instance might be described as an inversion of the romantic meeting. An unexpected (and unwanted) proposition by the perpetrator was rebutted, and in his police statement he describes his impression of a seemingly flirtatious stranger:

> She was wearing a white coat, a dress the colour of which I cannot remember. She was aged about twenty-six to thirty and attractive looking . . . during the journey she was reading a book. Whilst reading it she kept looking up now and again and it seemed like she was looking at me. It seemed that I was onto a good thing, so I moved up and sat opposite her. Nothing was said until we got to Faygate, when I then asked her, "What about it?" at which she sort of snubbed me . . . all along she had been showing plenty of leg and had not bothered to cover them up. At this I got annoyed.[35]

The perpetrator's indecent proposal was declined and the woman's demure response supposedly prompted him to kill—finally these strangers *did* form a lasting relationship, but only as perpetrator and deceased.

In these photographs, as in the case of the murder at the vicarage, the deceased's attire and position—with the skirt pulled up to reveal underwear,

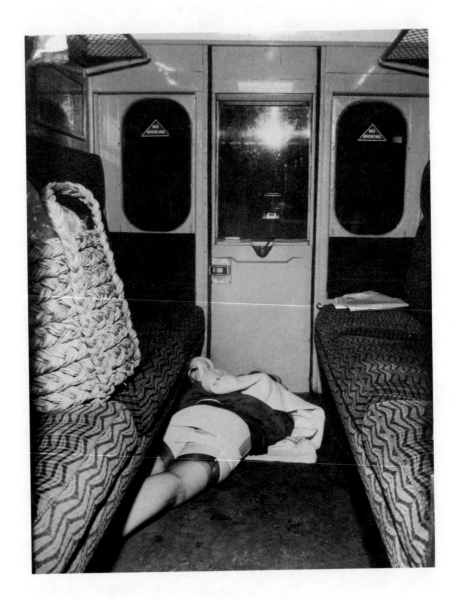

THE PERVERSE CRIME SCENE

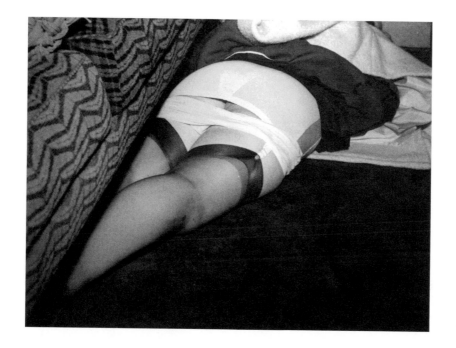

3.9

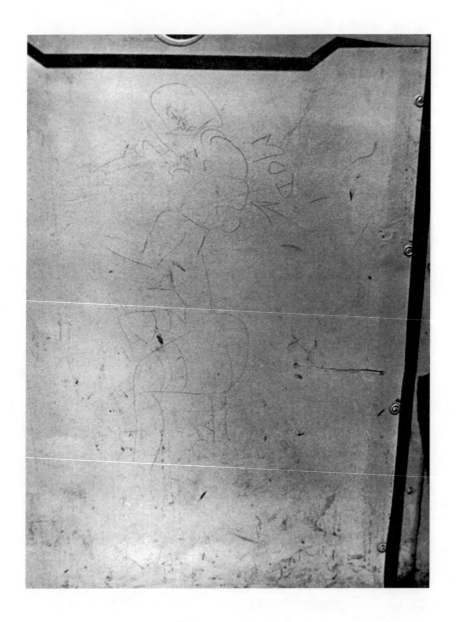

stockings, garter, and so on—immediately suggest some exhibitionistic or, at least, *sexual* dimension to the crime.

The detail that I am highlighting—enhanced in photograph 3.10—is an obscene/erotic graffiti that has been carefully etched into the compartment's door. Significantly, certain key elements within the graffiti drawing—etching—appear to parallel and echo the modus operandi (MO) of the killing, creating a dialogue between this initially insignificant drawing and the murder itself.[36] The starting point is the pretty, smiling and curvaceous pin-up girls that will be forever associated with that era.[37] But the pin-up image was always coy, not pornographic; its titillating effect was progressed through depictions of models in swimwear or lingerie—particularly the alluring stockings and suspenders that both of these "images" pointedly incorporate. Each of these new versions seemingly proposes an alternative to the vacuously alluring originals whereby harmless flirtation is replaced with blunt violence. The woman who is a cocktease and only leads men on by always alluding to sexual intercourse, but never submitting to it, who frustrates sexual desire as she *makes the man wait forever*, is, in these distorted remakes (or perverse parodies), forced to finally submit to gang rape as a punishment that includes ritual-like degradation and humiliation, or death.

Key to an interpretation of this detail—the drawing—is to characterize it, like the murder itself, as the *residue* of a perverse act. Considering the purpose or function of this, or any other graffiti, I note that it is not the specific imagery that is fundamental, but the fact that it appears *in a public place*—it is the modality of the communication that is primary: graffiti is not designed to be looked at by a specific individual; the audience for obscene graffiti is precisely an unknown and implied *Other*: an Other who cannot avoid (does not choose to view) some provocative image or statement, and is *corrupted* by it.[38] The essential dynamic is that for the artist—the scribe—the act of drawing/writing is always preconnected to an assumed audience; there is an exhibitionistic dimension to the process—the taboo (obscene) aspect is simply an effective device. As Lacan commented: "it is not only that I see the Other, I see him seeing me, which implies the third term, namely that he knows that I see him. The circle is closed."[39]

Thus both of these "depictions" (the drawing, the murder scene) may be described as renditions of a similar fantasy scenario, and both, I argue, are dependent on a supposed Other whereby the victim remains—cipher-like—only an element in a message. The implicit structuring mechanism that is essential to the formal construction of photograph 3.9 is, then, that it seemingly rearticulates a supposed freedom from the constraints of the Law, a freedom that, paradoxically, is finally always reinforced. And it is this protest or demonstration that comes to dominate in the form of a repetitive, claustrophobic scenario which is endlessly re-presented and

reasserted, only the format or scale may be varied—recall, for example, the image of the flat-topped mountain that Roy Neary (Richard Dreyfuss), in Steven Spielberg's film *Close Encounters of the Third Kind*, feels compelled to reify continually. Beginning with two-dimensional drawings, he moves on to three-dimensional renditions—in mashed potato at first. He goes on to construct a large-scale model, then finally a recognition of the shape as a physical geographical form: when he arrives at the alien landing site (the plateau on top of the mountain), it is undeniably familiar to him.[40]

It is as if the drawing of a violent rape were escalated. A fantasy that at some moment has to cross what Clavreul describes as a frontier (a fantasy—a graphic depiction of the fantasy—the carrying out of the fantasy *in reality*).[41] This notion of escalation is described too by an anonymous interviewee quoted by Ressler, who reveals fantasy scenarios which were "were too strong . . . they were going on too long, and were too elaborate. It is a development. Getting tired of a certain level of fantasy and then going even further and even more bizarre."[42] An essential quality of the perverse fantasy is that it is a fundamentally *built* image. It is portable and can be remapped in any new setting, like a series of instructions (a scalable diagram) that can be deployed as required—the visual artist Solomon LeWitt describes a perhaps allied notion when he asserts that "ideas alone can be works of art: they are in a chain of development that may eventually find some form. All ideas need not be made physical."[43] Perhaps this erotic/obscene drawing was produced by the murderer while traveling sometime before on a familiar train journey—as if he responded to the graffiti/diagram next to his seat by posing a brusque rhetorical question: "Does not one *perverse* image demand another?"[44]

In Michael Powell's *Peeping Tom*, Mark Lewis films his acts of murder, the killings are not an end point: once the "home movie" exists, it awaits an audience—an audience that will, in viewing the film, share in his horrifying secret. It is the innocent and naïve Helen Stephens who enunciates precisely his *ultimate* desire when she finally requests: "Take me to your cinema."[45]

Just as Sade supposedly gained pleasure from the knowledge that in every paragraph the reader is brought ever closer to understanding, identifying, or even participating in the horrifying activities he describes (the reader as Other), so too the sadistic criminal is, perhaps, aware that the crime scene is a site that will inevitably be scrutinized by the investigating officer, the evidence gatherers, and so on. Each of them must carefully record what they find, treat all with great care, and photograph it with precision: it is the CSIs who are finally *tricked*—or, perhaps more accurately, *seduced*—into making a series of obscene photographs, and thus also becoming unwitting collaborators, accomplices; it is they who finally enunciate the killer's "punch line."[46]

THE PERVERSE CRIME SCENE

Marie Bonaparte characterizes the perverse boy who "consoles himself by thinking that little girls grow penises in time, and goes on believing that grown women *at least and especially, his mother* are so endowed."[47] The perverse subject may conflate Oedipal "castration" with a physical reality. Otto Fenichel, for example, commented that "[childhood sexual theories] are much more grotesque than the conceptions of a later period."[48] The perverse subject simply retains—childlike—this early evaluation, and continues to presume that he must disavow or *deny all knowledge of* (symbolic) castration. The Lacanian psychoanalyst Joël Dor places this theme centrally, noting that "it is only when the child is in a position to symbolize sexual difference that he or she will be saved from the law of 'all or nothing.' This hovering in the balance is what eludes the pervert, in that he prematurely traps himself in the representation of a lack that cannot be symbolized."[49] Hence, too, the familiar appraisal of the perverse sociopath as "a man who never really grew up": the perverse criminal retains a dreaded thought—one that he has been stuck with since infancy.

And what emerges, as a consequence of such infantile fixation, is that the pervert "oscillates between the fantasmatic representations of two feminine objects, endlessly seeking their closest approximations in reality. A woman can therefore appear to him as a virgin, saint, or else as a repulsive whore . . . the repulsive mother, repugnant because she is sexual—that is, desirable and desirous with regard to the father," the *femme fatale*, behind whose irresistible allure lies a deadly threat.[50]

Thus, in the context of the visually identifiable residues with which I am concerned, I propose that there may be evidence of a limited narrative that is always a reformulation of Dor's "all or nothing": a narrative of seduction emerges in which the pervert has played out—and replays—a scenario in which a woman is idolized up until the crucial moment in which she is revealed—often in the act of removing her clothes—as *literally* castrated (Baudelaire asks: "What poet, in sitting down to paint the pleasure caused by the sight of a beautiful woman, would venture to separate her from her costume?").[51] The image of "a limited being"[52] is not accepted, it cannot be; it includes a fact *that is not a fact*. Hence the response of terror, unbearable anger, contempt, and so on—it is a response to something that is *impossible*.

In order to further develop this theme, I want to consider the documents of a murder committed in Kilburn, London, in 1959 (photographs 3.11–3.14). This set of photographs refers to a murder committed in a squalid bed-sit flat that recalls the apartment room described by Baudelaire in *The Double Room*: "The stagnant atmosphere is nebulously tinted pink and blue. And that perfume out of another world which in my state of exquisite sensibility was so intoxicating? Alas, another odour has taken its place, of stale tobacco

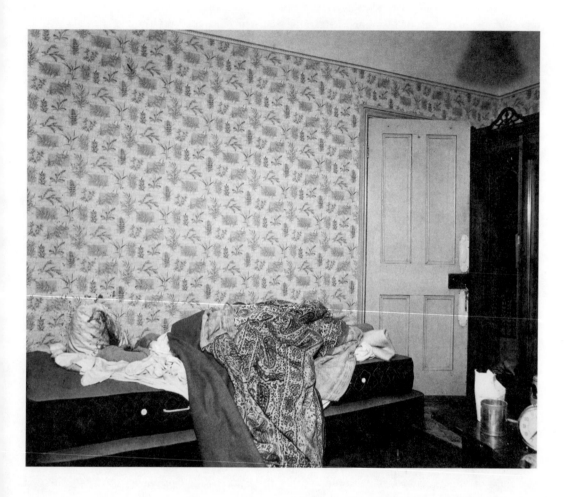

3.11

mixed with nauseating mustiness. The rancid smell of desolation."[53] In Baudelaire's conceit, the doubling of the room refers to two distinctly different atmospheres that characterize the writer's mood (state of mind) before and after sexual intercourse. The author describes/recognizes only a before—seduction-intoxication—and an after—disgust-repulsion. Any sense of a narrative structure is replaced with an entirely binary proposition that has flipped over one to the other. There is no seamless transition, only the Godardian "jump cut" that breaks—destroys—continuity.

In photographs 3.11–3.14, just such a distinctive splitting-doubling may be apprehended in the contrasting imagery across the separate photographs. One image depicting a distressingly defiled woman (3.12) is contrasted with a view that shows no evidence of a crime at all (3.13). In the second photograph, any imagery associated with rape or sexual murder is absent; there is not even evidence of a struggle. This second view thus seems to document a nonevent: something expected did not happen. Rather than being, say, brutally ripped or torn, the woman's clothes—including her underwear—remain as they must have been placed: conscientiously folded over a chair back.

This depiction of a motif from the everyday—quite familiar to all—seems to be incongruous in such close proximity to the torture and violence only inches away. But this highlighted detail is important because it signifies that this woman undressed in a leisurely—or, at least, controlled—manner. In relation to the depiction in 3.12, this is striking. The casually piled clothes offer evidence from which it must be concluded that nothing unusual had happened before this murder victim undressed—the SIO's report pointedly notes that she was a *common* prostitute, so in any case she would have required them in order to attract her next John. The neat arrangement implies that the onslaught did not commence as soon as the killer entered this private room—it was not some berserk attack. The events that culminated in murder erupted, it seems, only after the woman had removed all her clothes. So perhaps the "frozen moment" of nakedness also marked, for this killer, the collapse of the image of woman as masculinely endowed virgin/saint. In his commentary on Sade, Lacan reminds us that Sade's victims are always *incomparably beautiful*, noting: "we should see here the grimace of what I have shown regarding the function of beauty in tragedy: the ultimate barrier that forbids access to a fundamental horror."[54] The vile events of this murder probably followed a logic which coincides with Marie Bonaparte's observation: "the perverse killer seems to say, 'you are punished because you never had what I believed you had.'"[55]

And it is this dimension of a hopeless nontransition between dressed and undressed that is perhaps decisive, the woman remaining revered, unknowable, mannequin-like, up to the point where the perfected image

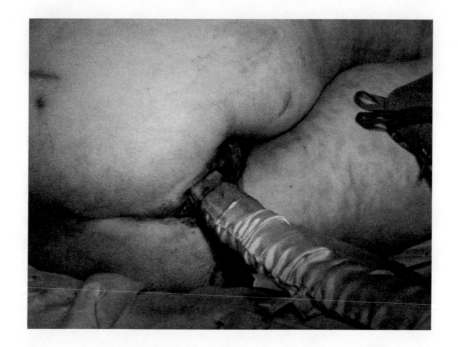

3.12

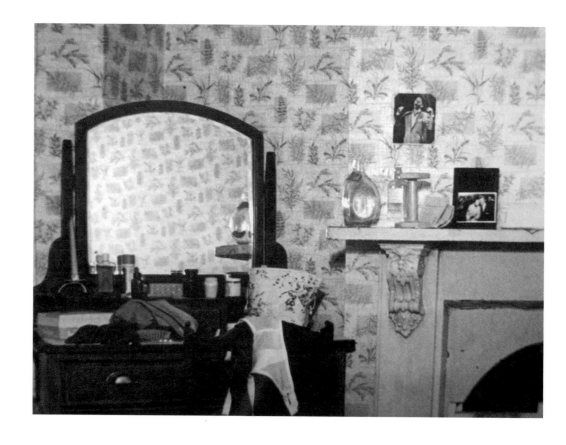

3.14

became demonstrably untenable. Perhaps this woman was encountered (like Baudelaire's duality) first as adorned and then as naked—frightening, repulsive—as if she were two entirely separate characters that allow for no possibility of a smooth dissolve or transition between exquisite intoxication and rancid desolation.[56]

A further instance of this theme can be adduced in the photographs which document a murder committed in Southwark, London, in 1955 (photographs 3.15–3.18). The depicted crime scene is an abject environment which places the victim in a bleak and unappealing location—actually revealed in the SIO's report to be a bomb site (an area of land that had not altered since London was subjected to bombing by German forces during World War II). The SIO also notes in his report that "the bombed site where the body was found is mainly enclosed by a high wall . . . these streets are practically unfrequented at night and the site is dark and little used."[57] This crime had taken place at a remove from the familiarity of the everyday, and might be interpreted as a physical manifestation that directly echoes a mental state, recalling, for example, Jean Genet's characterization of the criminal who actively seeks out forbidden sites: "repudiating the virtues of your world, criminals hopelessly agree to organize a forbidden universe. They agree to live in it. The air there is nauseating: they can breathe it. But— criminals are remote from you—as in love, they turn away from the world and its laws."[58]

Like the urban wilderness of the—abandoned—Zone in Tarkovsky's Stalker, the liminal landscapes of Jim Ballard's Atrocity Exhibition, or the unearthly-looking construction sites, landfill facilities, military installations, sewage plants, concrete substations, and underground access tunnels that Jan Staller documents, this is a place where the familiar codification of the quotidian is diminished and ordinary expectations are challenged.[59]

Every object in these photographs that is not twisted, torn, or broken is rusting, smashed, or discarded. This is a barren terrain—a terrain that can also be likened to photographs that depict another planet, such as those which have been sent back remotely from the surface of Mars and confront the viewer with a representation of a place in which, as in Genet's geography of perversion/criminality, we will—quite literally—never be able to breathe the noxious atmosphere.

Thus this dysfunctional locale is also a *lawless* space, a place where generally accepted rules do not apply, and transgression reigns. Just like the developmental truncation that is inherent to perversion, this site might have attracted the killer precisely because it is a place where the Law—whether it be as "Law of the land" or Symbolic Law—does not function. In such forbidden places it is possible to, at least temporarily, *deny all knowledge*.

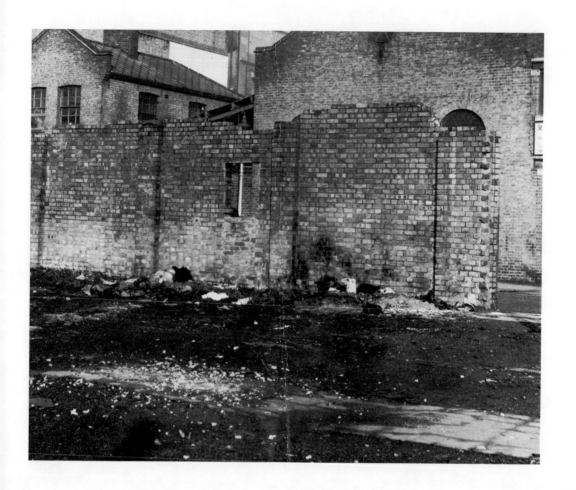

3.15

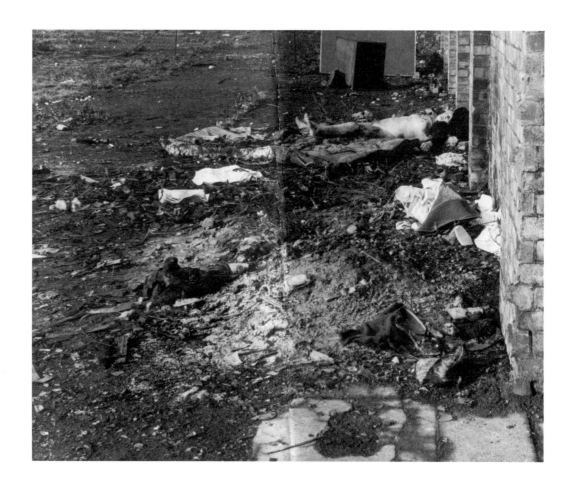

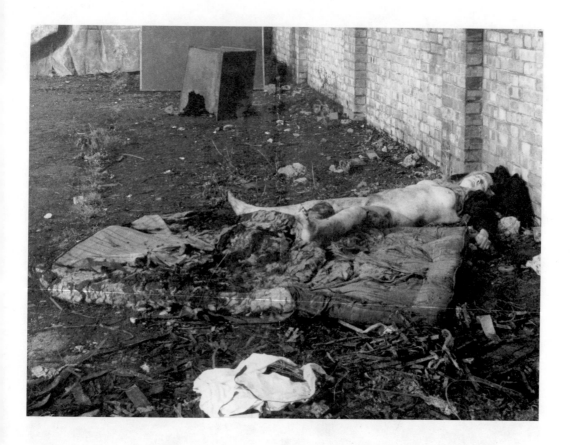

3.17

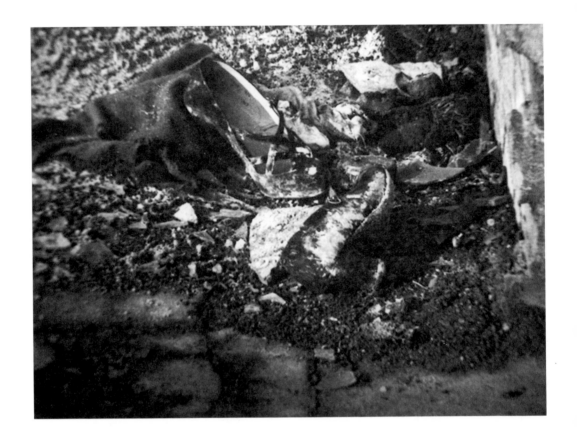

3.18

The detail I shall highlight is a pair of women's shoes—also isolated in photograph 3.18. These low-heeled black suede pumps—which seemingly belonged to the deceased—are covered in mud, as if deliberately or willfully defiled.

The psychoanalyst James Glover discusses a case study in which he describes the behavior of a perverse man who coded and defined women by their choice of shoe (his preference being for high heels). Having selected an appropriate woman in a social situation, he would then "corrupt her with alcohol" and encourage her to walk through mud until her shoes were "dirtied and spoiled."[60] As a consequence of this defilement, he would be aroused to masturbate, finally throwing the shoes violently away, shouting: "Now go to Hell!" Such a narrative follows Bataille's aphoristic assertion that "to despoil is the essence of eroticism [perversion]."[61] Thus—following Genet's theme of the "forbidden universe," and Glover's case of defiled shoes—my proposition here is that this desolate setting was, for the killer, a place in which his victim would be either encouraged, or forced, to play out a scenario in which a once revered, adored—unknowable—woman might be despoiled (or punished) with impunity.

The shoes remain as an index to this woman's former glamour or allure—and, as is well known, such shoes do literally function to even physically elevate: it is crucial that the artifice of the distant and *unknowable* female must initially function successfully in order that a (non-)narrative of descent/destruction may be initiated. However, the *sine qua non* is not this quasi-narrative *per se*, but the fact that it is only ever a veneer—it is unrealistic, utterly predictable, repetitive: the final cruel outcome always established before the drama has even begun.[62]

Indeed, the scene almost appears as a theater setting for a defiled version of a romantic seduction: removing the woman's shoes near the entrance of the site, the seducer then slowly removes her clothes—they form a trail that suggests a mannered striptease, to be completed by the time she reaches an appropriately discarded mattress. It is as if, in the act of unbuckling her shoes, this woman might also have began—unwittingly—to remove the powerful protective cloak of visual signifiers that had, up to that moment, ensured her safety. In the Lacanian conception of perversion it is precisely this X-rated, over-18s-only adult drama that is unsupportable: it requires the very knowledge from which these certificates of censorship protect the innocent child.

Another instance of this theme can be seen in the crime scene photographs that depict a murder committed in Birmingham in 1959 (photographs 3.19–3.21). In this set of photographs it is a wardrobe that seems to dominate the compositional organization; the nakedness of the corpse is emphasized by proximity to its coffin-like presence. The detail I am highlighting is of a

summer blouse and pleated skirt that can be seen hanging on a rail—isolated in photograph 3.21. This outfit selection hangs precariously, awkwardly, as if it was about to be selected, when—just at that moment—the process was halted.[65] From the SIO's report, it can be ascertained that the couple who feature in this dismal drama had resolved to go out to a New Year's Eve party when the crime took place: this woman was actually preparing to "dress up" for a night out.

The clothes depicted in this way suggest that the woman was perhaps attacked at precisely the moment she began to dress. This image seems to offer another version of the narrative proposed above. In this depiction, however, the elements that are essential to *fashion* the woman's image are still on hangers—the scene is comparable to something like a glimpse of a backstage dressing room.

And here—as with the earlier example of some neatly folded clothes on a chair back—the murder seems to have occurred at the same distinctive *transitional* moment. In this instance, however, the victim's nakedness—"the nakedness of the limited being"—must have been established some time (minutes, hours) earlier: a post-sex scene of the formulaic 1950s type which Godard so often parodied. As Clavreul reminds us: "The pervert's knowledge is a knowledge that refuses to recognize its insertion in a 'not-knowing' . . . it is rigid and implacable, it cannot be revised in the face of facts that belie it."[64] The pervert is trapped in a looped narrative that is unidirectional, one-way, nonreversible, but is simultaneously drawn irresistibly back to the locus of the *wound* by the strength of a—seemingly absurd—misapprehension.

Baudelaire proposed that dressing up was a woman's obligation: "In devoting herself to the task of fostering a magic and supernatural aura about her appearance, she must create a sense of surprise, she must fascinate; idol that she is, she must adorn herself, to be adored . . . it matters very little that the ruse and the artifice be known of all, if their success is certain, and the effect always irresistible."[65] It is this knowledge of a backstage preparatory area behind the glamorous façade that defines our experience of theater; the artifice is known to all ("the willing suspension of disbelief"): the audience agree to ignore the deceit. In these photographs, however, it is as if that knowledge was resisted, any agreement disavowed: as if the originally revered woman could never effectively reprise the role of "unknowable virgin"; hence the problem of "not knowing" is resolved—in a state of duress—by simply, and so brutally, freezing the action: producing a "frozen moment" which, above all, restores certainty. A resolution whereby a woman can be encountered only as a disposable "single-use" object that is designed or intended to be discarded—indeed, many such murders conclude with the body being deposited on *waste* ground, or "trashed" into a refuse bin or a builder's dumpster.

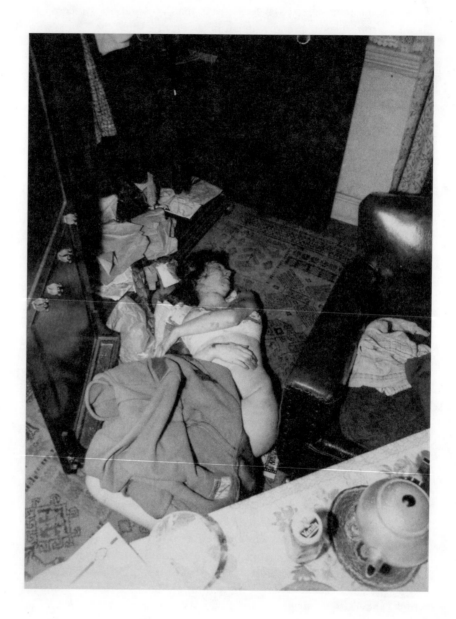

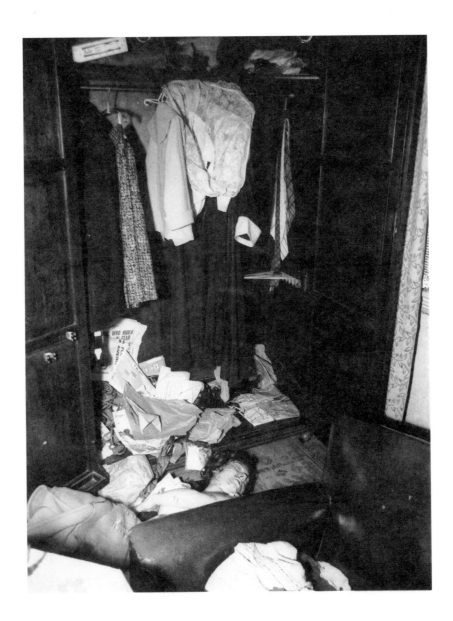

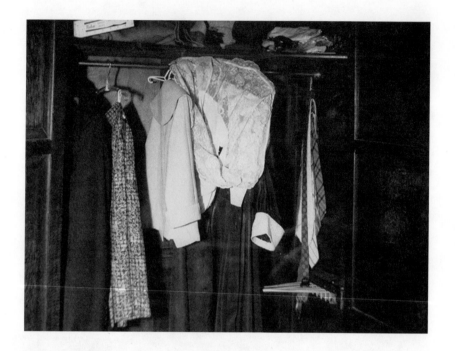

3.21

In the context of this bleak "fantasy" that is constantly *rescreened* (this terrorizing video clip), it is only a minor elaboration (a small step) to introduce the notion of a fetish, that is, an object that the pervert actually carries along or adds to the "picture" of the scene as a protective measure, something that is imbued with a symbolic—or magical—power.

The fetish object may thus also be conceptualized as an ingenious solution. Freud notes that "the subject created a substitute for the penis which he missed in females—that is to say, a fetish. In so doing it is true to say that he had disavowed reality, but he had saved his own penis."[66] Asserting this point in more overtly Lacanian terms, Clavreul comments: "The child must also discover that he was ignorant of the reality of sexual difference. It is a question not merely of having to accept a singular but contingent anatomical fact, but also of having to integrate the other fact, that only the lack can be the cause of desire. It is precisely on this point that the pervert brings his disavowal to bear: it is not the lack that causes desire, but a presence (the fetish). The discovery of the difference between the sexes is, for the young boy, the occasion for a reinterpretation of the cause of desire, and it is this reinterpretation that the pervert misses."[67] Thus, in relation to the photographic images, a depiction of a fetish object may be apprehended precisely because the signifying quality of the object chosen has been transformed. The fetish object might be a familiar enough object, but because it has been imbued with a specific privileged meaning—has been reused as a symbol—it has become iconic.

In order to develop this theme, I want to introduce a series of crime scene photographs which document a murder in Halifax, Yorkshire, in 1960 (photographs 3.22–3.25). This murder was committed in a basic and stark interior. The simple domestic objects present do not seem to differ greatly from, say, Braudel's description of workers' homes in preindustrialized France, where "poor people had few possessions . . . their furniture consisted of next to nothing, at least before the eighteenth century when a rudimentary luxury began to spread, chairs where before people had been content with benches, woolen mattresses, feather beds—together with decorative peasant furniture."[68] And the furniture and implements depicted in this series of photographs—particularly in photograph 3.23—are the industrialized updating of the peasant home that Braudel describes. Two hundred years later, it is still basic needs that dominate: a larder with a few pots and food items, a rudimentary sink. The major difference is that where there were once handmade objects (crafted), there are now factory-produced objects made with factory-produced materials: wood and wool are replaced with bent steel tubing, foam, PVC, and Formica. The brutality of this murder is striking—the force of a hammer blow enough to snap the handle.

3.22

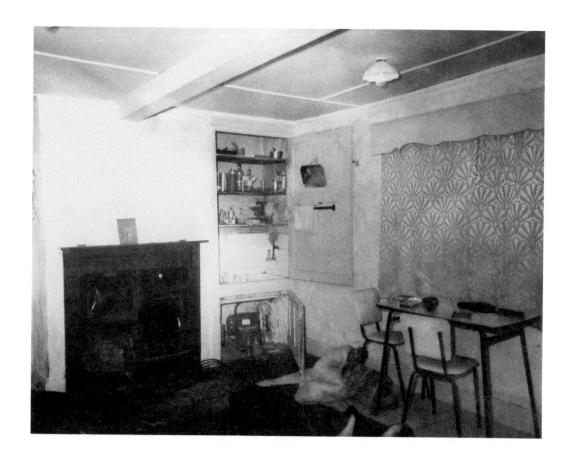

3.23

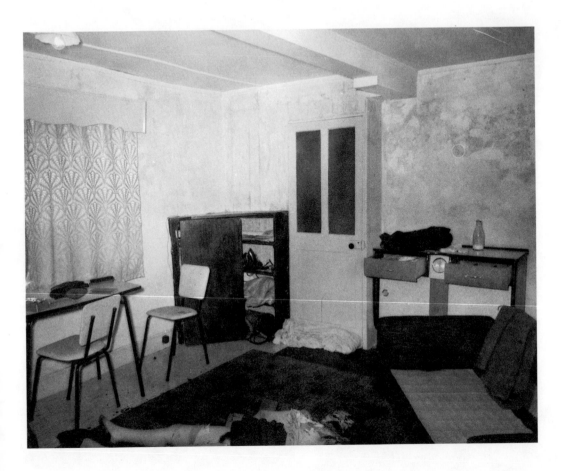

3.24

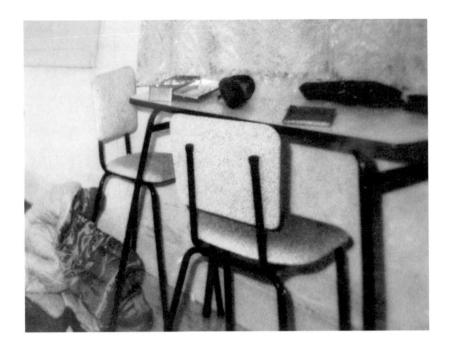

3.25

But beyond the lure of the provocative cadaver (as *studium*), I am drawn to the presence of a single stiletto-heeled shoe on the kitchen table (as *punctum*), a detail that is enhanced in photograph 3.25. This *individual* shoe has lost its intended function or purpose—to be useful, shoes must usually be in pairs. It is an object that is unquestionably out of place: shoes are usually thought of as being too dirty to be placed on a table. Indeed, many cultures actually put a taboo on that action, one which is enforced in England by the specter of "bad luck."[69] Not only is this shoe out of place—an unexpected concession to luxury in this otherwise basic interior—it is also *in the place* of something: food, sustenance. It is on the tabletop that we often place essential nourishment; the shoe is thus, significantly, in the place of "that which is essential." This shoe is not cast down and made abject, as are those in photographs 3.15–3.18, but is, conversely, placed into a setting in which it seems to be proudly esteemed. The presence of the shoe in its dysfunctional setting thus perhaps served as a talisman that was supposed to make sexual intercourse possible—whether as "lovemaking" or as a violent rape. The paradox, of course, is that the object appears as a substitute for something that was not, in reality, ever actually *missing* at all. In any case the fetish object, in this instance, failed to successfully defend the murderer from initiating again the destructive (non-)narrative that I have been considering.

A further theme that can be extrapolated from some of the crime scene material under consideration is evidence of a perverse strategy to undermine accepted truth or logic: to vex long-held beliefs or assumptions in order to demonstrate that a perception, even a seemingly obvious one, is *always* questionable, and hence that the Symbolic Order—the Law—is fallible. This is also a theme that is recognized by CCM and DSM—the sociopath as liar, cheat, and manipulator. Such behavior is broadly characterized in DSM under the classification antisocial personality disorder (APD):

> Individuals with Antisocial Personality Disorder fail to conform to social norms with respect to lawful behaviour ... [they often] disregard the wishes, rights, or feelings of others. They are frequently deceitful and manipulative in order to gain personal profit or pleasure, e.g., to obtain money, sex, or power. They may repeatedly lie, use an alias, con others, or malinger.[70]

Considering such behavior through Lacan's interpretive apparatus, Žižek characterizes perverse disavowal as "a defence against the motif of death and sexuality, against the threat of mortality as well as the contingent imposition of sexual difference. What the pervert enacts is a universe in which, as in cartoons, a human being can survive any catastrophe; in which adult sexuality is reduced to a childish game; in which one is not forced to die or to choose one

of the two sexes."[71] And Žižek's vignette raises again the theme of the infantile, the childlike. But it is Bataille who defines this theme—of supposedly anarchic aspirations—with a profound clarity: "Compared with work transgression is a game. In the world of play philosophy disintegrates."[72]

When we consider these behavioral patterns in relation to the photographic material, the first expectation—or familiar assumption—that can be vexed is the crime scene photograph's status as a *reliable* document. And I want to elaborate here an example of crime scene photography that is undermined or discredited (a basic reading of a photograph is corrupted or problematized) through the introduction of some questionable element that seems to disavow an accepted coding—photographs 3.26–3.28. This series of photographs records the scene of a murder committed in Harrogate, Yorkshire, in 1956. The interior depicted in photographs 3.26 and 3.27 recalls the familiar aesthetic so prevalent in estate agents' photographs of interiors— the basic organizing principle of that subgenre is that nothing must be pictured *in use*: a bed must always be made up; food items, clothes, and so on must be neatly stacked or stored (any evidence of residents must be appropriately anodyne). That is, there must not be any *excess* visible.

In this set of photographs, the *sine qua non* of the murder scene photograph—a corpse—is absent. In fact there is no visual evidence of a crime at all. And the most impressive quality of these images is that they fail to function as expected, for in this instance the criminal apparently removed all visual evidence that would normally confront the SOCO at a homicide: a body, evidence of a struggle, the activities that surrounded the killing, and so on. Often the scene of a murder contains hundreds of elements that pertain to the crime; here, however, we see only a well-made bed in a pleasant enough bedroom—the soft, diffuse lighting emphasizing a supposed normality.

The corpse of a murdered woman had, in fact, been locked in the wardrobe that can be seen at the far right edge of photograph 3.26.[73] The "truth"— of a brutal murder—has been (literally) hidden; the scene was altered in order to offer only an innocuous neutrality: the murder scene is replaced with "the everyday," that is, it is replaced with a nonevent. In these photographs the SOCO was forced to document only an ordinary room devoid of any execrable element. A dimension of farcicality is introduced—as I said above, the images seem to record a scene that has little to do with crime at all. This contrast with the expected subject matter is emphasized when the researcher, consulting the original case files—which are marked up with the usual legal notations, official stamps, and warning (Contains Disturbing Material)—is confronted with something like "disappointment."

Of course, an immediate inference that might be made with reference to this example may be that this criminal hid or disposed of the evidence in

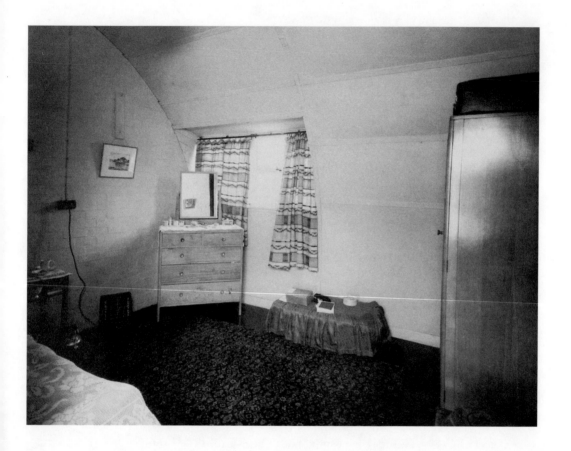

3.26

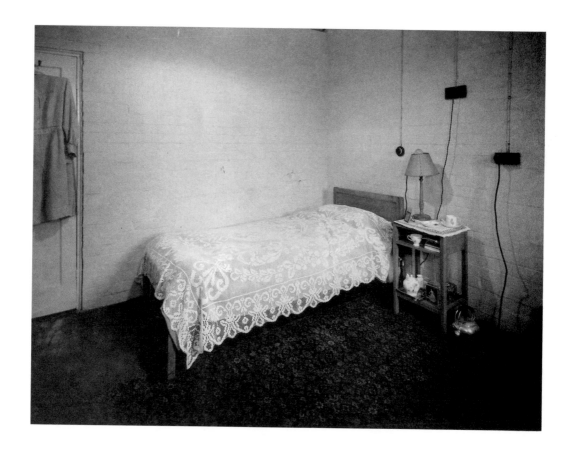

3.27

3.28

order to evade capture, but this evaluation fails to focus on a wider theme: the introduction of play as a disingenuous communication—one that uses parody to "laugh in the face" of those who pursue.[74]

In this example—photograph 3.26—a dimension of absurdity is heightened by the provocative fact—revealed in the SIO's report—that, while meticulously making the bed and cleaning the room, the killer was also *actually carrying out his expected job*: he was the woman's butler. That is, his cleaning of the room after the murder actually aroused no suspicion at all from co-workers.

However, the perpetrator did leave one clue on display in the room: a cup of tea on the bedside table (see photograph 3.28)—a detail which was noted also by the SIO, who reported: "The police officer made an examination of the premises and noticed that they appeared clean and tidy. On examination of the bedroom of the deceased, Detective Inspector —— saw that Miss ——'s bed had been made. A cup containing cold tea was found on the bedside table."[75] Insofar as drinking tea is a socially coded ritual, it is notable that someone often *serves* tea. Recall, for example, such charmingly predictable conversational elements as the uniquely English "Shall I be *Mum?*," or "We shall take tea now, if you please," or even "More tea, Vicar?" The serving of tea often includes the dynamic of an interaction: one person serves another. And what emerges from the information in the SIO's report on this case is the fact that the killer generally brought in an early-morning cup of tea as part of his duties; thus on this final occasion he had served tea to *someone he knew to be dead*. The tea cup functions as an index to an updating of the original relationship: the killer seemingly played out a long-fantasized scenario, noting in his confession statement: "When I got back [around 3 a.m.] it came into my mind again about strangling Miss ——."[76] The presence of the tea—slowly cooling, as the body also was—might be an object something like a "calling card," a proud declaration of a completed inversion and triumph over the designated law of *master and servant*. Crucially, though, for the perverse criminal, such a bleak—"sick"—joke is not designed to amuse. The purpose is simply to undermine, mock, and attack the taken-for-granted logic that the Symbolic Order imposes: the basic logic—"common sense"—that structures daily life.

A further instance of this phenomenon can be seen in photographs that document a murder committed in Hatfield, Herefordshire, in 1969 (photographs 3.29–3.30). The images record a body abandoned on open ground—the contents of the deceased's handbag and her clothing lying all around (3.29).

This crime was committed at night, so these photographs must have been made some hours after the discovery of the body the following

morning—a time period that is indexed in the layer of snow that has fallen on the scene in the intervening period; and the depictions seem to recall—so inappropriately—the strangely unreal—enchanting—world that might greet a child looking out onto a snow-covered winter morning. The idea that the perverse subject often creates a scenario in which *all is not as it seems* is reinforced in the sio's report of this case, where it is noted that the person who discovered the body did not believe what they saw from their back window, initially assuming that it was only an "unclothed female dummy."[77] Of course, the bitter *punctum* is that the victim appears as if she is deliberately and exhibitionistically flaunting herself—shamelessly. One of many objects near to the body is a tub of petroleum jelly (the well-known product Vaseline), which I have enhanced in photograph 3.30. This object—product—substance can be *read* in various ways. First, as an "innocent" object: Vaseline is a product which is traditionally associated with healing cuts, burns, and abrasions, and has typically been marketed as a family product, a staple of all medicine cabinets. But this would limit or ignore the equally familiar theme of Vaseline as a sexual lubricant, an index here to attempted anal penetration. As such, personal lubricants are used to make bearable, even pleasurable, acts that would *otherwise be painful*. And indeed, is it not that alternative use that is actually the "correct" use of Vaseline? Jean Genet described, for example, his own personal lubricant, as it lay in the banal setting of a prison record office, in his *Thief's Journal*. This object he coded with a secret or hidden meaning—it seemingly functioned to subvert the surrounding banality: "lying on the table, it was a banner telling the invisible legions of my triumph over the police . . . I was sure that this puny and most humble object [a tube of Vaseline] would hold its own against them; by its mere presence it would be able to exasperate all the police in the world."[78] And it is the notion of an *exasperating*, questionable presence that functions similarly here—the killer's statement offers the following explanation of the events:

> She [the deceased] started teasing me and that. She pulled up her skirt and showed me everything as if she was asking me to come and get it like.... She asked me not to hit her. I tore her bra off and started to suck her nipples. She never did anything then. I got the hard. She had her knickers partly down and I tore them off. I couldn't get it in because I lost the hard. I think she was moving about a bit then trying to help me. She was touching me up then. I know she said something because she was making fun of me and as we lay there I ripped her clothing off.[79]

The suspect's suggestion is that the death of his sexual partner was part of a wider series of events in which both parties played active roles: the deceased

THE PERVERSE CRIME SCENE

is presented as goading, even intentionally masochistic—supposedly encouraging and consenting to violent behavior.[80] The tube of Vaseline becomes an object that simultaneously signifies as an index to family, rape, anal penetration, frigidity, and relief from pain—the 2008 promotional strap line for this product also develops this theme: "Vaseline knows that healthy skin is a *miracle material* [sic]." Above all, it problematizes a presumed narrative that an initial reading of these photographs might provoke; an interpretation that must—logically—initially recognize evidence of a brutal killer and an innocent victim. The presence of this ambiguous lubricant introduces a dimension of questionability: the most obvious reading begins to become less stable, and it is just such a "spark of contingency" that the pervert often leverages in order to instigate a level of doubt, or hesitation, in the viewer, jury members, an interrogator: activating some seemingly trivial *punctum* in order to undermine a hitherto dependable logic. The perverse strategy is to enact a demonstration that *all is not as it seems*—familiar interpretations are eroded and challenged by relentless reappraisals: a proposition of accidental death is built up from some tawdry detail into a supposed defense—a *disavowal* of everyday presumptions which replaces them with an insidious malleability (the prosecution must always make their case so that guilt is proved beyond *reasonable* doubt), a sequence of events that are ever-shifting, an expedient rendition that is—like the lubricating embrocation—unctuously evasive.

The most cogent (and poignant) example of this notion of a pervert forcing a questioning of basic ethic/logic to be found in the clinical literature is an instance related by Dor: "He [the perverse patient] began to seem more and more horrifying to the analyst [perhaps Dr. Dor] as he subtly revealed the identity of his protagonists: there gradually emerged a group of eminent personages, including some from the best intellectual circles. He [the patient] had no concern for the consequences of taking defiance and transgression to their most dire extremes. Considering the analyst ripe for a final revelation, he revealed the identity of one of his most depraved and lewd sexual partners: she was none other than one of the analyst's daughters." Such a scenario questions and challenges a psychoanalyst's solemn obligation to protect the session as sacrosanct, entirely confidential, but beyond this ethical challenge is a recurrence of the basic leitmotiv: in sharing his corrupting revelation, the analysand also gains *an accomplice*.[81]

This notion of expected, familiar interpretations being eroded and challenged by a presentation—conceptualization—that offers instead open-endedness, and a quixotic shifting that produces a permanent state of permeability, is often evident in the—so-called "deconstructionist"—conceptualizations of the philosopher Jacques Derrida: perhaps there is a

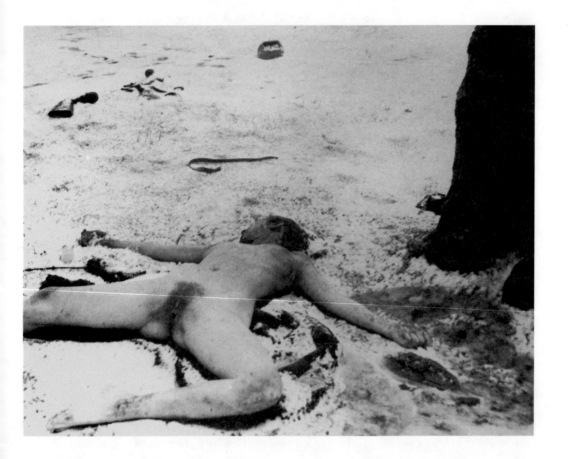

3.29

case for interpreting his—prevaricating, elliptical—"Freud and the Scene of Writing" as a perverse protest?[82] The film director Roman Polanski is—I believe—also highlighting the potency of a similarly inexorably corrupted narrative when, in his crime suspense drama *Chinatown*—a tale of incest, murder, and blackmail, i.e., transgression—Noah Cross turns to Jake Gittes and arrogantly asserts: "You may think you know what you're dealing with, but, believe me, *you don't*,"[83] his overbearing and contemptuous remark an ominous warning to the private detective that his determination to comprehend narrative events using logical deductions is futile, irrelevant.

The Psychotic Crime Scene

LACAN'S THEORY OF PSYCHOANALYSIS IS EVOLVED FROM THE SAUSSUREAN CONCEPTUALIZATION OF LANGUAGE AS A PURELY *RELATIONAL* GRID, WHEREBY "A LINK IS ESTABLISHED BETWEEN SIGNIFIER AND SIGNIFIED THAT WILL NEVER BREAK . . . WITHOUT [IT] EVERYTHING COMES UNDONE."[1] THUS, IT IS THE THEME OF THE *UNBONDED* SIGNIFIER WHICH RESONATES THROUGH SOME OF THE CASE MATERIAL THAT I HAVE CONSULTED, PARTICULARLY WHERE THERE IS EVIDENCE OF CHAOTIC DISORGANIZATION.[2] CONTRASTING PSYCHOSIS WITH NEUROSIS, LACAN COMMENTED: "WHAT COMES UNDER THE EFFECT OF REPRESSION RETURNS, FOR REPRESSION AND THE RETURN OF THE REPRESSED ARE JUST TWO SIDES OF THE SAME COIN . . . BY CONTRAST, WHAT FALLS UNDER THE EFFECT OF *VERWERFUNG* [FORECLOSURE] HAS A COMPLETELY DIFFERENT DESTINY."[3] TO UNDERSTAND THE PROFOUND—AND BREATHTAKING—CLARITY THAT LACAN BRINGS TO THIS TOPIC, IT IS WORTH CONTRASTING HIS IMPRESSION WITH THE MAIN SECTION IN DSM, *SCHIZOPHRENIC AND OTHER PSYCHOTIC DISORDERS*. IN THE PSYCHIATRIC APPROACH TO PSYCHOSIS THERE ARE MANY NUMEROUS DISORDERS THAT MAY BE DIAGNOSED, SOME OF WHICH ACTUALLY HAVE STRIKINGLY SIMILAR SYMPTOMS/OBSERVATIONS: CYCLOTHYMIC DISORDER; BIPOLAR DISORDER I; BIPOLAR DISORDER II, SCHIZOPHRENIA; DELUSIONAL DISORDER SPECIFIC; DELUSIONAL DISORDER NONSPECIFIC, AND SO ON. THE INTERMINABLE AND CONFUSING TAXONOMIES PRESENTED SEEM TO CREATE A NEW "DISORDER" WHENEVER ANY NOT PREVIOUSLY OBSERVED SYMPTOM IS EVALUATED. IN DSM THERE IS NO ATTEMPT TO SEEK OUT OR APPREHEND ANY BASIC MECHANISM THAT MAY BE MORE COGENT OR ESSENTIAL, THAT IS, SOME UNDERLYING STRUCTURE—IT SEEMS UNNECESSARY, PERHAPS, AS MANY PSYCHIATRISTS CONSULT DSM ONLY IN ORDER TO LOOK UP AND PRESCRIBE "APPROPRIATE" MEDICATION. BRUCE FINK NOTES THAT "MODERN PSYCHIATRY, FOR ITS PART, HAS NOT IN ANY WAY EXPANDED OUR UNDERSTANDING OF [FOR EXAMPLE] PERVERSION. PSYCHIATRY HAS SIMPLY PROVIDED A PANOPLY OF NEW TERMS TO DESCRIBE THE PARTICULAR OBJECTS THAT TURN PEOPLE ON: PAEDOPHILIA, FROTTEURISM, TOUCHERISM, TRANSVESTIC FETISHISM, AND SO ON."[4]

This *destiny* of the subject, in whom the mechanism of the Name-of-the-Father—or Symbolic Castration—is foreclosed, is likened by Lacan to a computer: "one feeds figures into them [computers] and waits for them to give what would perhaps take us 100,000 years to calculate [manually]. But we can only introduce things into the circuit if we respect the machine's own rhythm—otherwise they won't go in and can't enter the circuit."[5] To update his analogy, the psychotic's mind might be imagined as an unformatted computer hard drive that remains useless until it is "initialized": it must first become subject to an operating system (a specific computer language) before anything can be "written to it." Fink also borrows a term from computer jargon to describe the process of Symbolic Castration as one in which the "imaginary register—that of visual images, auditory, olfactory, and other sense perceptions of all kinds, and fantasy—is restructured, rewritten or 'overwritten' . . . the new symbolic or linguistic order supersedes the former imaginary order."[6]

Thus the visual theme that I want to elaborate here emerges through evidence at the crime scene which seems to demonstrate how objects so familiar and ubiquitous in daily life have been radically recategorized: unbonded from this (symbolic) signifying grid.

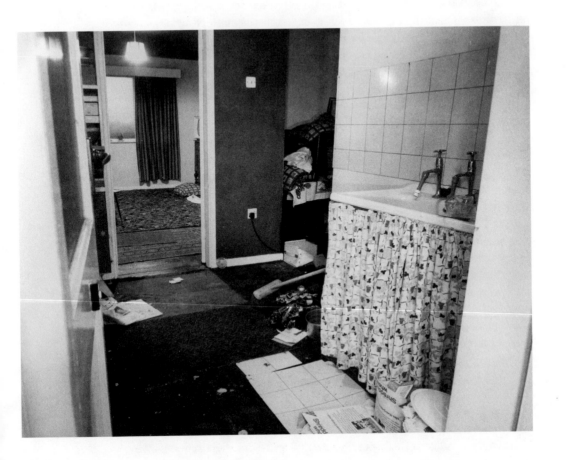

4.1

THE PSYCHOTIC CRIME SCENE

The first instance I have highlighted is the crime scene photographs that document a killing that took place in Dunscroft, Yorkshire, in 1967 (photographs 4.1–4.5). In the SIO's report on this case it is noted that the deceased was removed from the scene while unconscious—in a coma. The perpetrator called the emergency services many hours after a violent attack, and these photographs depict the scene as it was recorded on that day. Initially, it might appear that these views to a squalid interior record an extreme case of sloth, laziness, or perhaps a berserk rampage, but upon closer inspection, they reveal relentless—almost systematic—disruptions and mutilations to the familiar everyday objects depicted.

In my analysis of photograph 3.24 above, for instance, I noted that one privileged object out of place—a single high-heeled shoe on a kitchen table—might be relevant in determining the structure or narrative of the case, but in these images it is actually a majority of the many varied and diverse objects depicted that are out of place. The disorder has been created, it seems, over some time; it is not the consequence of a one-off event. There is no single privileged object which alone gains significance due to it being in the "wrong place"—as the instance of a lone stiletto placed on a kitchen table seemed to imply.

In photograph 4.5, diverse elements drawn from the familiar appear to be blurring and combining, their ordinary established domestic contexts jettisoned. A packet of Coleman's Instant Mashed Potato can be seen next to some worn lady's stockings. Next to this is a large piece of polythene and other textile garments, with what looks like underwear discarded on a loose pile of unprotected LP records (fragile objects, designed to be carefully returned to their sleeves), a torn book cover, a broken lampshade, fragments of crockery, a lone hair curler. A wider view of this scene—photograph 4.2—reveals a saucepan inexplicably placed on a bedroom cabinet, waste receptacles overturned or unused. In photograph 4.3, a suitcase is depicted with a large hole it—the contents accessed unconventionally. There are many objects throughout the images that are incomplete or diminished in some way: rags, tissues, packages, broken handles, a garter belt, personal correspondence, a trail of random book pages. It is as if the objects depicted are in an inexorable state of decay, subject to some fundamental tendency to disorder. However, it is not the theme of regression that may be decisive—as entropic decomposition—but the inference that this cluttered jumble-of-the-everyday is one that is resultant from—and indicative of—an *improvised* relationship between signifier and signified. A consequence of the fact that—as the psychoanalyst Lindsay Watson has commented—"[for the psychotic] words and their meanings seem to constantly slide off each other."[7]

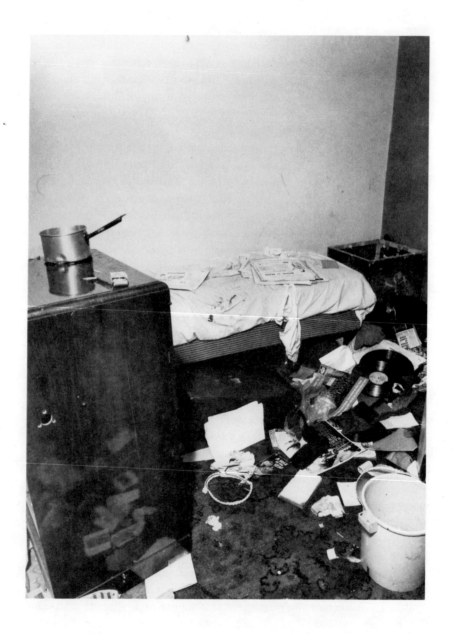

Outlining the general characteristics of schizophrenia, DSM notes that the behavior presented will include "impairments that grossly interfere with the capacity to meet the demands of life," and that that there will be "difficulties in performing activities of daily living such as preparing a meal or maintaining hygiene."[8] In these photographs there does not seem to be any a priori assumption that one object belongs in the kitchen, another in the bathroom, and so on. This factor is also discernible from the SIO's description of the search he carried out:

> [Police] officers found the flat to be in great disorder. It was found that there were two areas in the kitchen littered with broken crockery, broken glass, broken parts of a transistor radio, and the contents of a chutney jar . . . a milk bottle containing a green fluid was on the kitchen sink . . . the living room was found to be in an equal state of disorder with broken crockery and broken ornaments scattered about . . . the small bedroom was also in a state of great disorder . . . the bathroom was in a state of untidiness, wet clothing and a towel were in the bath and on the floor . . . [which was] littered with broken gramophone records and broken parts from a loudspeaker cabinet.[9]

This feature of disconcerting disruptions in the everyday is echoed by Gordon Burn in his description of the English serial killer Frederick West's abode: "the 'van [Frederick West's caravan] was littered with what looked like machine parts and tools and children's toys and dirty clothing all jumbled up. . . . There were tools everywhere in the trailer, on the chairs, on the floor and counter tops, and even on the beds . . . the trailer had the appearance of being a work shed or a tool room with the basic domestic necessities like a sink and a bed and a hot plate just barely squeezed in."[10] These photographs record a household interior in which—as in West's—the inhabitant's ability to order and differentiate is fundamentally impaired.

Beyond this impairment, the photographs in this series depict the quotidian as unfamiliar, even nightmarish, elements which are ordinarily waste—waste products—or are "used," are not separated from others which are clean, new, unused: both states seemingly retaining an equal status. The SIO's report describes one corner of the bedroom in which:

> It was noticed that the pillow case on a single bed was bloodstained. The bloodstained blue nylon shirt which had been partly torn was amongst the debris on the floor in this room. The wash basin contained a blue towel and a pair of lady's knickers which were both soaking in dirty water . . . a plastic bucket in the centre of the floor contained a quantity of discoloured fluid. A suitcase, from which the lid had been partly torn and which contained lady's clothing, was stood on end, near the bucket. A plastic container which contained brown liquid was also on the floor amongst the debris.[11]

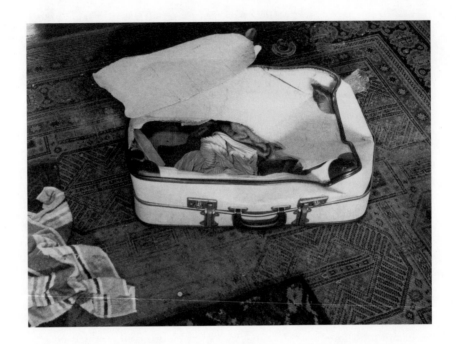

4.3

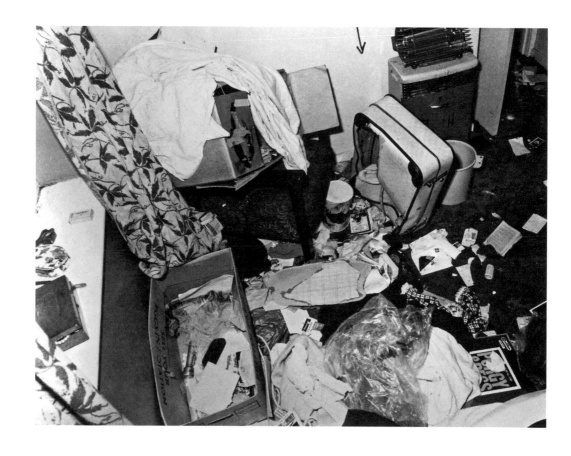

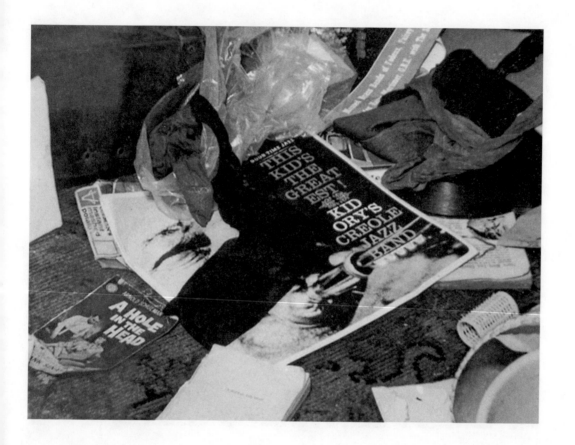

4.5

A root cause for these visually identifiable phenomena may be that the psychotic subject has no *motivation* to hide anything away or complete one activity before engaging in another. As Fink has observed: "[in psychosis] nothing is repressed and thus there are no secrets to keep from oneself."[12] A key organizing paradigm in considering these images is the absence of evidence of "the psychical dams of disgust, shame and morality," that Freud characterized as being some basic indicators of repression.[13] And without such mental barriers there is, it appears, no longer a need to limit and contain the flow of detritus, dirt, waste liquids, and so forth, that become juxtaposed with surprising objects in unexpected contexts, resulting in a continuity (no gaps) or a superimposition of the everyday. However, if the fundamental relational grid of signification has been so disrupted—or is nonexistent—it may be said that objects (and ideas) are not actually out of place at all, but exist "as is": they are experienced at face value. The disruption is such that coordinates for a specific determined function and position have never been generated—improvisations that are always innovated, reimagined. This assertion accords with a comment attributed to the improviser Miles Davis, who advised his fellow musicians: "Don't play what's there, play what's *not* there," or equally, when asked to introduce a set, proposed to the audience: "I'll play it first and tell you what it's called later."[14]

The psychotic's response to an object or idea is not necessarily bound by generalized—and familiar—assumptions, received wisdom, common sense, or the plethora of taboos that underpin (neurotic) daily life. And such a reading of psychosis as a creative reconfiguration of the everyday that also has a potent power to break down conformity parallels Bataille's concept of *informe*, which Rosalind Krauss has redefined: "Bataille does not give *informe* a meaning: rather he posits for it a job: to undo formal categories, to deny that each thing has its 'proper' form, to imagine meaning as gone shapeless, as though it were a spider or an earthworm crushed underfoot."[15] And Bataille's theory appears to be strikingly relevant: both the *informe* and the foreclosure of the Lacanian Symbolic function to interrupt the ordinary by deranging formal categories in a manner that reinforces how extraordinarily accustomed we are to order—we are *immersed* in it, it is indubitable—and is also a poignant characterization of the Lacanian Symbolic, which, like, say, the continuous effect of the force of gravity on the human body, becomes noticeable, observable, only when it is *not* present.[16]

An alternative way of reading evidence of endemic disarray is to interrogate it as if it were the residue of a *search* for order. I can elaborate on this with particular reference to the photographs—4.6–4.11—that document a killing which took place in southeast London in 1969.[17] This series of photographs is also characterized by evidence of an emphatic disturbance of daily life. Many objects captured in this interior seem to have been recontextualized

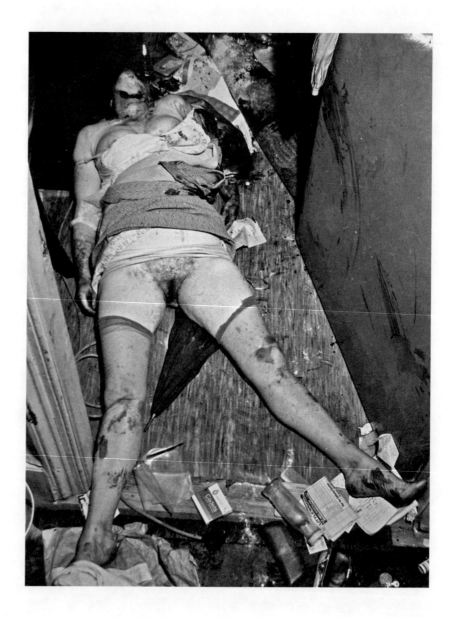

THE PSYCHOTIC CRIME SCENE

into a perplexing bricolage. But, significantly, various materials and substances appear to have been investigated or tested as if they were samples in a sequence of quasi-scientific experiments. These are attempts to evaluate whatever is to hand; a process of examining and exploring the relationships between a range of sometimes allied, and sometimes incommensurate, objects, substances, materials, surfaces, and so on.

At this scene the killing appears to coincide with many other somewhat obscure activities that have been carried out by the perpetrator; it is as if the killer were attempting to enact precisely the grid of signification that Lacan describes as being fundamental to identification: "in the symbolic order every element has value through being opposed to another."[18] So this set of photographs appears to document not a murder *per se*, but a series of rudimentary and brutal quasi-scientific experiments ("findings") that can perhaps be understood as a psychotic's attempt to produce some semblance of the oppositional, relational arena that Lacan describes.

Perhaps this killing was only the unfortunate outcome of one such test carried out on various materials (and under certain conditions) in order to determine permeability, malleability durability, magnetic attraction. It is as if a human body were utilized simply as *material*—like the vivisectionist who has "no choice" but to torture the animals he (or she) experiments upon. The killer's actions might also be likened to those of a young child who has not yet established that death is a definitive state, and is seemingly unable to determine a basic distinction between animate and inanimate.[19] And under such circumstances the range of experiments conducted might not be limited by any imposed moral system: guilt, fear of punishment, or any a priori expectations concerning outcome might be absent.[20] In photograph 4.7 there is a fan heater in the bottom left corner of the frame: evidence, perhaps, of an experiment that sought to consider how certain materials, including flesh—living or dead—may be altered or react to being air-dried, heated until liquid, or burnt.

Such a rudimentary search for order might be contrasted with, for example, the aural experiments of the late composer Karlheinz Stockhausen, who described his creative process—conversely—as an attempt to avoid or disallow the kinds of structure which are familiar to composition: "it is always the same thing that is sought and tested: the force of transformation—its effect as time: as music. So no repetition, no variation, no development, no contrast. All these presuppose *figures*—themes, motives—which are repeated, varied, developed and contrasted . . . all of this has been given up."[21] The creative aim is to systematically "free" sounds from numerous organizing structures (development, repetition, and so on), structures that are always *inherently relational*. What was perhaps attempted at this crime scene—and documented in these photographs—was the initiation of a process that might

be characterized as an inversion of Stockhausen's impulse, a project that began, it seems, without any relational language: it was precisely a set of basic restrictions or parameters that was being sought. A similar experiment—witnessed in a psychiatric ward—is recalled by Jim Ballard: "I watched an elderly woman patient helping the orderly serve afternoon tea [in a secure unit]. As the thirty or so cups were set out on a large polished table she began to stare at the bobbing liquid, then stepped forward and carefully inverted the brimming cup in her hand. . . . I like to think that what impelled her was a sense of the intolerable contrast between the infinitely plastic liquid in her hand and the infinitely hard geometry of the table, followed by the revelation that she could resolve these opposites in a very simple and original way."[22]

A striking example of such experimentation is revealed in the SIO's report on this case, which notes that the murder weapon—a knife—was found to have the victim's blood on it, but the knife *also* had strawberry jam on it.[23] Both of these substances have certain properties in common. Both are red, for example. Jam is even sometimes used as *fake* blood in photography, film, and theater productions. Jam is also usually spread with *a knife*: it is as if this killer had to personally evaluate the differences between these two initially similar substances.

The admixture at the center of the activity documented in these photographs included salt, wine, and flour. A food cupboard next to the body, which can be seen in the upper left-hand corner of photograph 4.7, has had numerous items removed from it, many of which have been incorporated into the physical space of experimentation. A fine white powder creates varied textures as it has been poured and sifted across the carpet, particularly where it is mixed with blood. Clumps of string and electrical cable are trailed across this background, book pages and numerous empty tobacco tins were added to this bizarre bricolage. And these diverse objects and materials *do* begin to gain a resonance: one that emerges out of a recognition of their contrasting qualities as they begin to form a language of textures, shapes, and so on.[24]

The interplay of elements such as those isolated in, for example, photograph 4.9 may be likened to a performance of the so-called Actionist artists who—in the 1960s—regularly made dauntingly destructive presentations (that included self-mutilation) in relation to other banal or monotonous activities.[25] In many of those harrowing works of performance art the central premise was to bring certain objects and substances into a relationship with the body—as a site and surface—that was not based on prior assumptions/expectations. The potential thresholds (or parameters) of the human body—pain or endurance, for example—were thus worked upon empirically, with only that which was actually ascertained or validated within the performance being of consequence.

But beyond these visceral activities we can also glimpse some attempts to incorporate words, as printed book pages, into the arena—for example, in photograph 4.10. Pages and parts of pages have been torn and hurled, trailed into the admixture: was this a recognition of the decisive power of language? It is as if this brutal researcher were asking: "Are words a material, an object—how can one physically interrogate words?"[26]

Continuing this consideration of psychosis, I can also elaborate a second key theme: the psychotic subject's tendency to implement a delusional system whereby a subject may come to accept—as a consequence of hallucination— an *organized* reality, but one that may be based on a bizarre premise. Thus the "formless" is replaced by "an order, which we shall call a delusional order."[27]

A hallucination is an entirely imagined event or communication that can be experienced as actually occurring, and can even come to dominate a subject's perceptions. In Lacanian terms these events/thoughts should not be considered as spontaneous or arbitrary, but as a makeshift solution: "the psychotic's attempt to 'paper over' the gap in the signifying chain."[28] Lacan described this mechanism as a "cascade of reworkings of the signifier from which the growing disaster of the imaginary proceeds, until the level is reached at which signifier and signified *stabilize* in a delusional metaphor."[29] But such a metaphor tends to be static rather than dynamic, and non-negotiable: psychotic delusion is fundamentally nondialectical. The delusional subject often feels that they are in possession of an unquestionable, fundamental truth, and a delusional belief system may therefore be contrasted with that of neurotics, who (as I will later elaborate) are, conversely, terrorized by doubt: "The neurotic [in contrast to the psychotic] is unsure, maybe the person was there, maybe not; maybe the voices are coming from some outside source, maybe they are not; maybe what they say has some meaning, maybe not. The neurotic wants to know: 'Am I crazy to be seeing (hearing) such things? Is it normal? How should I be viewing such experiences?' The neurotic has a certain distance from them [hallucinations]. The psychotic [simply] knows."[30] So evidence of a delusional *metaphor* might be recognized in, say, a crime scene photograph, through some detail that implies bizarre, unusual, irrational behavior, but, more specifically, behavior which also incorporates a dimension of certainty: a conceit which follows Nietzsche's proposition that "objections, digressions, gay mistrust, the delight in mockery are signs of health: everything *unconditional* belongs in pathology."[31] Substantiating Lacan's thesis, the FBI's Robert Ressler has observed that "schizophrenics characteristically take information from various sources and synthesize it in their minds, weaving it together in such a way that it makes a delusion and distorts the actual meaning of the information."[32] In his invaluable commentary on his own delusional world, Daniel Paul

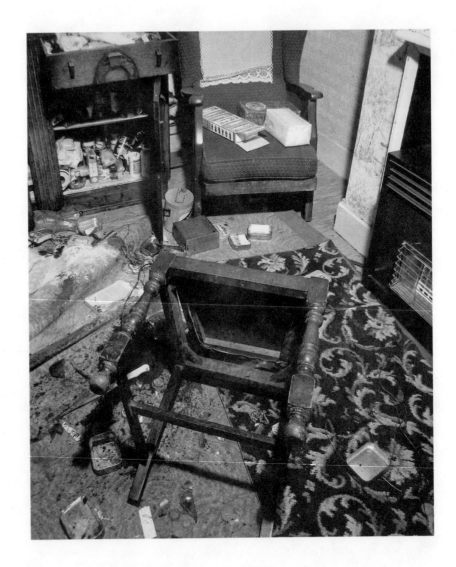

THE PSYCHOTIC CRIME SCENE

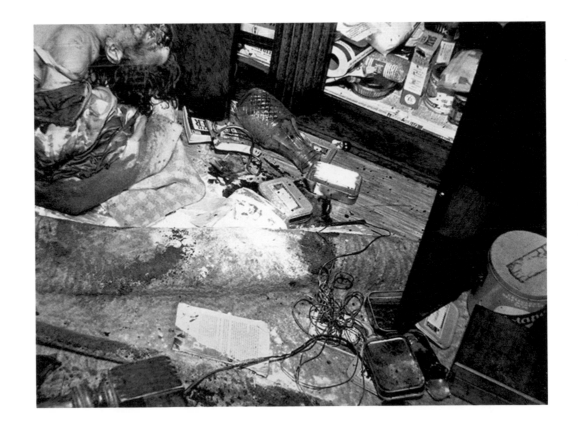

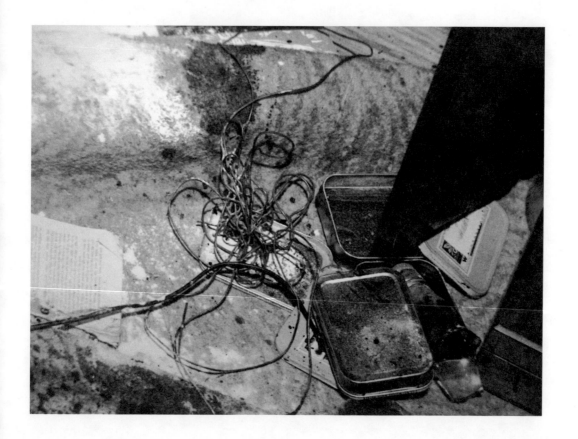

4.9

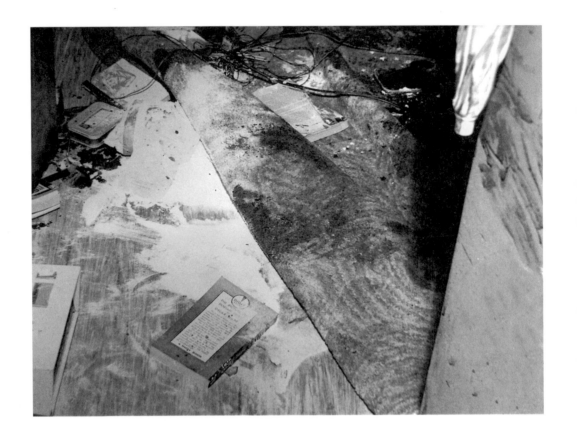

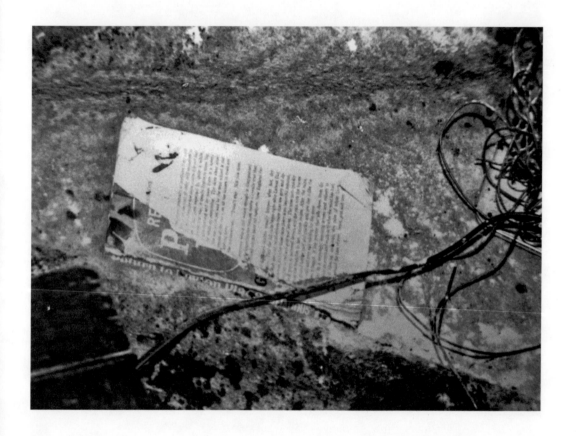

4.11

Schreber describes many distortions and inversions: "The souls to be purified learnt during purification the language spoken by God himself, the so-called 'basic language,' a somewhat antiquated but nevertheless powerful German, characterized particularly by a wealth of euphemisms—reward in the reverse sense for punishment, poison for food, juice for venom, unholy for holy, etc."[33] Such transformations of the everyday reformulate the commonplace in the same way that viewing a photographic negative of a familiar face or scene is disorienting—human skin tones are seen as a range of blue hues, dark areas of shadow appear as highlights, and so on.[34]

Returning to the theme of the banal or everyday object, I note an instance—in a case also discussed by Ressler—of how an ordinary object may become "doubly inscribed" in delusion in a way that is distinctively different from either the (perverse) transgressive object or the (neurotic) mystically infected object:

> [Richard Chase] admitted his murders, but said he had done them in order to preserve his own life. He told me that he was fashioning an appeal [against his conviction for murder], and that it would be based on the notion that he had been dying and had taken lives in order to obtain the blood he needed to live. The threat to his life was soap-dish poisoning. . . . Everyone has a soap dish, he said. If you lift up the soap and the part underneath the soap is dry, you're all right, but if it's gooey, that means you have soap-dish poisoning. I asked him what the poison did to him, and he responded that it turns one's blood to powder, essentially pulverizes the blood; the powder then eats at one's body and energies and reduces one's capacities.[35]

In this instance, an object as familiar—and banal—as a bar of soap actually came to signify as an object that held profound significance: however bizarre his belief, Richard Chase did not doubt the "message" that it seemingly communicated.[36]

In order to elaborate upon this theme, I want to consider the photographs of a murder that took place in Whiteley, near Sheffield, in 1955 (photographs 4.12–4.16). From photograph 4.14 it is evident that the mode of this killing was highly unusual: death occurred as a consequence of the killer sawing through the victim's throat. Photograph 4.12 records a scene as if illustrating a grotesque fairy tale like those by Jakob and Wilhelm Grimm, which are often set in the middle of a dark, *mysterious* forest; the bridge, too, echoes one that must be crossed in moonlight by the despondent and fearful children Hansel and Gretel.[37] The electronic flash used to make this photograph has illuminated the macabre scene unnaturally, highlighting the fact that this location is remote and isolated.

Successive photographs bring the viewer consecutively closer to this harrowing image; there is, however, no other side, no reverse shot offered.

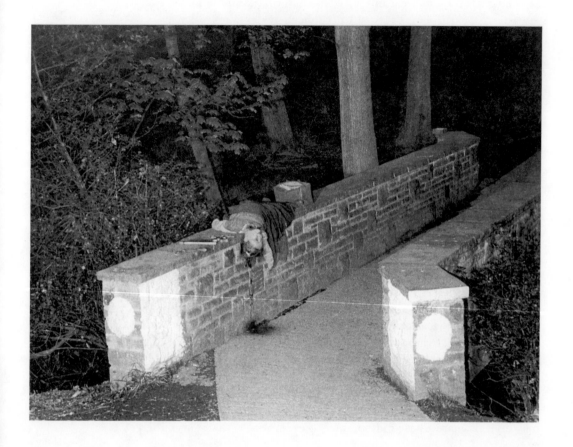

4.12

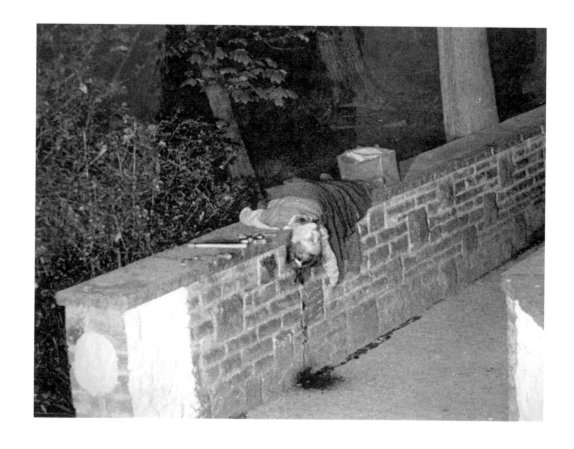

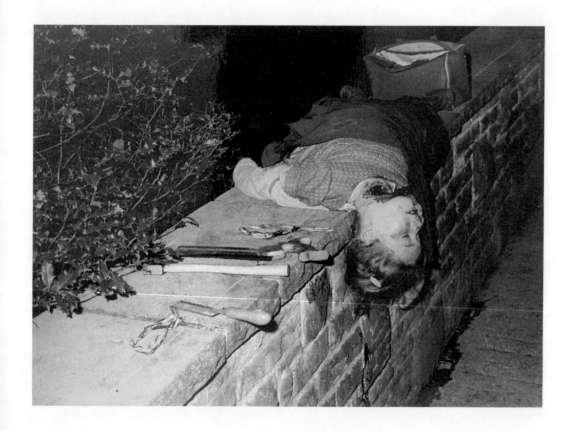

4.14

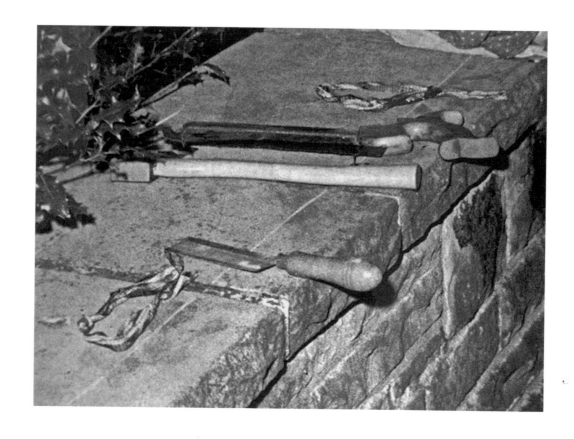

4.16

The angle of view is unchanging, constant. Two current London Metropolitan Police Scenes of Crime Officers, Nicky McAllister and Les Scott, have recently described their work: "we try to tell a story, we create a storyboard for every scene [that we photograph]."[38] And it is just such a narrative—or story—which seems truncated here: while documenting this particular scene, the SOCO seems to have been overwhelmed, caught up in the image in such a way that he repeatedly reiterated this one prevailing motif, incorporating only the variation of proximity. The photographer has not, for example, decided to circle around the scene, or introduce various perspectives or vistas. It is as if the scene can be read only one way, or *seen* only one way, as if it were dependent upon an entirely one-dimensional idea or thought. And it is just such a lack of controversy—a single-mindedness, if you will—that is characteristic of delusion.[39]

The detail that I highlight at this scene is the tool bag and tools isolated and enhanced in photographs 4.15 and 4.16. The choice of these tools as "murder weapons" is, I believe, highly significant: it is a bizarre choice. What is particularly striking is the manner in which the tools have been meticulously laid out. Such ordered preparation is reminiscent of a carpenter or a tradesperson organizing tools at work. From the details in the SIO's report it is clear that this bag of tools was brought to the crime scene quite deliberately, the female killer having made a specific journey to collect it from a friend's house earlier that evening.[40]

However, the reason or explanation for the presence of the tools in the narrative process that underlies this killing cannot be easily apprehended. It can be noted that there are, for example, none of the hallmarks of a sexual killing or evidence of regret—*undoing*. The crucial dimension or organizing detail in these photographs seems to be that any distinctive "key" is missing: like an esoteric ritual observed by the uninitiated, a clear explanation for this patently specific activity remains encrypted. Unlike the images of certain other cases that I have considered, what seems to be essential in a reading of this set of photographs is that the narrative cannot be adequately reinstated forensically. In the killer's confession statement, essential information concerning the events at the scene is also missing. Here, too, there is a gap: an interval or interspace that is emphasized by the inclusion of copious detail concerning the events leading up to and following the killing:

I should say it had struck ten o'clock when I got to the bridge. It was a very moonlight [*sic*] night and I went to the third house down from Mrs Rees's and found the saws in the wash-house. It had a sink in and a wringer stood there. I took them back to the bridge, also an axe which was fairly new, because it had a new handle. The wash-house had an electric switch on the left as you went in . . . I'm not going to give you a description of what happened on the bridge because I prefer not to.

My brown bag is still on the bridge. It was a bag my husband bought me. It was after what happened on the bridge I threw the pebble up to the window and heard Mr Rees ... I asked If I could see Betty and she came in after a while wearing a green dressing gown. I asked her for a drink and something to eat and she made me a cup of *Cadbury's Red Label Drinking Chocolate* ... I am not out of my mind or the least bit insane.[41]

The literary *punctum* is, of course, the killer's inclusion of the specific brand of post-murder beverage that she consumed, which—like her unclouded description of the wash-house interior—emphasizes the *lack of detail concerning the murder itself*. But what is the purpose of this preference not to disclose? The woman had already confessed, with considerable prima facie evidence all around. In relation to the Lacanian themes under consideration, it might be surmised that her predilection not to reveal an explanation was rooted in a wish, not to obscure the narrative time line of events, but to keep secure—to protect—her motivation: the true purpose of this ritual-like killing had to remain secret.

If I reframe that proposition in relation to the visual residue, it also seems significant—or noteworthy—that this secret activity was *also* performed by someone as if they were carrying out a job of work, as a carpenter or a mechanic might have: arriving at an appointed hour with tools that they then proceeded to set out for the task ahead. Thus, combining these two dimensions of *secret* and *work*, it seems tenable to propose that this photographic detail is one which documents the residue of a task that was completed as an obligation, or a duty: perhaps this murder was carried out by someone who was "at work," quite literally executing an instruction.[42]

This dimension of hallucination—of an instruction received, seemingly from without—is also invoked, in, for example, the courtroom testimony of Peter Sutcliffe (a notorious psychotic serial killer), who believed that he had been instructed to "clean the streets" (by killing prostitutes) through the voice of God: "I heard again the same sound. It was like a voice saying something but the words were all imposed on top of each other. I could not make them out, it was like echoes. . . . It had a terrific impact on me . . . I felt so important at that moment . . . I told no one because I thought that if it was meant for everyone to hear they would hear. I felt I had been selected."[43] For Sutcliffe, a fundamental quality of his delusion was the experience of having been supposedly chosen, and linked to this belief was the idea of a promise or a secret that also elevated him. An example of the potent force of such certainty is developed by Stanley Kubrick in his rendition of Stephen King's horror novel *The Shining*, in which there is no assertion of some (external) paranormal force, as King's original proposes. In Kubrick's version the visions that the protagonist Jack Torrance experiences—which finally

THE PSYCHOTIC CRIME SCENE

insist that he murder his wife and son—are not necessarily separable from some other reliable or rational state: Torrance *believes* the instructions of the characters that populate his delusional hallucinations; for him their wishes become unquestionable, no matter how irrational and macabre a course of action is proposed.

Returning to the notion of the signifying impasse that derails the annotation of photographs 4.12–4.16, it might be proposed that any decipherment would remain somewhat arbitrary, always unsatisfactory and "beyond belief" or beyond ordinarily comprehensible logic. For here is an example of an image that seemingly records the outcome of actions that had no basis in reality at all: actions that were, quite probably, "guided by voices."

In order to further develop this theme of delusion, I shall now consider a series of crime scene photographs that document the killing of two women in a textiles factory in Leicester in 1966 (photographs 4.17–4.20). In recording this scene, the police photographer has used only the diffuse "available light" that imposes or exaggerates a film-still-like quality—an instance, perhaps, of Golonu's premise that such images "come close to resembling stills from film noir classics"?[44] The absence of the many workers who would normally have tended these loud machines—the noise that greets the newcomer to many factory floors seems initially unbearable, like an inhuman torture—reinforces the setting as uncanny, recalling the climax of many zombie movies—in which the often harrowing last reel is regularly played out in an abandoned factory—or the settings so meticulously created in *Doom*, *Resident Evil*, or *Call of Duty*,[45] where the limited encounters are indeed with "fleeting-improvised-men."[46] The full-length protective tabard smocks and matching factory regulation mesh hairnets in which each of these women is dressed highlight their twinlike similarities. Such doubling or duplication recalls the photographic double exposure, the commercially "comped" image or the Rankian doppelgänger, and implies that beyond physical appearance—similarity—some other factor also might have bound these two women together; an understanding of which might be helpful in revealing the essence of the crime.[47]

From the SIO's report on this case, it can be ascertained that in the build-up to the killer's berserk outburst, the factory manager had received a complaint about him from one of his co-workers (but not from either of the two victims), and as a consequence he had instructed his works foreman to summarily dismiss the supposedly errant employee: a *fait accompli* that might easily have been perceived as unfair and one-sided, and resulted in the employee being dismissed *without explanation*.[48] In a Lacanian context such a factor is undoubtedly significant, for perhaps it was not the dismissal *per se* that proved unbearable for this hapless worker, but the question that the circumstances provoked (e.g., "Why me?" or "Why is this happening

4.17

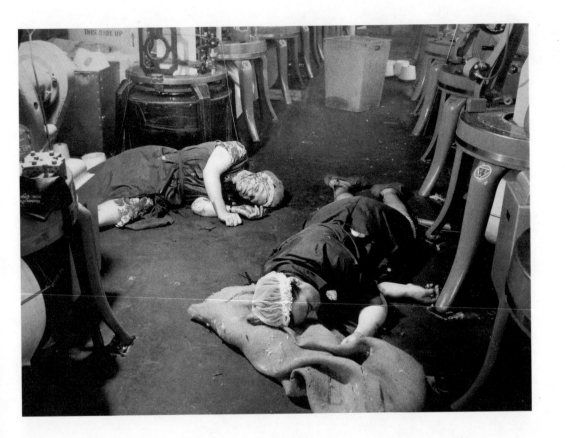

4.19

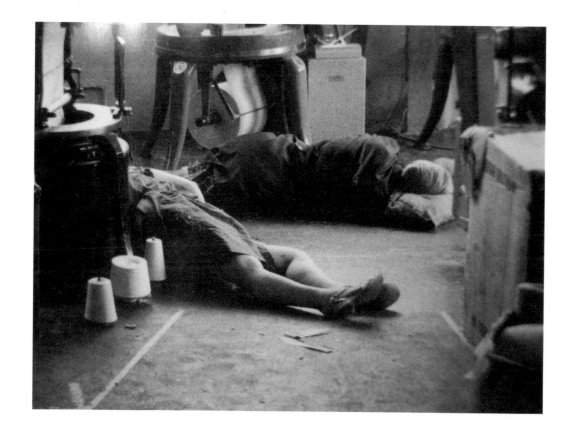

to me?"): a question that perhaps "brought him to the edge of a hole."[49] As Schreber implores his reader to acknowledge: "Where intellectual under-standing ends, the domain of belief begins; man must reconcile himself to the fact that things exist which are true although he cannot understand them,"[50] and this notion of reconciliation is precisely what the psychotic is defeated by.

In Christopher Nolan's film *Memento*, due to a malicious attack, the character Lenny cannot remember anything for more than a few minutes. His daily life is incomprehensible: he cannot make sense of anything he experiences (information is always unreliable, conflicted) until he develops an ingenious technique: he resorts to tattooing a series of known "facts" directly onto his body; these basic facts are the only information that he will accept as true. He survives in a world of "fleeting-improvised-men" by developing his own personalized—initially bizarre, but functioning—logic system.[51] Lenny's precarious logic barely allows him to negotiate daily life: it is a strategy for survival; for whatever reason, Lenny remains fundamen-tally excluded from the narrative events that continue around him. And it is in relation to this dimension of exclusion (from the symbolic arena) from which the idea of a massive, carefully organized, malicious conspiracy might emerge, a conspiracy that draws upon a familiar scenario: the "loser" in a group—a school, the military, etc.—who is relentlessly bullied: not in any physical sense, but through being ignored and excluded from all verbal communication—in all daily events, the victim is simply treated by his classmates as if he were not there. For the bullied "loser," their power to influence events through language is dramatically diminished: no one is listening.

And through the development of this organized—unjust—exclusion, it becomes almost inevitable that the victim might begin to seek out the source of the attack, assuming the mendacious presence of a figure that is capable of instigating or imposing the harmful situation. So, too, the delusional psychotic may incorporate the notion of a divine-like operator-being who watches and controls all.

This theme of some nebulous malicious authority that cannot be con-fronted is present in numerous psychotic and quasi-psychotic narratives such as Schreber's account, but also in narratives by Kafka and Burroughs.[52] In William Burroughs's novel *The Naked Lunch* (written under the influence of hallucinatory drugs), the notion of a unreliable malicious authority figure is introduced as the hostile, disingenuous Dr. Benway, "who had been called in as advisor to the Freeland Republic, a place given over to free love and continual bathing. . . . Benway is a manipulator and coordinator of symbol systems, an expert on all phases of interrogation, brainwashing and control

. . . the naked need of the control addicts must be decently covered by an arbitrary and intricate bureaucracy so that the subject cannot contact his enemy direct."[53]

It is the fact that the subject cannot retain some preset position—location—within the triangulated dialectic of castration ("cannot contact his enemy direct") that Lacan posits as the fundamental cause of the psychotic break: "[For the psychotic] the Name-of-the-Father must be summoned to that place in symbolic opposition to the subject . . . but how can the Name-of-the-Father be summoned by the subject to the only place from which it could have come into being for him and in which it has never been?"[54] And the consequences of this calling out to a place that has *never been* might be likened to a *meltdown* in a nuclear reactor, whereby an initially minor malfunction will quickly lead to massive, irrevocable destruction.[55]

Thus, returning to the specific imagery depicted in photograph 4.19, I propose that what this killer perhaps experienced as threatening, and hence worth attacking, was not either of these two specific employees, but something intangible: the *harmful words* that they exchanged between themselves, as if the killer launched an attack on language *as language*.[56] The S10's report notes that when the killer overheard the two women talking, they seemed to know all about his sacking; thus the logic of the killing was perhaps underpinned by a wish to stop a line of communication that was not only distressing but perceived as literally—physically—destructive.[57] For Lacan, the psychotic episode is characterized as "an abyss . . . a temporal submersion, a rupture in experience."[58] And, echoing Lacan's assertion, this man reportedly launched his attack with the following desperate cry: "What you want is a bomb to blow me off the Earth!"[59] This bizarre and extravagant statement appears to indicate the presence of a distinctive paranoia that has attached apocalyptic consequences to everyday events, so that factory-floor gossip is transformed into life-threatening utterances.

A further set of crime scene photographs—also seeming to indicate evidence of delusion—document a killing that occurred in Covent Garden, London, in 1968 (photographs 4.21–4.24). These photographs record a death that initially appears to be an assassination—a "hit." It is a scene which is almost stereotypical of this type of killing, often associated with so-called "gang-related" murders.[60] But the detail that I want to zoom in on here—in photograph 4.24—is initially prosaic: the depictions of the two calendars in the room. One is a large wall-mounted object, the other an at-a-glance calendar that displays the month. Checking this document against the S10's report confirms that this murder was committed on March 29—at around 6 p.m., after most of the staff had left work for the day. And the specific date/time may be of significance, for had the murder not been discovered *too early*, the company employees would have become aware of the incident

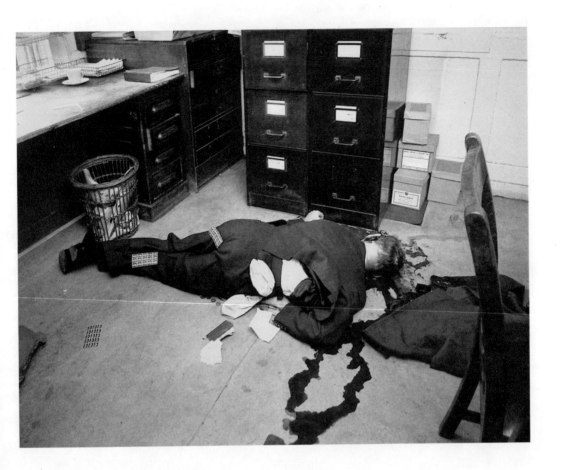

4.21

THE PSYCHOTIC CRIME SCENE

4.22

4.23

only when they returned to work after the weekend on April 1, or April Fools' Day: *the date as a message*—as a starkly disembodied fate or omen. A recent example of just such an abstracted metacommunication may also be noted in the circumstances of the attacks on New York's World Trade Center, and other targets. They were carried out on September 11, or "9-11" (the eleventh day of the ninth month), a sequence of numbers that is also the telephone number to be called from any telephone in the United States in order to report a sudden unforeseen crisis.

Such a blunt killing as the one depicted in these photographs does not initially seem to connect to the kinds of extreme or bizarre beliefs that may have illuminated the two previous cases considered. However, are not such *hit men* often referred to—and even revered—as "psycho" (a quasi-affectionate diminutive of "psychotic") or "nutter" (slang for crazy or insane)? Furthermore, such a killer does indeed take instructions from an intangible third party whom they *never actually meet*, and often works with the belief that, above all, the (secret) contract must be carried through no matter how illogical it may seem on the face of it (the inevitable killing of a close colleague or associate, perhaps). Thus, my argument here is that there can be no clear "professional" separation between delusion and organized crime: the hired assassin is often attracted to criminal activity only insofar as it enables the reification of a system that mimics delusion. Secretive fundamentalist "cells," cults, the so-called Cosa Nostra or the notorious Red Army Faction—initiated by Andreas Baader and Gudrun Ensslin—are all examples of organizations that seem to be structured in a way that is evolved out of the "architecture of psychosis," and thus also becomes inherently attractive to the psychotic: secret societies with a private knowledge or system that usually opposes and resists omnipresent dangers (e.g., "Imperialist Forces" or "The Family"): threats and attacks that are impossible to defend against because they emanate not from some identifiable enemy but from incalculable, insidious, "fleeting," and even invisible sources that are anywhere, everywhere. Many such organizations posit not the breakdown of any individual mind as the root cause for such beliefs but, rather, an evil—persecuting—force that is soon to realize an apocalyptic end-of-the-world-as-we-know-it global catastrophe.

Hence it is the theme of psychotic *certainty* that perhaps underpins this crime, which seems—on the face of it—to have been carried out by a clinical, calculating assassin.

The Neurotic Crime Scene

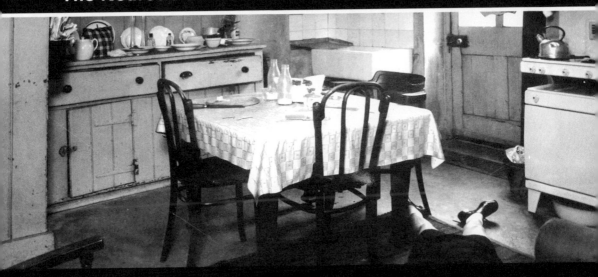

FREUD ASSERTS THAT "CONFLICT, REPRESSION, [OR] SUBSTITUTION INVOLVING A COMPROMISE, RETURNS IN ALL PSYCHONEUROTIC SYMPTOMS AND GIVES US THE KEY TO UNDERSTANDING THEIR FORMATION."[1] AND IT IS STRIKING HOW, WHEN CONSIDERING THIS THEME OF CONFLICT, CONTRIBUTORS AND COMMENTATORS HAVE OFTEN TURNED TO MILITARY TERMINOLOGY, ANALOGY, AND THE GENERAL LANGUAGE OF WARFARE TO DESCRIBE THE PHENOMENA PRESENT. FOR LEADER, "OBSESSION IS A BATTLE—A CONTRADICTION—A BATTLE BETWEEN CONSCIOUS AND UNCONSCIOUS, A WAR OF REPRESSION."[2] LACAN INVOKED A POTENT AND GRAPHICALLY VISUAL IMAGE WHEN HE OBSERVED THAT "THE I FORMATION IS SYMBOLIZED IN DREAMS BY A FORTIFIED CAMP, OR EVEN A STADIUM—DISTRIBUTING, BETWEEN THE ARENA WITHIN ITS WALLS AND ITS OUTER BORDER OF GRAVEL-PITS AND MARSHES, TWO OPPOSED FIELDS OF BATTLE WHERE THE SUBJECT BOGS DOWN IN HIS QUEST FOR THE PROUD, REMOTE INNER CASTLE WHOSE FORM (SOMETIMES JUXTAPOSED IN THE SAME SCENARIO) STRIKINGLY SYMBOLIZES THE ID."[3] AND THROUGH A CONSIDERATION OF THE DETAILS THAT I HAVE SELECTED TO EXPLORE IN THIS CHAPTER, THERE EMERGES EVIDENCE OF JUST SUCH A WAR: ONE WHICH MIGHT BE ALSO BE CHARACTERIZED AS A *WAR OF THE EVERYDAY* THAT IS WAGED BETWEEN TWO OPPOSING FORCES—OFTEN THE PARTNERS IN A MARRIED COUPLE, FOR INSTANCE. BUT IT IS ONE WHICH CAN ALSO BE LIKENED, NOT TO A THEATER OF WAR, BUT TO A COLD WAR: A WAR OF NERVES, ANXIETY, AND FEARS:[4] FEARS WHICH—LIKE THOSE THAT WERE HIGHLY CHARACTERISTIC OF THE "PARANOID" ATMOSPHERE OF THE COLD WAR—MAY BE COMPLETELY OUT OF PROPORTION TO ANY THREAT ACTUALLY POSED BY THE PERCEIVED ENEMY.[5] I STRESS THE THEME OF VIOLENCE—WARFARE—AND WHAT LACAN CALLED THE "IMMENSE MORBIDITY" OF NEUROSIS PARTLY AS A REACTION AGAINST THE DISPIRITINGLY FAMILIAR CLICHÉ— IN RELATION TO THE PSYCHOANALYTIC TREATMENT OF NEUROSIS—OF THE PATIENT WHO IS CHARACTERIZED AS, SAY, A WELL-OFF, COMFORTABLE, UPPER-MIDDLE- CLASS NEW YORKER. SUCH A CONCEIT IS OFTEN REASSERTED IN, FOR INSTANCE, THE FILMS OF WOODY ALLEN. THE CRUCIAL POINT IS THAT IN SUCH PARODIES ANALYSIS IS PRESENTED AS A SELF-INDULGENT PASTIME FOR A GROUP OF OTHERWISE BORED AND PROFLIGATE INDIVIDUALS. THE INSIDIOUS IMPLICATION IS THAT NEUROTIC SYMPTOMS DO NOT REALLY CONSTITUTE AN ILLNESS AT ALL.[6] THIS POPULAR MISPERCEPTION IS ENTIRELY AT ODDS WITH THE CLINICAL REALITY AND IS EMPHASIZED BY CLINICIANS, SUCH AS THE ENGLISH PSYCHOANALYST KAREN HORNEY, WHO ENABLE US TO COMPREHEND HOW NEUROTIC SYMPTOMS MAY BE TERRIFYING, DEBILITATING, AND MOST CERTAINLY LIFE-THREATENING.

In a neurotic subject, the symptom of compulsive action may be recognized as a defense against an anxiety-provoking thought.[7] Horney has asserted, for example, that "there is one essential factor common to all neuroses, and that is anxieties and the defenses built up against them."[8] Laplanche and Pontalis also state that "repressed material not only escapes destruction, it also has a permanent tendency to re-emerge into consciousness and it does so by more or less devious routes."[9]

DSM, too, recognizes a relationship between thought and action, the authors noting that "the [compulsive] person feels driven to perform a compulsion to reduce the distress that accompanies an obsession or to prevent some dreaded event or situation."[10] The analyst Dr. Juan-David Nasio has described the noxious quality of repression as "an inadequate

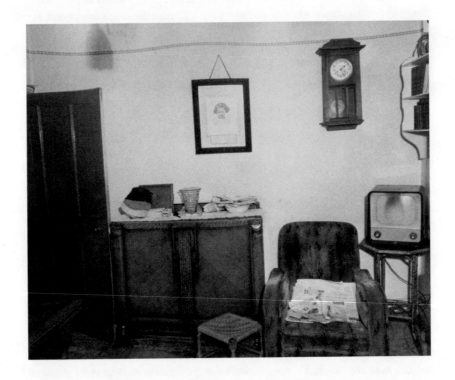

5.1

defense. . . . We may deem it just as unhealthy for the ego as the pathogenic representation it claims to neutralize."[11] Thus, repression might be likened to a toxin that, once inhaled or ingested, cannot be expelled from the body; the noxious substance slowly builds until a hazardous level is reached. This analogy emphasizes the chronic nature of neurosis and the insidious quality of repressed thoughts which—almost virally—attack daily life, finally producing a distortion that renders the quotidian decaying, isolating, absurd.[12]

In order to develop this theme in more detail, I want to consider the crime scene photographs that document a murder committed in Woodstock, Oxfordshire, in 1962 (photographs 5.1–5.5). Photographs 5.1 and 5.2 provide an overview of this crime scene—an almost generic 1940s interior. A typical-of-period tiled fireplace, fire guard, and upholstered lounge chair recall Orwell's introduction to "The Decline of the English Murder": "roast beef and Yorkshire [pudding] . . . have put you in just the right mood. Your pipe is drawing sweetly, the sofa cushions are soft underneath you, the fire is well alight, the air is warm and stagnant. In these blissful circumstances, what is it that you want to read about? Naturally, about a murder."[13] In his characterization, the contented reader's thoughts turn to murder at some appropriately relaxed moment. And this is quite different from the obsessional thought, which may be defined, rather, in terms of its pervasive quality: the obsessional neurotic is bombarded by unwanted thoughts, often in the form of fears or inhibitions. The Austrian psychoanalyst Wilhelm Stekel described, for instance, the way such thoughts will increasingly influence behavior, proposing a dynamic he called mystical infection: "If a taboo exists concerning certain objects, everything associated to the object also becomes taboo. [referring to a case study by Pierre Janet] In murder blood flows. A red tie reminds her [the patient] of blood. Her son who wears a red tie becomes taboo. The son sits down on a chair. The chair becomes taboo. The chair stands in a room. The room becomes taboo. The room is in a house. The house becomes taboo."[14]

The visual evidence I want to evaluate in this context is that of a seemingly pathological privileging of old newspapers that are placed on almost every flat surface of this home: on a window ledge (5.4), on and under a lounge chair (5.5), and on a sideboard (5.1), for example. Old newspaper pages were also used by the murderer in a feeble, unfinished, and unsuccessful attempt to clean up after this brutal killing (5.3).

In the 1960s, old or "yesterday's" newspaper pages were commonly reused for wrapping portions of "Fish 'n' Chips," stuffing wet shoes, or protecting an otherwise fragile surface (for instance, lining a drawer).[15] These pages might also be used when clearing ashes out of a hearth, or opened out to their full—A1—size in order to aid a recently lit fire to draw. During the period in which these photographs were made, the habit of retaining old

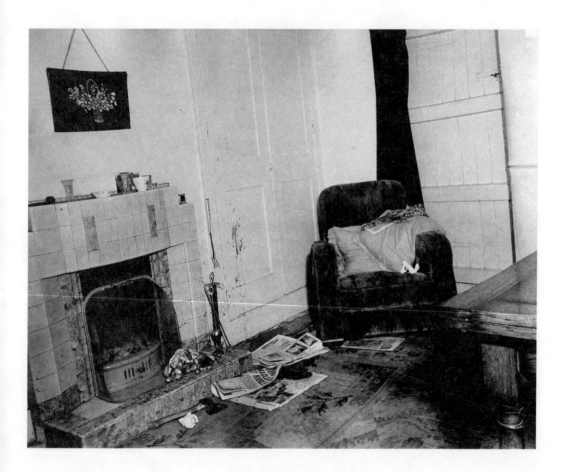

5.2

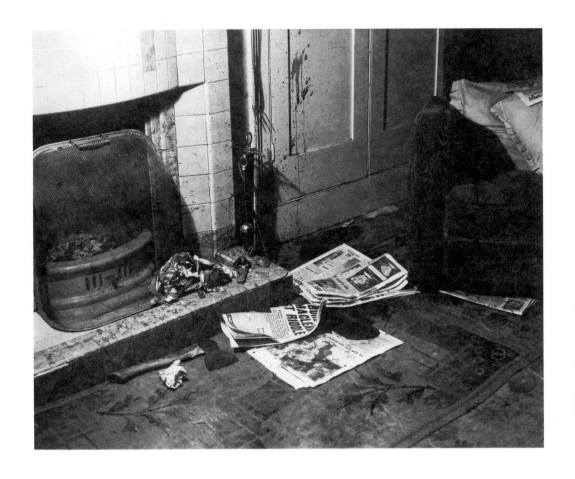

5.3

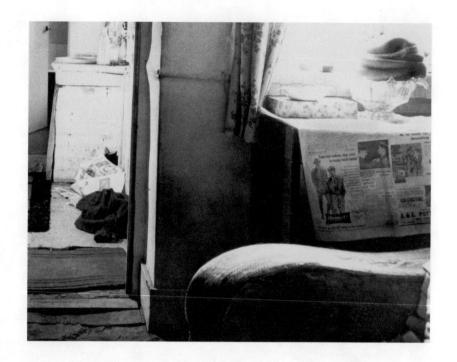

5.4

newspapers would have been completely commonplace. So it is not the presence of the papers *per se* that excites attention, but the fact that they have not been stored or put away: there are papers under chairs, strewn over the seat pads, placed in haphazard piles, a factor which becomes more significant when it is also observed that—unlike the interiors shown in photographs 4.1–4.5 and 4.6–4.11, which I annotated in terms of *the psychotic scene*—this interior is not otherwise chaotic. It seems that an ordinary activity has become distorted or mutilated in a manner that might be understood as an inversion of Stekel's mystical infection. In his example quoted above, an ordinary red tie is feared—and branded as taboo—on the basis that it provides a physical link to a murderous thought. As Stekel also noted: "The most tormenting compulsion disorders are those in which fear of a criminal impulse dominates the clinical picture. The most frequent form of this disorder is the fear of doing violence to a member of one's own family."[16] In these photographs it is as if the newspapers had the function of a totem: an object/material that, rather than being one which must be avoided, became instead one that *could not be absent*—a material which perhaps came to function as a physical embodiment of, and an index to, what might be described as *insurance* against some terrible event occurring. It is as if the implicit logic were that as long as old newspapers were present, a supposedly endangered person would be protected from the murderous impulses. But, furthermore, the specific image that did finally return—as the repressed must always—was that of "blood soaking into *newspaper*." Evaluating this factor in more detail, I note that an explicit function of a newspaper is to *document and report on the details of murder*, a factor which is emphasized in Alfred Harmsworth's apocryphal exhortation—to his staff at the fledgling newspaper the *Daily Mail*—to "Bring me a murder a day!"[17] During the period in which these photographs were taken, newspapers were the primary means of finding out about such crimes. Thus the significance of newspaper at this scene might be that it functioned to enable a repetitive obsessional checking: as if the subject felt a compulsive need to check the newspapers for a story about his own murderous actions that was manifested as his fear of being "in the papers." All the newspapers around were perhaps reassuring examples of newspapers which *did not* feature such a story, their presence seemingly ensuring his partner's safety—an omnipresent reminder of an exhortation that might have been formulated: "Take care—or you will be *all over the papers* [featured prominently] for killing your wife."

From the assorted loose collection the killer used one *in particular* to soak up (or blot) the majority of the blood that was seeping from his wife's head wounds, finally leaving it with a lead article clearly legible: "Burgess and Maclean Latest Riddle." The bold type refers to rumors which began to emerge in the press at this time (late in 1962), at the height of the Cold War,

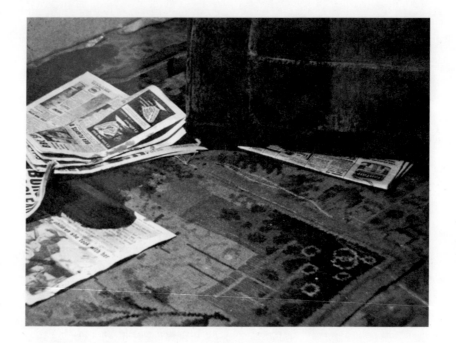

5.5

of a "Third Man," that is, a supposedly senior operator controlling the defected spies Guy Burgess and Donald Maclean.[18] The presence of such a detail might be evaluated as accidental or arbitrary; however, Freud was quite specific about the importance of such apparently minor occurrences. Considering this paradigm in relation to sartorial decisions, he stressed that "of significance to the physician, and worthy of his observation, is everything that one does with his [or her] clothing, often without noticing it. Every change in the customary attire, every little negligence, such as an unfastened button, every trace of exposure means to express something that the wearer of the apparel does not wish to say directly; usually he [or she] is entirely unconscious of it."[19] And, following Freud's observation, I interpret the choice of newspaper—residual in the mopping-up procedure—as containing a communication, but one that the subject *does not wish to make directly*: the newspaper story that seems to caption this crime scene concerns an unexpected traitor, and is not a husband who kills his wife indeed a traitor? To discover that your assassin is also the same person you share your intimate life with is surely to discover a treacherous act. Freud wrote: "obsessional neurosis presents a travesty, half comic and half tragic, of a private religion,"[20] and just as the spy's duplicitous activity comes to dominate their every thought and response—even to those seemingly closest to them—it is just such dark secrets (such as murderous thoughts) that the obsessional can never share, thoughts which—like the "sinful" thoughts of religious devotees— are rooted in a perceived need to control—or produce a deterrent against— any of the supposedly haphazard musings, daydreams, and associations that endlessly flicker across consciousness.

I have identified a further example of compulsive behavior in the photographs of a murder that took place in Fulham, London, in 1958 (photographs 5.6–5.8). Photograph 5.6 depicts a dead body at the top of a narrow staircase. Photograph 5.7 depicts a tabletop in a room on the ground floor of the same home, and it is the elements on that table which might be interrogated in order to illuminate this dispiriting scene—in particular, a stack of nine books. If we enhance this detail, we can observe that the stack includes *Close Quarters*, *A Corpse at Camp Two*, *Seven Wonders of the World*, and *The City in the Air*, with what appears to be a handwritten note.

The selection of books seems to indicate a voracious reader, a reader who regularly indulged in the repetitive genre scenarios of popular adventure and mystery novels. This type of writing, sometimes referred to as airport fiction or poolside fiction, is usually purchased (or borrowed) in relation to some preset block of time—to pass the boring hours of a journey, or days spent on a holiday sun-lounger. The plot, narrative, and characterization of such bestsellers are often formulaic, but—it might be argued—that is no defect: such books function only to engross the reader, they are mental chewing

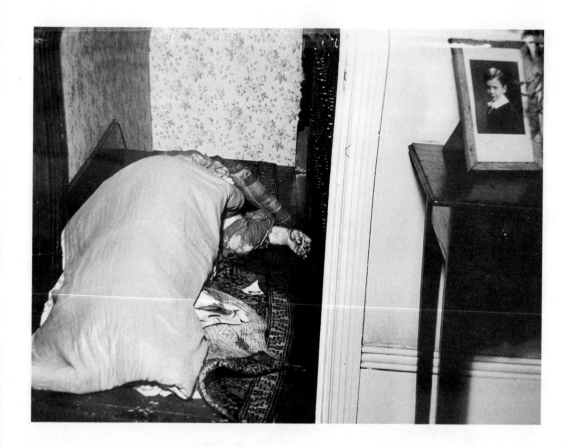

5.6

THE NEUROTIC CRIME SCENE

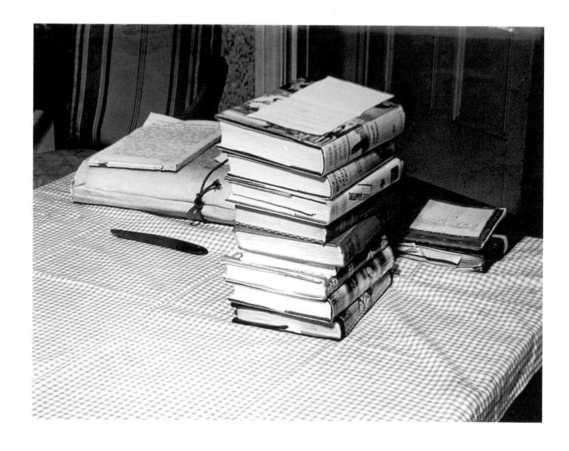

5.8

gum that primarily *distracts* attention and provides temporary relief from anxieties and worries that the reader would otherwise have *on their mind*.[21] This type of reader, it might be said, reads such books only in order to avoid thinking about *something else*: reading-as-ritual—one or two books of this type might be normal, nine implies some kind of exaggeration, suggesting that this reader's carefully organized activity might have functioned to distract a disturbed mind. It is as if unacceptable or unwanted compulsive thoughts could be blocked out by obliterating—laying over—an unending series of fictional disasters, adventures, and *journeys*, like a self-imposed or improvised version of behavioral therapy in which the patient is trained to consciously block errant thought patterns and replace them with others that have less damaging consequences.[22]

If we consult the Senior Investigating Officer's recommendation letter to the DPP, we can ascertain that these books were actually library books. And next to the books the murderer left a brief confession letter, but next to the confession is a written request that reads (in full): "Please return these 9 books to Fulham South Library."[23] Ordinarily, the mundane task of return-ing library books before they become overdue—along with other such minor errands and chores—might, in such stressful circumstances, be forgotten or overlooked. But, for this killer, the return of the books remained important: the return of the library books was—on one level—*a matter of importance equal to murder*. And if these books indeed functioned as an essential line of defense against compulsive murderous thoughts, then this request—that those unfortunate enough to discover his wife's body should also make a brief detour to his local library—may perhaps be understood as an expression of a deeper decision: to lay down the defensive strategy altogether—as if, in the act of giving it up, the return of a violent impulse became inevitable.

A second element that I want to highlight in this set of crime scene photographs is a detail that can also be seen in photograph 5.7. On the tabletop there is an object that appears initially to be a pen, but when it is enlarged/enhanced it is actually revealed to be a straight or cut-throat razor (a traditional blade used for shaving beard growth, now antiquated, which features an open blade). Its presence is seemingly inexplicable on this dining-room tabletop, while the SIO's report records his erroneous obser-vation, made when searching for evidence, that "it is [an object] that appears of no real significance."[24] However, the object is—following elementary Freudian technique—inherently important, because it is *out of place*. This type of razor, obviously intended for shaving beard growth, also has another, equally obvious, alternative use—as a lethal weapon. In this example the deceased was actually killed by several blows to the skull with a heavy object, the open razor was not utilized, but recognition of a second "backup" alter-native murder weapon indicates an affective state that Stekel defined as "the

characteristic symptom of compulsion neurosis . . . present in every case,"[25] that is, a state of doubt. The reification of this *sine qua non* of obsession is not the deadly razor *per se* but the prospect that the killer may have struggled to decide upon the modality—or modus operandi—of the murderous act, perhaps questioning the implications and consequences attached to each method in a vexing vacillation between two "options."

Such a self-imposed crisis recalls the debilitating conundrums that beset Freud's Rat Man, who, in "Notes upon a Case of Obsessional Neurosis," is shown to be constantly agitated by numerous much-debated obligations, rules, and exhortations—the issue of his girlfriend's safety in particular producing an opaque cycle of action and inaction: "On the day of her departure he knocked his foot against a stone lying in the road, because the idea struck him that her carriage would be driving along the same road in a few hours' time and might come to grief against this stone. But a few minutes later he was *obliged* to go back and replace the stone in its original position in the middle of the road."[26]

In "The Expelled," Samuel Beckett records an example of such thought processes: "There were not many steps. I had counted them a thousand times, both going up and coming down, but the figure has gone from my mind. I have never known whether you say one with your foot on the sidewalk, two with the following foot on the first step, and so on, or whether the sidewalk shouldn't count. At the top of the steps I fell foul of the same dilemma. In the other direction, I mean from top to bottom, it was the same, the word is not too strong. I did not know where to begin nor where to end, that's the truth of the matter."[27] The obsessional often isolates some calculation or decision that must be resolved, only to then be sidetracked and foiled by minute considerations concerning implementation, and this set of photographs seems to expose just such thoughts—thoughts that led not to inertia but instead to a disastrous course of action of the type that prompted Lacan to characterize neurosis as "very nearly that systematic refusal to acknowledge reality [*méconnaissance systématique de la réalité*] which French analysts refer to in talking about psychoses."[28]

A further Freudian theme that is cogent to any consideration of neurosis is the phenomenon known technically as *reaction formation*: the subject exhibits behavior that is an exaggerated, once-and-for-all, overcompensated inversion of an unconscious wish/drive. The logic of reaction formation is that the subject attempts to reduce anxiety by taking up a "single-issue" version of repression: the adoption of a "stock" position that is unnatural, robotic, generic—an example that is often given is that of a homophobic man whose inflexible anti-gay attitude and behavior actually mask unconscious homosexual desires: it is not the attitude to homosexuality that is decisive, but the inflexible quality of the categorically held opinion which is so

stubbornly cherished.[29] Laplanche and Pontalis defined the phenomenon as "a psychological attitude or habitus diametrically opposed to a repressed wish, and constituted as a reaction against it."[30] Thus, in seeking evidence of this theme in a crime scene photograph, the key must be a pictorial element that now carries significance that is *precisely opposite* to the "real" thought. Analyst Darian Leader says of this phenomenon, in relation to the act of photographing: "if you take a photograph of someone [such as a lover] that is sweet, cute. But if you take hundreds of photographs, that may mean that [unconsciously] you want to kill them."[31] And this theme may be expanded if we look at the photographs of a murder that took place in Bradford in 1957 (photographs 5.9–5.11).

Photograph 5.9 documents a murder that has taken place in a squalid interior: a series of interlocking carpet remnants look like worn paving slabs, as if the dead man were actually lying on a sidewalk, a gutter—as if his home offered no respite or shelter from the brutality of the street. In this room there is also a small table (see photograph 5.10), which "had been prepared for a man returning home from a day of labouring work":[32] a dinner table set for a lone diner by a seemingly organized and caring wife. Even without the imposition of a psychoanalytic perspective, an English meal table is very often rife—laden—with untold clues to the current state of household affairs: the cutlery, crockery, cruets, and so on recording a microcosm that may reveal much about the age, race, gender, or class of the owners.

The detail I have isolated in photograph 5.11 reveals a plate with chocolate biscuits that has been placed atop the gingham tablecloth, a selection that includes two Tunnock's caramel wafers and a Jacobs Chocolate Marshmallow. In a contemporary setting this assortment might be unremarkable, but it does become unusual when it is considered in the appropriate historical context.[33] In Bradford, in 1957, in a laborer's home—long before the expansion of choice, and in a period when basic groceries were generally unbranded, generic, and even rationed—this selection of biscuits may indeed be highlighted as remarkable: the person laying out this evening meal had, it seems, decided to present a generous selection for her husband's tea. She had decided—as such a gesture might have been described in the local idiom—to "give him a surprise," or "give him a little something extra."[34] But—as the SIO's report also qualifies—these refreshments were placed on the table by a woman who would, later that evening, murder her husband.

This carefully prepared meal table is not initially indicative of the tragic events to come, but perhaps it reveals instead a residue of reaction formation. To make sense of this detail it is necessary to infer that this setting, pleasant enough on the face of it and indicative of some heartfelt—or, at the very least, contentious—gesture was actually rooted in an unconscious effort to cover over (disguise) quite opposite thoughts that were also present.

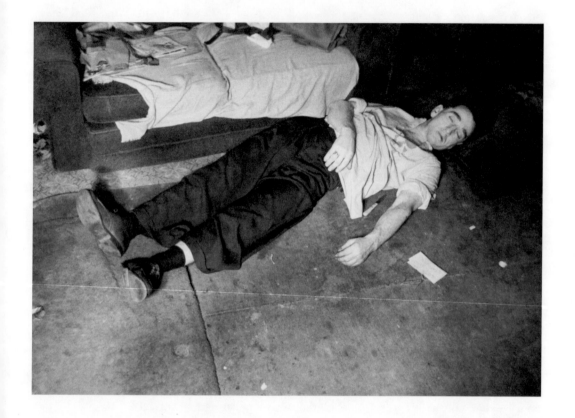

5.9

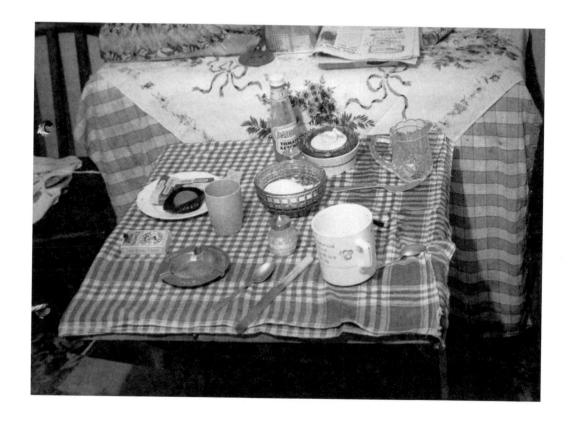

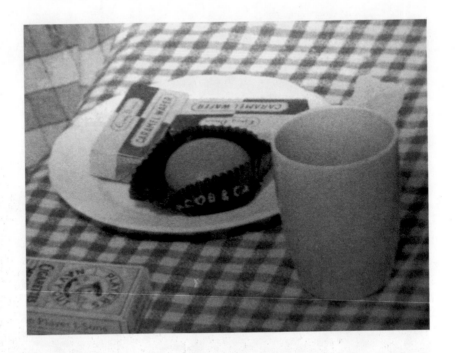

5.11

Is it not indeed the case that, very often, romantically involved couples have their most destructive arguments and disputes precisely when they are doing something that supposedly reinforces their attachment? How often a quiet candlelit dinner, a romantic country walk, or a surprise Valentine's Day gift choice—somehow predictably—serves to also highlight a couple's differences, or, more specifically, the aggressive (ambivalent) thoughts that are *also* directed toward the partner.

David Lynch's brief slow-motion preface to *Blue Velvet* commences with a series of shots that establish the setting for the film: a seemingly peaceful small town in the United States is introduced with an image of a traditional whitewashed picket fence/children crossing the road after school/local fireman waving in a friendly way from a fire truck/man watering a neat garden/woman sitting down to drink a cup of coffee while watching television.[35] Those reassuring scenarios work together to portray a wholesome and familiar provincial setting. However, the audience is not supposed to accept this proposal at face value; the series of vignettes is *too rigid*—these opening moments *actually communicate the exact opposite of what is on screen*, that is, that the film's theme will be an exposition on corruption, lust, terror, prostitution, torture, and so on.[36] To comprehend *Blue Velvet*, the viewer has to accept a priori a notion that Lacan was unequivocal in asserting: "The frightening unknown on the other side of the line is that which in man we call the unconscious, that is to say, the memory of those things he forgets. And the things he forgets are those things in connection with which everything is arranged so that he doesn't think about them, e.g., stench and corruption that always yawn like an abyss. For life after all is rottenness."[37] And, as David Lynch's opening sequence illustrates, the very danger is in the fact that certain thoughts and motives are covered over by a thoroughly unsustainable veneer.

In this way, a psychoanalytic reading of a crime scene photograph might also expose aggressive motives hidden or inverted in evidence of an apparently kindly act: in this instance the plate of biscuits offered seems to be an index to a dutiful and kindly attitude that was, perhaps, pathological—the detail that might once have read as an index or trace of a "loving wife" might also have been recoded—like Lynch's title sequence—as a warning, a danger signal.[38]

A second instance of this idea may be explored with reference to a series of crime scene photographs that document a murder committed in Eastbourne, Sussex, in 1955 (photographs 5.12–5.15). These photographs might have been useful historical documents of a provincial interior—note, for example, the early examples of Thonet chairs. Photograph 5.12 depicts a general view of an interior—a rough wooden Welsh dresser evoking an interior decoration style that is popular with those who hark nostalgically back to these supposedly simpler times, before the advent of our too-inauthentic

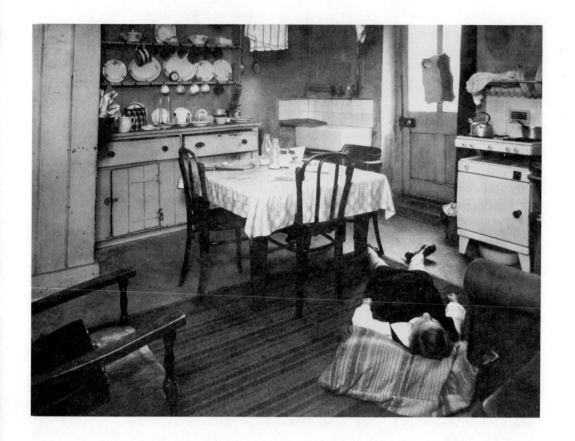

5.12

present—and these documents function successfully enough as an instant rebuttal to the fallacy that such an era was any less brutalized or depraved, since they also record the presence of a murdered child lying across this kitchen floor.

The naturally clear light of this crisp September morning, well captured in these photographs, evokes a subdued, reverent atmosphere, and contrasts with the technique of electronic fill-in flash, which so often sets a tone that highlights an invasive, probing examination—casting starkly irregular jagged shadows.

The SIO's report records that the murder was committed—at approximately 8.30 a.m.—by the child's legal guardian (her maternal grandmother). The remnants of their breakfast have not, it seems, been altered by the events of the murder (see photograph 5.13). The tabletop remains as if it were a traditional example of the still life or *nature morte*, in which each individual element of the composition *does* have an allegorical/symbolic meaning. Commenting on Gustave Courbet's 1866 painting *Le Sommeil* [The Sleepers], Hélène Toussaint writes: "The bunch of flowers on the unlikely side-table appears as if poised in mid-air. The square table and the vases on it are fascinating in their ugliness and morbid luxury. Here again Courbet cannot help expressing himself in allegorical terms . . . remorse or absolution is signified by the broken string of pearls trailing from the crystal goblet, in the same way as a snake emerges from the poisoned chalice in old pictures of the legend of St John the Evangelist."[39] Thus, in this still life, an allegorical style reading may determine that the open drawer is death/a coffin, while the milk represents maternal kindness—a sustenance that is ominously *finished*; the hairbrush symbolizes vanity, and so forth.

This is a familiar English breakfast table: two almost empty milk bottles, a butter dish, a teapot under a tea cozy, a breadboard and carving knife; but it is the hairbrush and hairpins that *sting me sharply*, and it is these details that I want to highlight—details that offer an index to the child having her hair brushed out and fixed for the day. Popular associations/connotations around this activity include, for instance, highly idealized ("cheesy") television dramas such as, say, *Little House on the Prairie* or *The Waltons*, in which a charming girl (perhaps dressed in a billowing nightdress) sits with a relative as her hair is combed out—yelping each time the brush encounters resistance. There is a special vulnerability and poignancy attached to this process—something which is also discernible in, for example, Edgar Degas's painting *La Coiffure*, a now clichéd postimpressionist painting that might literally be seen on a chocolate-box lid or pastiched in a low-grade advertisement.[40] The hairbrush remains as an index to the theme of parent and child involved in a personalized and intimate exchange—but such activities are frequently idealized as the "pretty small town" that Lynch exposes. Fenichel argues

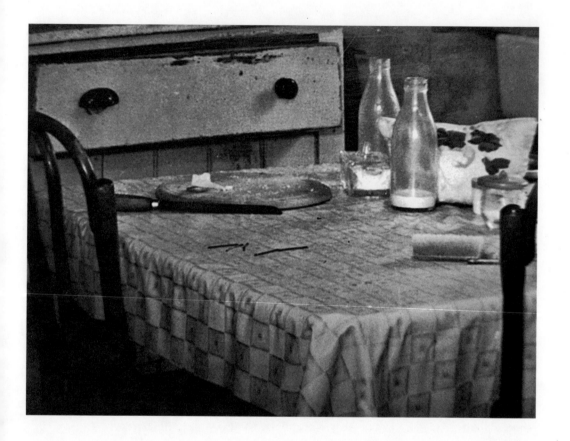

5.13

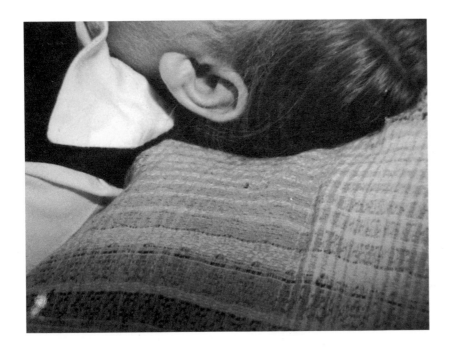

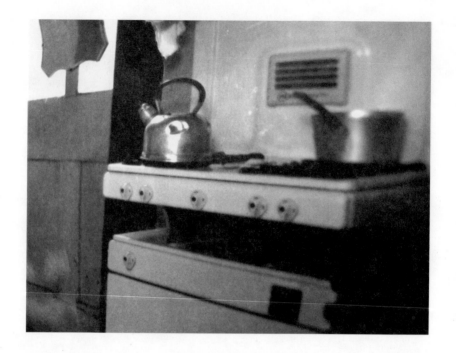

5.15

that "a hysterical [neurotic] mother who unconsciously hates her child may develop an apparently extreme affection for the child, for the purpose of making the repression of her hatred secure."[41] And—as with Lynch's sequence, discussed above—I argue that the key to these images is ambivalence: a co-existing, aggressive, destructive version of events—what might be charac-terized as an entirely charmless version of the same scenario. One in which, while brushing the girl's hair—with the departure time for school rapidly approaching—the child's guardian was overcome with an—inexplicable—urge to strangle the child.

The logic of reaction formation demands that the level of reaction or defense (against opposite unconscious feelings) will be proportional; thus the return of the repressed will emerge from a place which is heavily fortified with opposite affect, that is, at a moment when—perhaps—the child's inno-cence (and her guardian's pride) were privileged.[42] Indeed, this factor of ambivalence is confirmed in the SIO's report on this case: "The grandparents [the child's legal guardians] idolised their little grand-daughter, particularly the accused woman, who became very possessive as far as —— [the child] was concerned, so much so that the dead girl became really a spoilt child."[43] Thus it is revealed that the relationship between woman and child was indeed vexed: for is not a spoilt child, in effect, only the victim of *too much love*—a stultifying form of affection that cannot engage, but only gives more? The final *punctum* of this crime scene is encapsulated in a detail that is only partly discernible in the images: the girl was asphyxiated with a "soft crepe bandage" (partially visible in photograph 5.15)—this modus operandi is pointedly symbolic: the *spoilt* child complains, negates, and disputes with a—now silenced—voice.[44]

This Freudian trajectory of inner conflict exposes a narrative that evolves from thoughts and impressions that become unconscious, which in turn produce symptoms and may ultimately conclude in a failure of such attempts to defend or fend off the unconscious, which never vanishes, only seeps back. A level of anxiety is produced that can breach any defense—whether it be obsessional action (checking newspapers) or reaction formation (spoiling a husband or a child). The psychoanalyst René Laforgue has asserted that "beyond a certain degree of intensity it seems impossible for many people to bear anxiety indefinitely. There comes a moment when the subject desires peace at any price."[45] Karen Horney has also described a "rage which is removed from conscious awareness but it is not abolished . . . whilst it is split off from the context of the individual's personality, and hence beyond control, it revolves within him/her as an affect which is highly explosive and eruptive, and therefore tends to be discharged."[46] In *acting out*, the unconscious literally takes over or takes control—the unconscious as hijacker, temporarily wres-tling control of the joystick from an overwhelmed pilot.

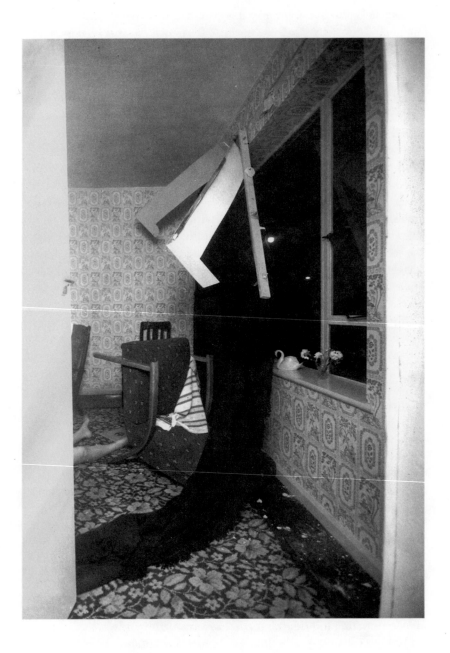

To consider this theme further, I want to introduce the crime scene photographs (5.16–5.20)—which document a murder that took place in 1958, in Doncaster. In photograph 5.17, the deceased appears to be lying in a garden of flowers—the detailed repeating pattern of flowering lilies suggests repose in a romantic garden; of course this is only a tawdry carpet, but the theme of courtship *is* apposite.

The SIO's report reveals that this murder was discovered while the perpetrator was still present at the scene, and he remained there. "'Has she gone?' said the accused. Mrs —— [a neighbor] told him to turn off the television. He did so and then crouched on the floor, put his head on the body, and wept."[47] In this instance, the typical narrative of the murder mystery—so often present in detective fiction or the thriller genre—is completely absent. Those investigating such a murder will often find that it is not necessary to apprehend the perpetrator; the assigned SIO has only to secure a confession statement from the killer, often a spouse or partner, who may well be found—as here—sobbing next to the corpse. This case again seems to incorporate a paradox or conflict: if you love someone, why would you kill them? And in order to elaborate an answer to that question, I highlight the pillow that has been placed under the victim's head (photograph 5.20) and the glass of water at her side (photograph 5.19).[48]

Having struck his partner with an apparently fatal blow, this man was instantly flooded with quite opposite affect, and immediately ran to get help: "The man [ran out into the street, stopping a passing car] said 'Can you get an ambulance quickly. I think my wife is dead. We've been fighting.'"[49] And the objects I have highlighted function to index several—alarmingly futile—attempts by the killer to undo the crime: in bringing the dying woman a pillow and a glass of water, the murderer seems to wish, hope, that the young woman will soon recover; he has begun to tend her as one tends the sick.[50] This phenomenon of capitulation is also recognized by CCM: "*Undoing* is the killer's way of expressing remorse or the desire to undo the murder . . . [it] is demonstrated by washing up of the offender and the weapon. The body may be covered up, but this is not for concealment purposes. Washing and/or redressing the body, moving the body from the death scene, and positioning it on a sofa or bed with the head on a pillow are all expressions of undoing."[51] But this theme of the seemingly rational person carrying out some irrational or disproportionate misachievement[52] is greatly illuminated if we scrutinize it in the context of the Freudian paradigm of acting out, whereby the remorseful actions—"undoing"—become indexical of the aggressor who has, as it were, regained control of their motor functions, following an action that was "carried out whilst in the grip of . . . unconscious wishes and phantasies"; and, as Laplanche and Pontalis reiterate, "the subject then, in the aftermath, behaves as if they have acted against their own wishes."[53] Criminal acts, such

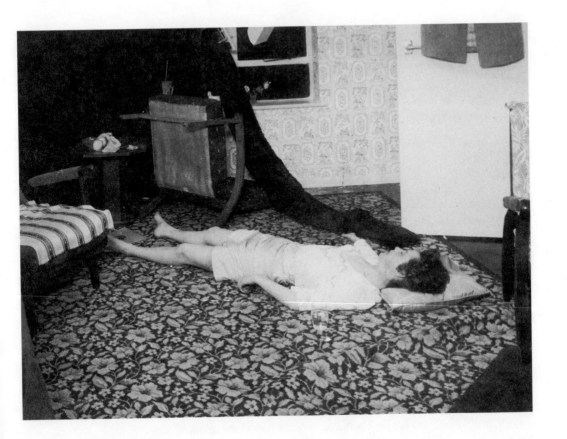

5.17

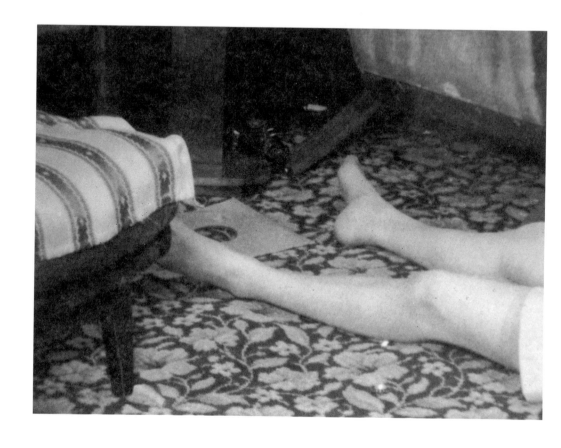

5.18

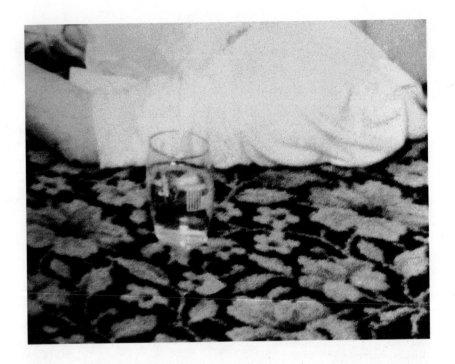

5.19

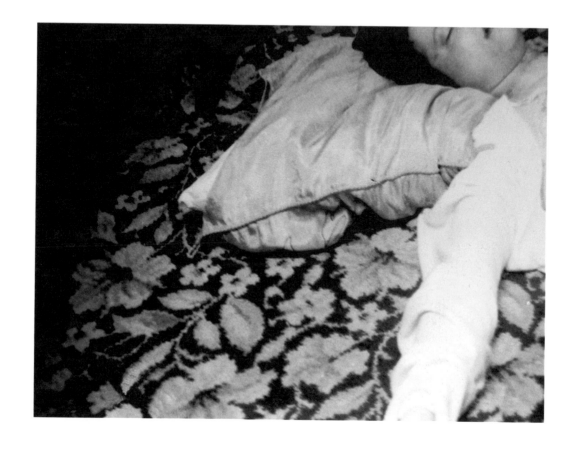

5.20

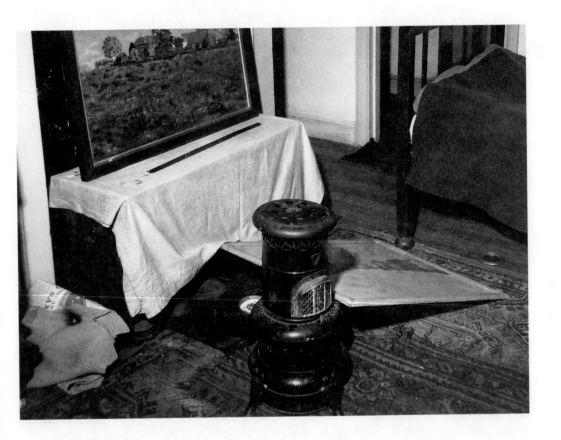

5.21

as the one recorded here, are comparable to a slip of the tongue or some other erroneously carried-out action: the structural explanation is the same. Examples of such mistakes offered by Freud are often incidental or charming—a broken ink bottle, jumping on the wrong tram—but the mechanism does not always produce consequences that are trivial or anecdotal.[54] David Ormerod notes from English law cases several murder trials in which the defense offered was that the action of the defendant was simply a *mistake*: one example involves the trial of a defendant who came home drunk and *accidentally* stabbed a friend who lay asleep in bed—he believed that he was stabbing a shop dummy. Or another trial in which the defendant—a nurse—placed a baby on a fire *thinking it was a log.*[55]

In his all too brief commentary "Criminals from a Sense of Guilt," Freud reveals that many apparently senseless neurotic criminal acts may be illuminated by interpreting them in the context of preexisting unconscious guilt: "Analytic work [has] brought the discovery that such [criminal acts] were done principally because they were forbidden, and because their execution was accompanied by mental relief for the doer. He [or she, the criminal] was suffering from an oppressive feeling of guilt, of which he [or she] did not know the origin, and after he [or she] had committed a misdeed this oppression was mitigated. His [or her] sense of guilt was at least attached to something."[56]

Another possible example can be seen in the photographs of a crime scene that depict a murder committed in 1962, at Burnham, near Slough (photographs 5.21–5.25). Photograph 5.21 shows one corner of what appears to be an informal living room which recalls Joel's description of his bedroom (at Miss Amy's house) in Truman Capote's *Other Voices, Other Rooms*: "The rug, which was bald in spots and of an intricately Oriental design, felt grimy and rough under his bare feet. The stifling room was musty; it smelled of old furniture and the burned-out fires of winter-time: gnat-like motes of dust circulated in the air."[57] It is like a nightclub, familiar in half-light and semidarkness, that is revealed—as bright end-of-session lights are turned on—to be surprisingly shabby. Here, too, the harsh illumination of the CSI's flash gun exposes a threadbare carpet, grimy surfaces, a squalid abode.

The detail that I have isolated is a domestic photo album that can be seen in photographs 5.23–5.25. Incongruously, it is located in the kitchen, next to the sink, surrounded by half-empty milk bottles, a teapot, jam jars, and so forth. Here again we have an object that is out of place, but this object does not seem to have been isolated, like the fetishistic shoe considered above; merely put down in haste, at an unplanned moment.

The significance of this disruption in the everyday is confirmed in the text of the murderer's confession document. Explaining how the events occurred on a visit to a friend's home, the man recalls that "he [the deceased]

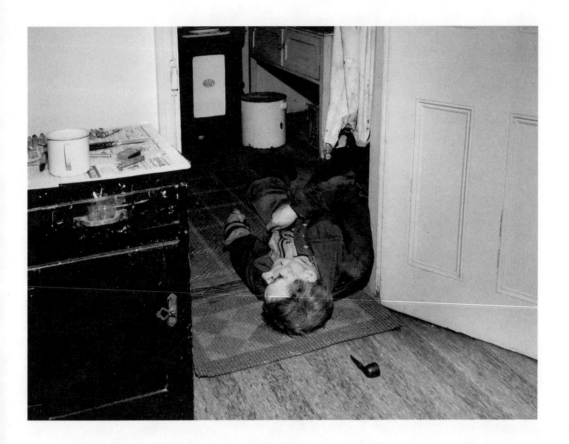

5.22

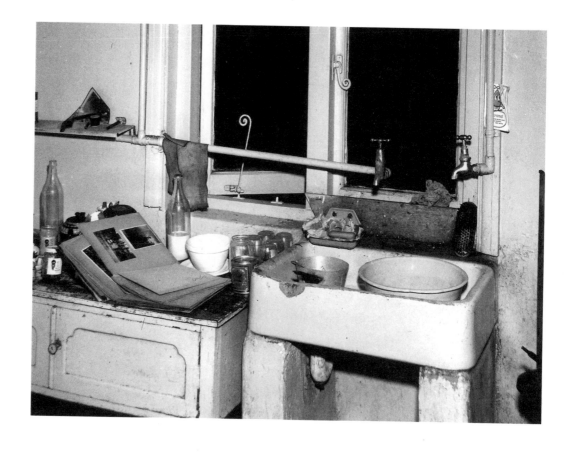

5.23

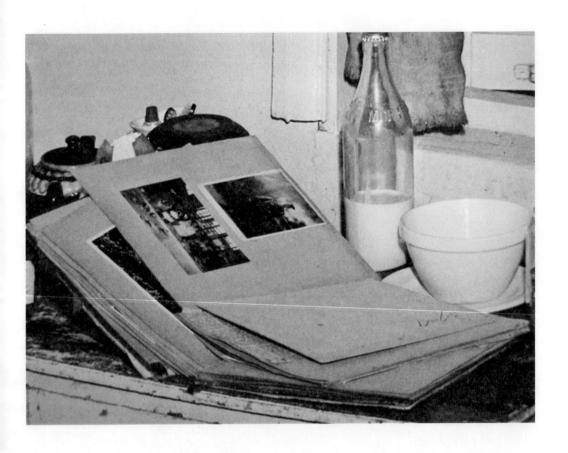

5.24

was on about his brother, he went into the kitchen to find a photograph of him. I followed him in. He went and got a photograph album, he brought it to me, and then turned his back to me . . . I stabbed him several times, he turned round and screamed."[58] The narrative of this murder is framed around two moments: first, the murderer was given a photograph to look at; secondly, the victim turned away. And this theme of a symptom/symptomatic act that is triggered by reading something (an image or words on a page) recalls a case history cited by Leader in which a woman suffered a (neurotic/hysterical) panic attack on a train. In that clinical example, the significance of the symptom was traced back—associated to—not, as might be expected, the motion of the train, the presence of another passenger, or some other physical object, but a passage in a book that the woman was reading: *a passage of literary description*.

I have enhanced and skewed the image in photograph 5.25 in order to reveal more clearly the subject matter: a studio portrait of an *army officer*. This discovery becomes significant in the context of the SIO's report, which records that the assailant had recently been forced out of the army with a dishonorable discharge.[59] So a familiar polite obligation to peruse another's dearly held keepsakes and souvenirs ("he was on about his brother") that may be unedifying, tedious, yet bearable for a majority was perhaps experienced—and transformed—by this attacker into "a feeling of defenselessness toward what is felt as an overpowering danger menacing from outside."[60] As Karen Horney argues: "[In neurotics] there is an imperative need to get rid of the dangerous affect which from within menaces one's interest and security . . . a reflex-like process sets in: the individual *projects* his hostile impulses to the outside world. The first *pretence*, the repression, requires a second one: he [the subject] *pretends* that the destructive impulses come not from him but from someone or something outside."[61] But it is not the story of this tarnished reputation that is central: the final—and characteristically Lacanian—*punctum* in this malodorous setting is the probability that neither player in this risible two-hander *consciously determined the events*, a factor that can also qualify any supposed arbitrariness; after all, this incident did not follow on from a dispute, an argument, or a drunken brawl, but came, conversely, quite out of the blue: one man's entirely inadvertent and innocuous provocation set in motion and triggered off in another a paroxysm that burst forth like a convulsive fit or seizure.[62]

Afterword

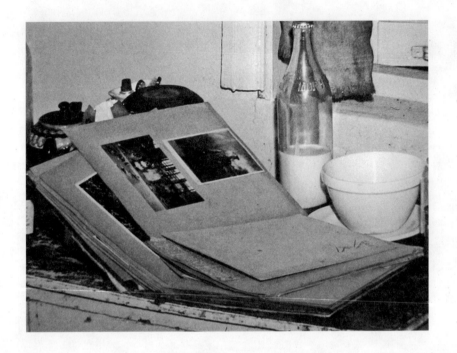

5.24

AFTERWORD

THE DEPICTION OF A PHOTOGRAPH IN A FAMILY ALBUM IN PHOTOGRAPH 5.24 ABOVE ALSO RECALLS JOHN WALKER'S WELL-KNOWN COMMENTARY ON THE SIGNIFICANCE OF CONTEXT IN PHOTO THEORY.[1] AND WITH AN AWARENESS OF THE POTENCY OF CONTEXT, I MIGHT REFORMULATE WALKER'S SENSE THUS: "CONSIDER A PHOTOGRAPH *OF A SOLDIER*, AND THEN THE VARIETY OF CONTEXTS IN WHICH SUCH AN IMAGE COULD BE ENCOUNTERED: IN A FAMILY ALBUM; FRAMED ON THE MANTELPIECE IN A LIVING ROOM; IN THE WINDOW OF A LOCAL COMMERCIAL PHOTOGRAPHER'S SHOP; IN A LOCAL NEWSPAPER. . . . "[2] FOR WALKER THE DIFFERENT IMAGES COEXIST, THEY ARE CONCURRENTLY ON DISPLAY IN THEIR VARIOUS SETTINGS. THE IMAGES I HAVE INTERROGATED IN CHAPTERS 1–5 HAVE ALSO BEEN AFFECTED BY CONTEXT, BUT CONTEXT AS A NARRATIVE: AS IF THEY HAD LITERALLY BEEN RIPPED OUT OF ONE AND PLACED INTO ANOTHER.

In photograph 5.25 there are three *generations* of documentary, each one removed from the next by a layering process, but also inextricably bound to it, in a chain of evidence whereby each one is also a verifiable document. Each level or generation is redefined only by a renewed need to create a document (a straightforward record). The original photograph documents an army officer (perhaps recently commissioned) standing in photo studio— as a formal record. A second generation of documentation was introduced by a SOCO tasked with the job of recording a murder scene as part of a police investigation. And, in a third "layer," this police material was, in turn, rephotographed as part of my research with macro close-up photography—as if the picture had been on a physical journey. And this *photograph of a photograph of a photograph* seems to be accordingly degraded, as if it were battered and bruised from its tour.[3] What emerges is an image that offers up/foregrounds a paradox: as a consequence of these ongoing attempts to create a neutral, objective document, each new layer has also incorporated an *ever-increasing distance* from the original event.

This basic photo problem is explored by Michelangelo Antonioni in his famous film *Blow-Up*: the more Thomas attempts to identify some ambiguous details he has spotted (at a crime scene) by enlarging a photo in a traditional wet darkroom, the more he is confronted by an increasingly confusing and infuriating picture.[4] As the film concludes, his "blow-up" has become entirely abstract; stark black-and-white patterns—the results of continual reprocessing—now dominate: the slick photos that Thomas makes as a professional fashion photographer (aspiration, *myth*) are replaced with an inquiry into photography that seems to "go nowhere." This notion of the image that recedes as it is prevailed upon is apposite in the context of this inquiry, too, since it is crucial to Lacan's key theme: the object that is searched for, longed for, will always be *just out of reach*.

Žižek—recalling Lacan's commentary on the gaze—describes how "the Object [*objet petit a*] can be perceived only when it is viewed from the side, in a partial, distorted form, as its own shadow—if we cast a direct glance we see nothing, a mere void. . . . The Object, therefore, is literally something

that is created—whose place is encircled—through a network of detours, approximations and near-misses."[5] And my search, or trawling, for insight and relevant interpretation in the above annotations is surely, too, only a series of detours, approximations, and near misses. As a part of the process of researching this book, I did physically visit—return to the scene of—several of these crimes *in reality*. I arrived always with an expectation of familiarity (having pored over the pictures for many a long hour) which was met—of course—with a bitter but inevitable enough truth: none of the places I visited even *existed* any more, having been replaced in many cases with new developments, office blocks, council facilities, and so on. In my disappointment I had to remind myself that my original interest in the crime scene was precisely its *inherent transience*.[6]

However, this project remains, above all, not a search for some (lost) object—or any neatly asserted outcome—but an exercise in *thinking psychoanalytically*. The art historian John Roberts, in considering Benjamin's exposition on the surrealist project, has argued that "to reconstruct the 'everyday' armed with psychoanalysis . . . was to engage in a fundamental battle over where art/photography stood in relation to realism. . . . Benjamin could see that [for the surrealists] the content of the photographic image was not contained by its phenomenal content, but could be written into other times and spaces, other histories." *Armed* with clinical psychoanalytic theory and my—perhaps gunlike—camera, I have articulated, elaborated, and evaluated some instances of these "other times and spaces, other histories."[7]

The photographs that I worked with are socially coded as *taboo*; thus one of the challenges presented to the researcher is to remain determined to take on and overcome the embarrassment, shame, and humiliation that can easily be associated with looking at these "gruesome," "gory" pictures which reside at the *limit* of photography. The unrelentingly extreme depictions of suffering may be likened to the repetitive literary descriptions of rape and torture provided by de Sade: appalling, yet arguably an essential cornerstone or reference point in the history of literature. The argument in favor of *not burning* Sade's books advanced by Simone de Beauvoir was based on a belief that it is "better to assume the burden of evil than to subscribe to this abstract good which drags in its wake abstract slaughter . . . in thinking that we are defending ourselves, we are destroying ourselves."[8] John Taylor makes a similar point when he observes: "failure to bear witness [to body horror] suggests that individuals enjoy a particular relationship with the present . . . choosing to forget the world of obligation which for them remains distant."[9] But beyond a socially encoded axis of "good versus evil," de Beauvoir, crucially, returns the argument to the individual: "what he [Sade] demands is that in the struggle between irreconcilable existences each one engage concretely in the name of his [or her] own existence."[10] Thus, whether it be

through further inquiry into de Sade's *oeuvre*, photojournalists' depictions of war, or a study of crime scene documents, it seems entirely plausible that engagement with this kind of material can, finally, enhance and extend our understanding of literature or photography. And, as a consequence of my inquiry, I have progressed from an initially awed—and repulsed—response to the crime scene material with which I was confronted to one which has been altered as a consequence of my activities—rephotography/the application of a Lacanian differential nosology. Through these interventions I have come to recognize in the images the motifs that are now distinctive and readily discernible to me. I have replaced a perplexed curiosity with intellectual clarification.

The technology available to the crime scene photographer has evolved dramatically since these photographs were originally taken, around fifty years ago: contemporary soco documents, with digital equipment and in color, typically recording a murder scene with hundreds of photographs—as opposed to the half-dozen that was normal for the cases I consulted—as well as a video walk-through; images which also have far greater resolution than those I have worked with here; together with recent advances in the reliability and clarity of the CCD, have thus rendered the groups of photographs that I have worked with almost quaint.[11] Yet in no way are these photographs obsolete or antiquated. Indeed, they are the most up-to-date archive currently available, and I have been the first (and to date, the sole) researcher to engage with them. Thus I am, literally, opening up this material for further discussion. As I have noted, depicting the crime scene has been a task *required* of the camera since photography's inception; thus it is inevitable that much of significance can be discovered through a sustained consideration of these images, and I hope that this text will indeed be a catalyst for further academic inquiry or, even better, some practical application of my thesis at the scene.[12]

Crime scene photography records what would ordinarily have remained private, personal, and often intimate—the victims would surely never have wanted anyone to look at these pictures. Commenting on his own experience with crime scene documents, Ralph Rugoff has reported: "rather than perusing color prints, I feel like I'm handling a dead man's belongings," and part of this taboo—as I have discussed—is the recognition (or repudiation of the knowledge) that viewing such objects has a voyeuristic dimension, or perhaps the realization of an unconscious wish to look where it is forbidden to look.[13] One of Nietzsche's most popular aphorisms asserts: "Wer mit Ungeheuern kämpft, mag zusehn, dass er nicht dabei zum Ungeheuer wird. Und wenn du lange in einen Abgrund blickst, blickt der Abgrund auch in dich hinein [Anyone who fights monsters should see to it that in the process he does not become a monster. And when you look long into an abyss, the abyss also looks into you]."[14] However, as John Taylor has commented, "The

professional use of the camera lens allows photographers to look at indecent subjects. This is not without personal cost or trauma, though photographers usually survive."[15] During this study I have looked at "indecent subjects" and "looked long into the abyss," and I too have survived the ordeal. I was led to these desolate places, seemingly paradoxically, through my ongoing interest in depictions of the banal, the ordinary, the gesture—daily life, and so forth. And it is a long-held fallacious belief in a neat divide between *the everyday* and *the extraordinary* that this study has corrected or resolved for me. The borderland between these two conveniently tagged "thematic areas" is unlike the—recently completed—undeniably imposing steel fence along Arizona's border with Mexico, and more like one along the network of winding narrow paths in the arid mountainous regions of the Hindu Kush, where the borders between Afghanistan, Turkmenistan, and Tajikistan are sometimes marked only by an improvised pile of rocks, or a rusting illegible sign hanging from a stunted tree—or, equally, the brightly lit yet unmemorable borders encountered along the generic concrete-and-asphalt high-speed autobahn routes of Europe, which (particularly at night) may prompt the tourist driver to inquire: "Which country are we in now?"

NOTES

Foreword

1. Available online at http://ebooks.adelaide.edu.au/p/proust/marcel/p96g/chapter1a.html.

2. Mladen Dolar, "Telephone and Psychoanalysis" (in Slovene), *Filozofski vestnik* (Ljubljana), no. 1 (2008), p. 12; I rely heavily on this text here.

3. Ibid., p. 22.

4. Ibid., p. 11.

5. Quoted from Richard Taylor and Ian Christie, eds., *The Film Factory* (London: Routledge, 1988), p. 92.

6. Darian Leader, *Stealing the Mona Lisa: What Art Stops Us from Seeing* (London: Faber and Faber, 2002), p. 142.

7. Gilles Deleuze, *L'Image-Mouvement* (Paris: Éditions de Minuit, 1983), p. 122.

8. Ibid., p. 81.

Introduction

1. Perhaps this whole vignette is influenced by memories of Peter Sellers's comic portrayal of the fictional French detective Inspector Jacques Clouseau.

2. Jacques Lacan, "Aggressiveness in Psychoanalysis" (1948), in *Écrits* (New York: Norton, 2006), p. 90.

3. I use the acronyms CSI and SOCO somewhat interchangeably to describe the team responsible for documenting the scene and collecting evidence from it. Those working in England are known as SOCO, while those working in the United States are CSI.

4. The purpose of these clothes is often misunderstood; the aim is not to protect the operative from harm, but to protect the scene from contamination by the operative's presence—the suit, gloves, and so on are part of a continuous process of minimizing the residues that the forensic workers bring to—or add to—the scene.

5. Specialized lens-based equipment includes the commonly used Leica DMR Comparison Microscope, the Leica DMR Comparison Macroscope, and the Leica DMRB Fluorescence Microscope.

6. A 35mm-style SLR camera with either a 50mm or 35mm lens attached is typical—the Nikon D3 is widely used for producing this type of material (12 mp CMOS).

7. The issue is known as *contaminating the scene*—individuals who were patently not involved with the events may diminish or destroy important evidence. The basic criterion followed is that, as far as possible, the scene

should remain untouched and unaltered until all forensic evidence has been gathered—a theme I return to several times in this study.

8. Roland Barthes, *Image, Music, Text*, trans. Stephen Heath (1970; London: Fontana, 2000), p. 65. Four years later—and only a few weeks before his death—Barthes said: "If photography is to be discussed on a serious level, it must be described in relation to death. It's true that a photograph is a witness, but a witness of something that is no more." (Roland Barthes, *The Grain of the Voice*, trans. Linda Coverdale [New York: Hill and Wang, 1981], p. 358.)

9. A notion that the writer Geoff Dyer also explores in *But Beautiful* (1998). The author reconsiders certain well-known photographic depictions from the history of the jazz scene. As he says in an introductory note: "Photographs sometimes work on you strangely and simply: at first glance you see things you subsequently discover are not there. Or rather, when you look again *you notice things you initially didn't realize were there* . . . for although it depicts only a split second the felt duration of the picture extends several seconds either side of that frozen moment to include—or so it seems—what has just happened or is about to happen." This approach to the "narrative" of a still image led Dyer to construct a series of short stories that describe the possible events—before and after—the selected photograph. See Geoff Dyer, *But Beautiful* (London: Abacus, 1998), pp. xi–xii; emphasis added.

10. William Burroughs, *The Job* (London: John Calder, 1969), p. 19.

11. László Moholy-Nagy, *Painting, Photography, Film* (1924; London: Lund Humphries, 1969), p. 28.

12. For a contemporary account of the extraordinary possibilities of these photo technologies, including thermal imaging and so on, see Michael Marten et al., *Worlds within Worlds* (London: Secker and Warburg, 1977).

13. Walter Benjamin, "Little History of Photography" (1931), in *Selected Writings*, ed. Michael Jennings, Howard Eiland, and Gary Smith, vol. 2 (Cambridge, Mass.: Harvard University Press, 1999), p. 510. Benjamin's passage has been cited by many other writers on photography including Ulrich Baer, Geoffrey Batchen, Rosalind Krauss, Peter Wollen, and Martin Jay. The casual reader might assume that researchers in this field are quite lazy and unoriginal in their regular citations from Benjamin and Barthes; this, however, would be a fallacy: the themes raised by these two scholars during their considerations of the "status" of the photograph remain cogent, and are, I would argue, still key to any discussion of the medium. They have positions similar to Schoenberg and Stockhausen in the scene of modern music—they are predictable names but so . . . unavoidable.

14. Jacques-Alain Miller, "An Introduction to Seminars I and II: Lacan's Orientation prior to 1953," in Bruce Fink, Richard Feldstein, and Marie Jaanus, eds., *Reading Seminars I and II* (Albany: State University of New York Press, 1996), p. 17.

15. Edgar Allan Poe, "The Murders in the Rue Morgue" (1841), in *The Complete Crime Stories* (London: Orion, 2001), p. 21.

16. Maurice Blanchot, "Two Versions of the Imaginary" (1955), in *The Gaze of Orpheus and Other Literary Essays* (New York: Station Hill Press, 1981), p. 84. The paradox for Blanchot is that the person has *gone*, but is also inexplicably still present.

17. The theme of the cadaver physically altering the space around it is also raised in this description of a crime scene by the American novelist and screen-writer Ray Chandler: "The shutting of the French doors had made the room stuffy and the turning of the Venetian blinds had made it dim. There was an acrid smell on the air and there was too a heavy silence. It was not more than sixteen feet from the door to the couch and I didn't need more than half of that to know a dead man lay on that couch." (Raymond Chandler, *The Long Good-Bye* [1954; London: Penguin, 2000], p. 215.)

18. There are many crime scene photographs where a tension between *everyday* object and *shocking* cadaver is not initiated: an injured person may attempt to seek help and leave the scene; a dying person may be discovered by a member of the public and carried away; a crime scene may be, say, a crowded dance floor or a busy street which often cannot be adequately preserved. In such instances photographs are often made only later, and may therefore document only an unremarkable landscape or street scene. A murder may also have two key locations: the site of the original murder and the so-called "dump site," where the body is disposed of.

19. In the popular—forensics-themed—television drama series *CSI*, such details are often highlighted by the tight beam of a six-cell Maglite inspection torch—a motif that is well established in the show's distinctively formulaic visual repertoire.

20. "Richard Prince Interviewed by Larry Clark," in Lisa Philips, ed., *Richard Prince* (New York: Whitney Museum of American Art, 1992), p. 129.

21. In a paper written in 1933, Lucien Febvre notes: "When a historicist looks through the lens of his microscope, does he immediately grasp the raw facts? The essence of his work consists in creating, as it were, the subjects that he observes, often with the assistance of exceedingly complex techniques; and then, once he has acquired these subjects, 'reading them,' 'reading' his prepared specimens. A daunting task, in truth. Because to describe what one sees is one thing; but to see that which must be described, that is the hard part." (Lucien Febvre, "Leçon d'ouverture au Collège de France, 13 décembre 1933," in *Combats pour l'histoire* [Paris: Librairie Armand Colin, 1992], p. 8; cited in Carlo Ginzburg, *The Judge and the Historian*, trans. Anthony Shugaar [London: Verso, 1999], p. 37.)

22. Cornell Woolrich's fictional photojournalist Hal Jeffries witnesses a murder through a camera lens while engaged in voyeuristic activities, and admits: "Sure, I suppose it was a little bit like prying, it could have been even mistaken for the fevered concentration of a Peeping Tom." See Cornell Woolrich,

"It Had to Be Murder" (1942), in *Armchair Detectives*, ed. Peter Haining (London: Mammoth, 1977). The story was later dramatized and filmed by Alfred Hitchcock as *Rear Window* (1954)—the character of Hal Jeffries was rewritten as the convalescent photographer L. B. Jeffries. Brian de Palma's later film *Body Double* (1984) also reuses/utilizes this basic theme of the photographer-as-voyeur-as-witness. William Burroughs also elaborates on it in a text included in "Lee's Journals." In his conception, a photo-voyeur witnesses a murder and photographs it. He then uses the evidence only to blackmail and humiliate the perpetrator. See William Burroughs, "Lee's Journals," in *Interzone* (c. 1951; London: Penguin, 1989).

23. Rosalind Krauss, *The Optical Unconscious* (Cambridge, Mass.: MIT Press, 1993), p. 179.

24. Krauss's book is not, in any case, conceived as a sustained study/investigation of Benjamin's/Moholy-Nagy's concept, but is actually an appraisal of various works of art by Bellmer, Giacometti, Duchamp, Picasso, and Ernst. Krauss actually notes: "My own use of optical unconscious, as it has been invoked in the pages of this book [*The Optical Unconscious*], is thus at an angle to Benjamin's. If it can be spoken of at all as externalized within the visual field, this is because a group of disparate artists have so constructed it there, constructing it as a projection of the way that human vision can be thought to be less than a master of all it surveys, in conflict as it is with what is internal to the organism that houses it." (Krauss, *The Optical Unconscious*, pp. 178–179.)

 It is also worth pointing out that Krauss's interest in psychoanalysis appears—in that book—to be a specific focus on the domain of neurosis (a struggle between the competing forces of the unconscious and consciousness), and it may be useful for the reader to be aware that the theme of repression is *only one* paradigm of psychoanalytic theory. It is important to note that such a conflict is not always primary: sometimes we encounter no conflict between the unconscious and real-life action (perversion) or, indeed, we also encounter the absence of an unconscious altogether (psychosis).

25. Barthes, *The Grain of the Voice*, p. 352. Benjamin precisely foreshadows Barthes's later conceptualization of the *punctum* when he describes his aim, while looking at a photograph: "the beholder feels an irresistible urge to search . . . a picture for the tiny spark of contingency, of the here and now, with which reality has (so to speak) seared the subject, to find the inconspicuous spot where in the immediacy of that long-forgotten moment the future nests so eloquently that we, looking back, may rediscover it" (Benjamin, "Little History of Photography," p. 510).

26. J. G. Ballard, *The Atrocity Exhibition*, rev. and annotated ed. (1969; London: Flamingo Classics, 1993), p. 37. Ballard is commenting on the casual reuse of many initially horrifying images made by photojournalists during the Vietnam War.

27. Barthes also notes that "there is no punctum in the pornographic image; at most it amuses me (and even then boredom quickly follows)." (Roland Barthes, *Camera Lucida* [1980; London: Vintage, 2000], p. 59.)

28. Barthes, *The Grain of the Voice*, p. 352.

29. The complete series of paintings is reproduced—using superior-quality offset-litho printing—in Robert Storr, ed., *Gerhard Richter: October 18, 1977* (New York: Museum of Modern Art, 2000).

30. In the same passage Sante also notes: "evidence is a magnet of the random. It is precisely those objects that inspire contempt, if we think of them at all in the course of daily usage, that are most likely to seem poignant when drawn into the circle of evidence by association" (Luc Sante, *Evidence* [New York: Noonday Press, 1992], p. 62). Of course, it is the notion of the—supposedly—*random* that I am negotiating throughout this text.

Chapter 1

1. See Michel Frizot, ed., *The New History of Photography* (Cologne: Könemann, 1994).

2. Ian Jeffrey, *Revisions: An Alternative History of Photography* (Bradford: National Museum of Photography, 1999). Some of the most well-known books that have propagated the notion of the master practitioner's *oeuvre* include: Helmut Gernsheim, *A Concise History of Photography* (New York: Dover Publications, 1965); Beaumont Newhall, *The History of Photography* (1937; New York: Museum of Modern Art, 2002); John Szarkowski, *Looking at Photographs* (1966; New York: Bulfinch, 1999). For a far more comprehensive list of such studies, see Geoffrey Batchen, *Burning with Desire: The Conception of Photography* (Cambridge, Mass.: MIT Press, 1997), p. 222.

3. In highlighting this omission it is not my intention to undermine the validity of this useful addition to the literature.

4. Gail Buckland, ed., *Shots in the Dark* (New York: Little, Brown, 2001); William Hannigan, ed., *New York Noir* (New York: Rizzoli, 1999); Deborah Aaronson, ed., *Scene of the Crime* (New York: Abrams, 1994).

5. Buckland, *Shots in the Dark*, p. 48.

6. Mike Mandel and Larry Sultan, *Evidence* (1977; New York: Distributed Art Press, 2003), unpaginated; emphasis added.

7. Sandra Phillips is also the editor of the glossy—and fairly purposeless—*Police Pictures* (San Francisco: Chronicle, 1997).

8. Berin Golonu, *To Protect and Serve: The LAPD Archives* (Los Angeles: Yerba Buena Center, 2003), p. 1.

9. Gail Buckland, "Crime Photographs," in Buckland, ed., *Shots in the Dark*, p. 41.

10. Harold Evans touches briefly on the underlying theme when he notes that "crime photographers . . . risk being denounced for giving us what we secretly [unconsciously?] want" (Harold Evans, "Looking Photography Squarely in its Disturbing Eye," in Buckland, ed., *Shots in the Dark*, p. 11).

11. Personal communication (e-mail, 2005). I was prompted to make this request after reading his short essay "A Camera as Rare as a Pink Zebra," in Phillips, *Police Pictures*. In that brief text the author notes, as I also do, the relationship between the history of photography and the history of detective fiction; however, Haworth-Booth's incomplete—and poorly annotated—time line overlooks the crucial contributions of Atget, Benjamin, and numerous others.

12. John Taylor, *Body Horror: Photojournalism, Catastrophe and War* (Manchester: Manchester University Press, 1998); Ulrich Baer, *Spectral Evidence: The Photography of Trauma* (Cambridge, Mass.: MIT Press, 2002); Wendy Lesser, *Pictures at an Execution* (Cambridge, Mass.: Harvard University Press, 1993); Ariella Azoulay, *Death's Showcase: The Power of the Image in Contemporary Democracy* (Cambridge, Mass.: MIT Press, 2001); Jay Ruby, *Secure the Shadow: Death and Photography in America* (Cambridge, Mass.: MIT Press, 1995). Baer's study considers photographic documentation of psychiatric conditions from the archive of the Salpêtrière hospital in Paris. It also adds an important study of the photographic archive of the Nazi Walter Genewein—whose personal "amateur" photographs documented the Łódź ghetto—to the existing literature. However, I am obliged to rebut his absurd comment that "the power of images remains a stumbling block in psychoanalytic theory" (p. 182). This assertion is without foundation, whether made in the context of Freud or of later contributors, and indeed, the opposite is true: psychoanalytic theory was actually evolved out of a belief in the power of the image and an ongoing recognition of its centrality in the human mind.

13. Sue Taylor, *Hans Bellmer: The Anatomy of Anxiety* (Cambridge, Mass.: MIT Press, 2000); Eugenia Parry, *Crime Album Stories* (Zurich: Scalo, 2000); Luc Sante, *Evidence* (New York: Noonday Press, 1992); Joel Sternfeld, *On This Site* (San Francisco: Chronicle, 1996); Ralph Rugoff, ed., *Scene of the Crime* (Cambridge, Mass.: MIT Press, 1997).

14. Nicole Ward Jouve, *"The Streetcleaner": The Yorkshire Ripper Case on Trial* (London: Marion Boyars, 1986); Brian Masters, *Killing for Company: The Case of Dennis Nilsen* (London: Jonathan Cape, 1985); Gordon Burn, *Happy Like Murderers* (London: Faber and Faber, 1998). On the subject of creative writing/literature, Roy Hazelwood (the celebrated FBI "Mindhunter") says: "I used to be in charge of the training for police scholarship. We would give them a reading list, and unlike most academic institutions, ours was not limited to textbooks. We put in novels, too, because you can learn from reading those. I use *Crime and Punishment*, *The Angel of Darkness*, *The Alienist*, and *An Instance of the Fingerpost*. I also recommend true crime books like *St. Joseph's Children*. That's about a serial killer of kids. I worked on that case. Every time the police got close to him, he'd go into a mental institution. I also recommend *All His Father's Sins*. One of the texts I strongly recommend is Robert Hare's *Without Conscience*. He has the most valid measuring instrument for psychopaths."

Roy Hazelwood interviewed by Katherine Ramsland (trutv.com, 2005) http://www.trutv.com/library/crime/criminal_mind/profiling/hazelwood/1.html.

15. Roland Barthes, "Change the Object Itself," in *Image, Music, Text*, trans. Stephen Heath (1977; London: Fontana, 2000), p. 165.

16. The crime scene photograph—as photograph—is also mythologized: the visual shorthand of dominant film language often focuses the audience onto the *reaction* of the detective's partner, or, say, a stunned family member, to a set of 10" x 8" photos of the scene in order to communicate its heinous nature—and *not* onto the actual content of the pictures, which need only be implied: i.e., a crime scene photograph is presumed to be disturbing.

17. For a detailed commentary on the role of the press photographer at the crime scene, see Taylor, *Body Horror*.

18. Colleen Wade, ed., *Federal Bureau of Investigation Handbook of Forensic Services* (Quantico, Va.: FBI Publications, 2003), p. 161.

19. Barbaralee Diamonstein, "An Interview with Garry Winogrand," in *Visions and Images: American Photographers on Photography, Interviews with Photographers* (New York: Rizzoli, 1982).

20. The press photographer, often portrayed in such situations a sleazy, grubby nuisance, does however fulfill an important role: that of a "watchdog" whose presence tends to encourage the integrity of police procedure.

21. The daunting level of documentation required is clarified in the current FBI list of guidelines: "Photograph the most fragile areas of the crime scene first. Photograph all stages of the crime scene investigation, including discoveries. Photograph the condition of evidence before recovery. Photograph the evidence in detail and include a scale, the photographer's name, and the date. Take all photographs intended for examination purposes with a scale. When a scale is used, first take a photograph without the scale. Photograph the interior crime scene in an overlapping series using a normal lens, if possible. Overall photographs may be taken using a wide-angle lens. Photograph the exterior crime scene, establishing the location of the scene by a series of overall photographs including a landmark, photographs should have 360 degrees of coverage. Consider using aerial photography, when possible. Photograph entrances and exits from the inside and the outside. Photograph important evidence twice; a medium-distance photograph that shows the evidence and its position to other evidence; a close-up photograph that includes a scale and fills the frame. Prior to entering the scene, acquire, if possible, prior photographs, blueprints, or maps of the scene." (Wade, *Federal Bureau of Investigation Handbook of Forensic Services*, pp. 162–163; original is formatted with bullet points.)

22. The typical series of shot list being: medium shot looking onto a photographer about to take a picture/a flash gun produces a momentary white-out/a crane-mounted shot pulls back to reveal an overview of the scene. Film

language has also propagated its own motifs, such as the wholly erroneous notion that CSIs draw a chalk outline around the body.

23. Raymond Siljander, *Applied Police and Fire Photography* (Springfield, Ill.: Charles Thomas, 1976); Richard Saferstein, *Criminalistics: An Introduction to Forensic Science*, 7th ed. (Upper Saddle River, N.J.: Prentice Hall, 1977); David Redsicker, *The Practical Methodology of Forensic Photography* (Boca Raton, Fla.: CRC Press, 1994).

24. A. Kraszna-Krausz, *The Focal Encyclopedia of Photography* (London: Focal, 1956), p. 1141; emphasis added.

25. Federal Bureau of Investigation Behavioral Science Investigative Support Unit, *Photography Requirements* (Quantico, Va.: FBI, 1999), p. 1. Equally, in Alan Moore and Eddie Campbell's graphic novel *From Hell*, Chief Inspector Abberline and Chief Inspector Godley attend the horrifying murder scene of Mary Kelly. The two detectives immediately recognize the killing as the work of "Jack the Ripper," and Abberline comments: "See, the older you get, it's not so much the buckets of blood that stick in your mind as the things like that [blackened kettle]." See Alan Moore and Eddie Campbell, *From Hell* (1996; London: Top Shelf, 2005), ch. 8, p. 11.

26. William Eggleston, *The Democratic Forest* (New York: Doubleday, 1989); Keith Arnatt, *I'm a Real Photographer* (London: Boot, 2007); Boris Mikhailov, *Unfinished Dissertation* (Zurich: Scalo, 1998); Georg Philipp Pezold, *Recollection Recovered* (Vienna: Cajetan Gril, 2006).

27. See my *100 Photographs* (Farnham: James Hockey Gallery, 1991); *La Vie quotidienne* (Essen: 20/21, 1999); *Point and Shoot* (Ostfildern-Ruit: Cantz, 2000); or *Interiors Series* (Antwerp: FotoMuseum Provincie Antwerpen, 2005).

28. "William Eggleston in Conversation with Mark Holborn," in Eggleston, *The Democratic Forest*, pp. 172–173.

29. Perec's description of Jane Sutton's apartment resonates with the photographs under consideration: "The only other piece of furniture in the room is a narrow low table filling the available space between the bed and the window, on which stands a gramophone—a tiny model, known as a disc-muncher—plus a quarter-full bottle of Pepsi-Cola, a set of playing cards, a potted cactus complemented by some multicoloured gravel, a little plastic bridge, and a minute parasol. There are some records piled up on the low table. One of them, out of its sleeve, stands almost vertical against the edge of the bed: it's a jazz record—Gerry Mulligan: Far East Tour—and the sleeve depicts the temples of Angkor Wat in morning haze." (Georges Perec, *Life: A User's Manual* [*La Vie mode d'emploi*], trans. David Bellos [1978; London: Harvill, 1989], p. 37.)

Also this passage from *A Man Asleep* highlights the notion of the banal as fundamental, final: "You no longer exist: across the passing hours, the succession of days, the procession of the seasons, the flow of time, you survive, without joy and without sadness, without a future and without a past, just like that: simply, self-evidently, like a drop of water forming on a

drinking tap on a landing, like six socks soaking in a pink plastic bowl, like a fly or a mollusc, like a cow or a snail, like a child or an old man, like a rat." (Georges Perec, *A Man Asleep* [1967; London: Harvill, 1990], pp. 176–177.)

30. Daniel Spoerri, *An Anecdoted Topography of Chance* (1962; London: Atlas, 2000), unpaginated.

31. The parallels between the crime scene photograph and the *nouveau roman* have also been noted by Peter Wollen, who highlights the work of Alain Robbe-Grillet. See Peter Wollen, "Vectors of Melancholy," in Rugoff, *Scene of the Crime*, p. 85.

32. Olivier Richon, "Thinking Things," in Ute Eskildsen, ed., *Real Allegories* (Göttingen: Steidl, 2003), p. 164.

33. Pierre Bourdieu, "The Social Definition of Photography," in *Photography: A Middle-brow Art* (1965; Stanford: Stanford University Press, 1990), p. 91.

34. Walker Evans, "Photography," in L. Kronenberger, ed., *Quality: Its Image in the Arts* (New York: Atheneum, 1969), p. 118; reproduced in Mike Weaver, ed., *The Art of Photography: 1839–1989* (New Haven: Yale University Press, 1989), p. 133.
 Although it is only a "partial match," his description recalls a regularly reproduced photograph by Elliott Erwitt that features a square of New York pavement (sidewalk) with a man's foot and a spilled cup of coffee (New York, 1950). See Frizot, *The New History of Photography*, p. 643.

35. Through studying such documents (e.g., records of the exact angle at which an object came to rest) a ballistics expert will make extensive inferences about physical trajectory through the air, the speed at which it was moving, what level of force would have been required, and so forth.

36. Stock photographs *are* made of "mistakes" or "accidents"—e.g., coffee spill, shaving cut, airport dash—but they are always sanitized, and therefore rendered generic; as if there were a normal, average (and reassuring) way to make—carry out—an error. There are no stock photographs of subjects such as "used tampon" or "dried vomit."

37. Ralph Rugoff is making a similar point when he notes that "we are already into the stage [historical epoch] of constructing new experiences that conform to photographic realities." Ralph Rugoff, *Circus Americanus* (London: Verso, 1995), p. xi.

38. I have also explored the theme of the prepackaged image in my collaborative work with Liam Gillick: Henry Bond and Liam Gillick, *Documents*: a series of photographs and text panels which were the result of a decision to acknowledge and engage with the highly coded environment of the "news event," much of which is predetermined, rehearsed, generic, and so forth. The work evolved from attendances at events, press conferences, and photo opportunities from a list produced by the Press Association. See Henry Bond and Liam Gillick, *Documents* (London: One-Off Press/APAC, Nevers, 1991).

39. Publications such as *Amateur Photographer* also prioritize the most asinine and generic image production. The implicit premise of such publications—and others marketed to the camera enthusiast—is that subject matter must always adhere to a known code: "wildlife photography," "landscape photography," "portraiture," etc. Once the *type* of photograph has been established, an assumed set of techniques can then be appropriately deployed. Each modality also has predetermined equipment associated with it—choice of lens, filters, accessories; any inappropriate decision is derided as being literally wrong: *a mistake.*

40. Sigmund Freud, *The Interpretation of Dreams* (1900), in *The Basic Writings of Sigmund Freud*, ed. A. A. Brill (New York: Modern Library, 1995), p. 160.

41. Adorno elaborated this dichotomy through reference to musical composition, setting up an opposition between the approach of Arnold Schoenberg, which he characterized as "progress"—an engagement with the ephemeral, the arbitrary, deconstruction—and that of Igor Stravinsky, which he characterized as "the restoration"—a search for the permanent, the ideal, the eternal: "hostile to the dream and inspired by the dream of authenticity." See Theodor W. Adorno, *The Philosophy of Modern Music* (1949; Minneapolis: University of Minnesota Press, 2000), p. 106.

 Specifically in relation to the photographic document, in the film *One Hour Photo*, the minilab operator Sy Parrish tells the audience: "People take pictures of the happy moments in their lives. Someone looking through our photo album would conclude that we had led a joyous, leisurely existence free of tragedy. No one ever takes a photograph of something they want to forget." The tagline of this film is also seems to propose a distinctly Lacanian theme: "The things that we fear the most have already happened to us . . ." See *One Hour Photo*, dir. Mark Romanek (Los Angeles: Fox Searchlight, 2002).

42. "Richard Prince Interviewed by Larry Clark," in Lisa Philips, ed., *Richard Prince* (New York: Whitney Museum of American Art, 1992), p. 129. Lacan described the often prissy, consciously mannered speech often presented in the session by obsessional patients as "empty speech." One of the apocryphal anecdotes passed between scholars is that supposedly, Lacan, during sessions, in response to the wearisome droning speech being monotonously enunciated by an obsessional patient, would occasionally get up and make a coffee or do chores in the kitchen while they continued to ramble on the couch.

43. Sigmund Freud, "Three Contributions to the Theory of Sex" (1905), in *The Basic Writings of Sigmund Freud*, pp. 551–552.

44. The phantasmagoria shows (exhibitions and events) of the late nineteenth century were captivating for the audience precisely because the images on the screens did seem to blur the distinction between reality, the spectral, the imagined, the hallucinated.

45. Georges Bataille, "The Solar Anus" (1927), in *Visions of Excess*, ed. Allan Stoekl (Minneapolis: University of Minnesota Press, 1985), pp. 6–7; emphasis added.

46. This theme of *myth* might also be introduced into the categorization of photography recently offered by Julian Stallabrass, who asserts: "four broad types of photographer can be identified: the professional, the snapper, the amateur and the artist" (Julian Stallabrass, *Gargantua* [London: Verso, 1996], p. 14). If we opt to keep the primary groups proposed, then it might be valuable to also consider the relationship of each to the production of *myth*: of course, professional photographers (the food, wedding, advertising, or sports photo- grapher, for example) are the chief propagators of myth—insofar as they are often *obliged* to reiterate a received idea. The often ludicrous amateur enthusiast photographer tends to actively *aspire* to producing a cliché. The photo-artist has every reason to intervene in a manner that derails the propagation of myth, but the results (products) often tend to be comfortably identifiable as art (contemporary photo-art is often instantly recognizable through such elementary features as the initial appearance, e.g., grandiose size, extravagant framing, and so on). Thus, is it not only the final group, "the [casual] snappers"—that is, those whose basic relationship to the medium is a desire to simply document some event or experience such as a birthday, holiday, class reunion—who are at all likely to transcend dominant visual conventions, even if it is only accidentally or inadvertently?

Equally, in this exchange with the Victor Bockris, the writer William Burroughs repudiates the equivalent of the generic "stock" image in speech:

VICTOR BOCKRIS: Do you think what appears in newspapers, on television, and in daily intercourse is quite meaningless?

WILLIAM BURROUGHS: Absolutely, because they're always using such generalities. There is no such entity as "Americans," there is no such entity as "most people." These are generali- ties. All generalities are meaningless. You've got to pin it down to a specific person doing a specific thing at a specific time and space. "People say . . ." "People believe . . ." "In the consensus of informed medical opinion . . ." Well, the minute you hear this, you know you're listening to meaningless statements.

Victor Bockris, *With William Burroughs* (New York: Seaver Books, 1981), p. 10.

47. It is not relevant in this inquiry to get sidetracked by the differences between discovery—in more than one place almost simultaneously—and the notori- ous "announcement" of the invention, thus I am sticking here with (the fairly debatable) 1839. For a far more complete survey of these events, see Batchen, *Burning with Desire*.

48. Edgar Allan Poe, "The Daguerreotype" (1840), in Alan Trachtenberg, ed., *Classic Essays on Photography* (New Haven: Leete's Island Books, 1980), p. 37.

49. Edgar Allan Poe, "The Mystery of Marie Rogêt" (1841), in *The Complete Crime Stories* (London: Orion, 2002).

50. In Daniel Stashower's commentary on the Rogers case, the author notes how— with perhaps unconscious precision—Poe's commentary makes use of the "lens of fiction." (Daniel Stashower, *The Beautiful Cigar Girl: Mary Rogers, Edgar Allan Poe, and the Invention of Murder* [New York: Dutton Adult, 2006], p. 6.)

51. The torn strip of fabric that had apparently been used to tie an improvised "handle" onto the corpse and enabled the murderer to drag it to the river's edge—a factor that also implies that the murderer acted alone and was not part of a larger group—supposedly members of the so-called Pug-Ugly gang—who would have simply carried the corpse rather than drag it.

52. Geoffrey Batchen, "Ectoplasm: Photography in the Digital Age," in *Overexposed: Essays on Contemporary Photography* (New York: New Press, 1999), p. 12.

53. Edgar Allan Poe, "The Murders in the Rue Morgue" (1841), in *The Complete Crime Stories*, p. 70. In Arthur Conan Doyle's "The Five Orange Pips"—a story which was undoubtedly influenced by Poe's earlier Dupin tales—the fictional detective Sherlock Holmes similarly states: "The ideal reasoner . . . would, when he has once been shown a single fact in all its bearings, deduce from it not only all the chain of events which led up to it, but also all the results which would follow from it. As Cuvier could correctly describe a whole animal by the contemplation of a single bone, so the observer who has thoroughly understood one link in a series of incidents, should be able accurately to state all the other ones, both before and after." (Arthur Conan Doyle, "The Five Orange Pips" [1890], in *The Adventures of Sherlock Holmes* [London: Everyman, 1977], p. 103.)
 One recent development in crime fiction that has evolved from the close reading of the crime scene is a specific subgenre known as the "police procedural"; in such murder mysteries the protagonist/detective uses the evidence-gathering techniques currently used in forensic work in order to reveal the identity of the killer. A leading exponent of this genre is the writer Patricia Cornwell, who claims a high degree of authenticity and accuracy in the descriptions of police work that she includes. See, for example, Patricia Cornwell, *Body of Evidence* (New York: Pocket, 2004).
 In this context it is also relevant—and unfortunately necessary—to note Jed Rubenfeld's *The Interpretation of Murder*, a murder mystery novel in which the protagonist is none other than Sigmund Freud himself. Set during Freud's visit to the United States in 1909, the book also includes Sándor Ferenczi in a "Watson" role. Rubenfeld makes numerous claims as to the authenticity of the historical events described—Freud is resident in the same hotel where he actually stayed on that trip; he has to give a lecture upstate, etc. However, it is important to note that the supposedly psycho-analytic deductions that the characters make are misleading and absurd. See Jed Rubenfeld, *The Interpretation of Murder* (New York: Henry Holt, 2005).

54. John Roberts, "Surrealism, Photography and the Everyday," in *The Art of Interruption* (Manchester: Manchester University Press, 1998), p. 100.

55. André Breton, *Nadja* (1928; New York: Grove Press, 1960), p. 16. The idea that we respond to images at the level of both consciousness *and* unconscious association is a basic premise of surrealist activity. When the artist Marcel Duchamp exhibited a series of *ordinary everyday objects* in the art-gallery context—including a bottle rack and a snow shovel—beyond any challenge to craft/originality, he was also engaging with this notion of the disconcerting object.

56. Walter Benjamin, "Little History of Photography" (1931), in *Selected Writings*, ed. Michael Jennings, Howard Eiland, and Gary Smith, vol. 2 (Cambridge, Mass.: Harvard University Press, 1999), p. 519.

57. John Szarkowski, "Atget and the Art of Photography," in Szarkowski and Maria Morris Hambourg, *The Work of Atget*, vol. 1, *Old France* (New York: Museum of Modern Art, 1981), p. 11. Was it not also the wish to comprehend a *seemingly random* attack that motivated the writer Truman Capote to begin his journalistic investigation into the killing of the Clutter family? See Truman Capote, *In Cold Blood* (1966; London: Penguin, 2000).

58. Of course this is the trajectory *since* the invention of photography. If the trajectory is allowed to advance—or curve forward—from some moment before that, then the entry point could be recalibrated to include Diderot's *Jacques le fataliste* or even earlier works, perhaps, and this *ancient* history of evidence I shall take up elsewhere. See Denis Diderot, *Jacques le fataliste* (1778; London: Penguin Classics, 1995).

59. I should clarify here that apart from using these details in order to prepare this volume, I also decided to exhibit a series of these rephotographs in an art gallery: Henry Bond, "Forensic Series," Emily Tsingou Gallery, London, July 2007.

60. Although the use of this term seems obvious enough, it is not actually the agreed definition of that word. For, despite its general usage of in relation to fine-art photographic practice, the technically agreed use of this term outside of a specifically art/photo historical context refers to the practice of returning to the spot where a (usually ancient) photograph was made—often in order to compare the depicted scene then and now. This technique is apparently popular in the disciplines of architecture and urbanism—the study of the built environment.

61. Michel de Certeau, *The Practice of Everyday Life* (1974; Berkeley: University of California Press, 1984), p. xxi.

62. Andy Grundberg, "Richard Prince, Rephotographer," in *The Crisis of the Real* (New York: Aperture, 1984), p. 133.

63. Is it not just such an alienation that stops the time traveler from recognizing the enigmatic image of a man on the airport concourse—in Chris Marker's *La Jetée*—as the moment of his own death?

64. Lacan's technical terms are introduced and considered in considerable detail in chapter 2.

65. Darian Leader, "Lecture on Citibank Prize Finalists," *Gallery Talks* (The Photographer's Gallery, London, March 23, 2000). This quotation is from my own longhand transcription made—in real time—in a lecture theater. I have not been able to locate an audio recording of Dr. Leader's paper; I hope my version is accurate enough to do justice to the speaker's intended purpose.

66. Richard Prince, "The Perfect Tense" (1987), in Philips, *Richard Prince*, p. 168. Surely the fact that the artist, writer, poet, or composer cannot *encounter* the desired is the basic theme of romantic longing? The desirer seeks out truth, beauty, love, etc., only to find that a crucial element is always missing, disappeared, lost. In modernism the theme of alienation becomes a given; it is assumed—hence "longing" is often disparaged as futile.

67. Douglas Crimp, "The Photographic Activity of Postmodernism," in *On The Museum's Ruins* (Cambridge, Mass.: MIT Press, 1993), p. 117. The phrase (or adverb) *always-already* is firmly associated with "postmodernist" theory, yet it was—as is perhaps well known—first employed by Kant, and later by Heidegger: it is thus a phrase that has been—appositely enough—borrowed or *appropriated* from another preexisting discourse.

68. Roland Barthes, *The Grain of the Voice*, trans. Linda Coverdale (New York: Hill and Wang, 1981), p. 354.

69. Ibid., p. 137.

70. Peter Wollen, "Godard and Counter-Cinema" (1972), in Philip Rosen, ed., *Narrative, Apparatus, Ideology: A Film Theory Reader* (New York: Columbia University Press, 1986), p. 133.

71. The photograph is actually entitled *Penny Picture Display, Savannah*, 1936. The term *straight* photography has often been used to distinguish practitioners who photograph the situations that they happen upon from those who prepare, control, and *set up* their photographs. It now seems outmoded, as there is no longer any meaningful means of discriminating—notwithstanding also the confusing dimension (in the context of contemporary nomenclature) that it might be intuitively assumed that straight photography would logically, in any case, be opposed only to gay/queer photography.

72. The photographs to which I am referring were made during the period 1935–1938.

73. Douglas Fogle, ed., *The Last Picture Show: Artists Using Photography 1960–1982* (Minneapolis: Walker Art Center, 2005), p. 19. I understand Fogle's sense here as an allusion to hallucination and somnambulant states, for, of course, the critique of photography in the mass media, to which he refers, depends, a priori, upon some rationalized—shared—agreement about the visual world. And it is to this theme of questionable time scales and memory lapses that much recent photo-art returns.

74. Jacqueline Rose, "Sexuality in the Field of Vision," in *Sexuality in the Field of Vision* (London: Verso, 1986), p. 228.

75. The restoration of Fritz Lang's film *M* [*Mörder*] (1931) was organized and directed by Martin Koerber. His process was intensely "forensic": he had to reconstruct the narrative of the film without an original shot list. He returned to the German censor's shot list and the original dialogue editor's notes,

literally rebuilding the film using surviving documents. During the process, 18,000 film frames were individually "cleaned."

I should also add that the content of the film—as a film—is also a *reconstruction* of the murderous crimes of Peter Kürten, the "Vampire of Berlin," a serial killer who also murdered many children. In Lang's film the killer is portrayed as a psychotic who cannot control his horrifying actions, not as a one-dimensional *evil* killer: I believe that this is the first film to introduce what is basically a modern treatment of crime/mental illness. (*M*, dir. Fritz Lang [1931; Berlin: Nero, 2003].)

76. Having greatly enhanced one small area of a photograph, revealing some formerly obscure details, Deckard simply instructs the machine: "Give me hard copy. Right there." Moments later, a Polaroid-style print of the detail emerges from a slot. In the two "director's cut" versions of the film, and several other special editions, the *Esper* sequence remains unaltered— this was clearly one scene which all those involved agreed to include in the finished picture. However, such a machine is not actually mentioned by Philip K. Dick in *Do Androids Dream of Electric Sheep?*, the story on which the film is loosely based; it therefore seems likely that the *Esper* machine should be attributed to the authors of the screenplay, Hampton Fancher and David Peoples. See *Blade Runner*, dir. Ridley Scott (Los Angeles: Blade Runner Consortium, 1982); Philip K. Dick, *Do Androids Dream of Electric Sheep?* (1968; London: Orion, 2002). See also Giuliana Bruno, "Ramble City," *October* 41 (1987); Batchen, *Burning with Desire*, p. 214.

77. Conversely, since the digital image became dominant in crime scene photography—in the mid-1990s—a key professional issue has become the SOCO's ability to guarantee—robustly, and in court—that a digital file has *never* been altered or digitally retouched in any way. Obviously, this is crucial: how easy it would be to remove an important piece of evidence by simply using Photoshop's clone tool. Lexar Corporation's LockTight system is a current solution that has recently become popular in the challenging field of file integrity. Adobe Photoshop—version 1.0—was written by Thomas Knoll and released in 1991. Photoshop has now reached version 10—also known as CS3.

78. The advanced manipulation work required on some of the images was carried out by the retoucher Brian Voce. Brian is one of the most revered digital retouchers in London, and it was fascinating to sit next to him watching him manipulate the photographs. The more closely we scrutinized the images, the more detail seemed to be revealed: the maker's mark on cutlery; the actual number of a newspaper page; the selected score-draws on a "pools" coupon; a previously illegible book title; graffiti etched into a rail carriage door; the lettering on a food package; the details of a formerly ambiguous snapshot in a domestic photo album: details which became the basis of my *Lacanian* annotations. Of course, my—creative—activity (see also note 76 above) immediately renders these examples of evidence photography inadmissible— dysfunctional/worthless—as evidence in court.

79. Walter Benjamin, "The Author as Producer," in *Selected Writings*, vol. 2, p. 774.

80. Wade, *Federal Bureau of Investigation Handbook of Forensic Services*, p. 162.

81. For example, Ralph Rugoff inquires: "since every subject of a photograph shares a certain cadaverous stiffness, the line can blur between the lifeless and the living. How then do you shoot a corpse so it appears truly dead?" Questions of this kind can really be raised only in a critical (philosophical) rather than practical/utility-based context, and are of no concern to the CSI. See Ralph Rugoff, "On Forensic Photography," in *Circus Americanus*, p. 183; Siljander, *Applied Police and Fire Photography*, p. 7.

82. I do not attend in this text to the possibility of a rereading of the work of these CSI photographs as distinctively authored. I did not notice enough of a particularized approach from any one photographer to highlight that factor. Due to time and space restrictions, I have downplayed the role of any individual crime scene photographer's specific contribution the evolution of the visual language of the CS photograph; this theme will have to be developed—if at all—elsewhere.

83. The use of the document in postwar fine-art photography is considered in detail in Fogle, *The Last Picture Show*. The significance of the contributions of these innovators is the blurring of the traditional dichotomy—or "battle lines"—which are established in photo history as the opposition between a supposedly cool and detached "topographic" mode of production that intends to privilege description—with the Düsseldorf School of photography only the most recent version of this long tradition—and the assertions of the so-called "pictorialist" photographers, such as Alfred Stieglitz (1864–1946) or Edward Weston (1886–1958), who proposed, even demanded, that the art of photography is valid only when it is intensely subjective, poetic, spiritual. Here, for example, is Weston writing on his approach to photographing a seemingly mundane piece of evidence (a rock/boulder): "recording unfelt facts by acquired rule, results in sterile inventory. To see the Thing Itself is essential: the quintessence revealed direct without the fog of impressionism—the casual noting of a superficial phase, or transitory mood. This then: to photograph a rock, have it look like a rock, but be *more* than a rock." Or here, on photographing a red pepper: "to be sure, much of my work has this quality—many of my last year's peppers, but this one, and in fact all the new ones, take one into an inner reality—the absolute—with a clear understanding, a mystic revealment [*sic*]. This is the 'significant presentation' that I mean, the presentation through one's intuitive self, seeing 'through one's eyes, not with them': the visionary." (Edward Weston, *The Daybooks of Edward Weston* [1927–1934; New York: Aperture, 1990], pp. 154–181.)

84. Siljander's comment seems to refer primarily to a now anachronistic subset of the paparazzi photographer, the so-called "ambulance chasers," of whom Arthur Fellig ("Weegee") is the most well known. Fellig appeared to revel in his invasive, intrusive activity. The author George Coxe also introduced a fictional crime photographer, Jack "Flashgun" Casey, or Flash Casey, in such books as *Photo of the Dead* (1947) and *Scene of the Crime* (1949). Flash Casey is notable here because he actually used photography in order to solve murder investigations. Coxe also wrote a screenplay around this character, filmed as *Women Are Trouble* (dir. Errol Taggart, 1936).

85. Barthes, *The Grain of the Voice*, p. 354.

86. Mandel and Sultan, *Evidence*.

87. Mandel and Sultan are not the only artists to use this technique. They were, however, perhaps the first artists to do so in such a self-conscious manner. Other notable examples of this technique include Isa Genzken, *Der Spiegel 1989–1991*, which comprises a selection of images from the German weekly illustrated news magazine reproduced without any captions at all; and Hans-Peter Feldman's *Voyeur*, in which the profuse images—drawn from numerous anonymous sources—are represented in groupings and arrangements by the author. I should also mention here my own *100 Photographs*, a series of photographs that I selected from the archive of the *Farnham Herald*, a local small-town weekly newspaper published in England. In each of these cases the overall effect is similar: the viewer tends to invent/insert a narrative where a proscribed one is missing. These new narratives may be more strange, more phantasmagoric, and even more hallucinatory than the original captions, which in the case of my series included: a lower-league football match played under floodlights; a fire officer demonstrating a recent innovation in fire-extinguisher technology; hot weather causing areas of Tarmac on a road to buckle; carnival fancy-dress revelers, and so on. See Isa Genzken, *Der Spiegel 1989–1991* (Cologne: Walther König, 2003); Hans-Peter Feldmann, *Voyeur* (Cologne: Walter König, 1997); Henry Bond, *100 Photographs*. Also relevant here is Douglas Gordon's *Timeline* (New York: Museum of Modern Art, 2005).

In his "Little History of Photography," Walter Benjamin makes the opposite case to solve the same basic problem—a wish go beyond the approximate/cliché: Benjamin proposes extending the photo's text caption in order to make each photograph much more individual and specific: "One thing, however, both Wiertz and Baudelaire failed to grasp: the lessons inherent in the authenticity of the photograph. These cannot be forever circumvented by a commentary whose clichés merely establish verbal associations in the viewer. The camera is getting smaller and smaller, ever readier to capture fleeting and secret images whose shock effect paralyzes the associative mechanisms in the beholder. This is where the inscription must come into play, which includes the photography of the literalization of the conditions of life, and without which all photographic construction must remain arrested in the approximate." (Benjamin, "Little History of Photography," p. 527.)

The notion of a photograph's caption being disingenuous, misleading, false, and so forth has been one of the key themes addressed by contributors to photo theory since the rise—in the 1960s—of advertising that uses photography to sell a product. See, in particular, John Walker, "Context as a Determinant of Photographic Meaning" (1980), in Jessica Evans, ed., *The Camerawork Essays* (London: Rivers Oram Press, 1997), or almost any essay by John Tagg.

88. The original TAT test cards were originally prepared and introduced by psychologists Henry Murray and Christiana Morgan in 1935: a highly organized sequence of 31 etchings, drawings, and illustrations that are reminiscent of the stilted depictions of everyday life painted by Edward Hopper. Card 1, for example, is an etching that depicts a boy staring blankly at a violin.

A psychologist may use these cards in a similar way to a Rorschach ink blot: they will be shown to the viewer/patient in order to encourage them to *tell a story* about each image. This "projective test" is designed to reveal or coax out "inner thoughts."

89. This modality of *creative* intervention into an existing archive has also been questioned; arguing against this mode of research, the prominent art historian Rosalind Krauss has commented: "Everywhere at present [the mid-1980s] there is an attempt to dismantle the photographic archive—the set of practices, institutions, and relationships to which nineteenth- century photography originally belonged—and to reassemble it within the categories previously constituted by art and its history . . . [it is] difficult to understand the tolerance for the kind of incoherence it produces." (Rosalind Krauss, "Photography's Discursive Spaces," in *The Originality of the Avant-Garde and Other Modernist Myths* [Cambridge, Mass.: MIT Press, 1982], p. 150.) For Krauss it is coherence that is under threat. But this presumed coherence is, of course, itself only a set of codes that equally depends upon numerous beliefs—or desires: that, for instance, old things should be tidy, organized (preferably alphabetically), ordered, and *put away*.

90. Sophie Calle, *L'Hôtel* (Paris: Éditions L'Étoile, 1984).

91. Benjamin, "Little History of Photography," p. 527. It is also worth noting that this idea of the *flâneur* who is basically an unwitting detective—like Poe's Man of the Crowd—returns in Benjamin's 1938 essay "The Paris of the Second Empire in Baudelaire," where he offers the following précis of Dumas's *Mohicans de Paris*: "Forensic knowledge coupled with the pleasant nonchalance of the *flâneur*: this is the essence of Dumas's *Mohicans de Paris*. The hero of this book decides to go in search of adventure by following a scrap of paper which he has given to the wind as a plaything. No matter what trace the *flâneur* may follow, every one of them will lead him to a crime. This is an indication of how the detective story, regardless of its sober calculations, also participates in the phantasmagoria of Parisian life." See Walter Benjamin, "The Paris of the Second Empire in Baudelaire" (1938), in Michael Jennings and Howard Eiland, eds., *Selected Writings*, vol. 4 (Cambridge, Mass.: Harvard University Press, 2003), p. 22; Edgar Allan Poe, "The Man of the Crowd," in *The Fall of the House of Usher and Other Writings* (London: Penguin, 1986).

92. Recent visually based research around the notion of any supposed reliability of the photographic image has not been carried out *within photography* at all, but in fine-art painting. Several practitioners have used the *inherent distance* between the painting and the photograph to question the integrity of the latter, as may be seen in the works of Gerhard Richter, Luc Tuymans, or Eberhard Havekost, for example. This turn of events is a complete reversal of the art scene as it was in the 1980s. Batchen, for example, makes the point that much interesting art made during that period used photography—the work of Levine, Prince, Sherman, Lawler, and so on. See Batchen, *Burning with Desire*, p. 214. Ralph Rugoff has recently curated a major exhibition of paintings consisting entirely of works made using photographs as source material. See Ralph Rugoff, ed., *The Painting of Everyday Life* (London: Hayward Gallery, 2007).

93. Independent Television Commission (ITC) Code of Conduct.

94. This idea of the potentially desublimated sex scene has been pursued by other authors. The example that I am struck by is milder but more insidious: in television and film drama characters rarely go to the toilet—on the rare occasions that they do, the actual bodily function is always cut out/skipped over. Without introducing the theme of repression, there is no tenable explanation for this utterly pervasive, rigorous forgetting.

95. I also pursued the possibility—with several English county police forces—of actually attending and photographing a live murder scene. The issue that remained outstanding in each of my negotiations was not the validity of my request, but my potential to—even accidentally—destroy or contaminate important evidence. My "ambition" currently remains unfulfilled; however, advising a police force on a current unsolved murder would be an entirely plausible next step: testing the theory "in the field."

96. Theodor Reik, *The Unknown Murderer* (New York: International Universities Press, 1945), pp. 237–240.

97. Equally, the former home of murder victim Nicole Brown Simpson, at 875 South Bundy Drive, Brentwood, Los Angeles, was rebuilt—on the same site—and the house number changed to 877 (the original number, 875, ceased to exist). Fred West's home at 25 Cromwell Street, Gloucester, England—the site where he committed several murders—was demolished by the local council and replaced with an area of anonymous pedestrian walkway. The garage/greenhouse in the grounds of 171 Lake Washington Boulevard, Seattle, where Kurt Cobain died was also demolished by the executors of his estate. Decisions taken to make such sites disappear may also be understood in relation to the theme of repression, but what is striking is that these efforts—like the repressed thought—are never completely successful. The traces of murder cannot easily be completely annihilated, demolished; they are like the site of a now invisible bodily wound which remains sensitive—we flinch, recoil, even after it has healed. Those who do overcome taboo and make specific visits to such places in order to create impromptu memorials, mark the site, etc., are derided as ghouls—the mythical demons that are supposed to rob graves and sleep in graveyards.

98. Dr. Michael Pinfold has noted, in relation to this point, that "*they* do not want you to see how easy it is [to commit a murder]" (personal conversation with Dr. Pinfold, 2005). And this point has certainly been confirmed through my investigation: we *are* surrounded—in daily life—by effective lethal weapons, we just don't typically use them to kill: a peeling knife, a short length of rope, a dumbbell.

99. Reik, *The Unknown Murderer*, p. 237. Compare Reik with Marie Bonaparte, whose commentary is complementary: "When one of these great perverts such as Vacher [a French serial killer] or Kürten [a German serial killer] appears on the scene, men who kill simply for pleasure, a wave of excitement sweeps through the masses. Nor is this due merely to horror, but to a

strange interest in the crime, which is our deep-rooted sadism's response to theirs. It is as though, civilized and wretched, with our instincts fettered, we were all, in some way, grateful to these great and disinterested criminals for offering us, from time to time, the spectacle of our most culpable, primitive desires enacted at last. Obscurely we sense, *though we dare not admit it,* that perhaps it was they who had enjoyed erotic pleasure in its starkest, purest form." (Marie Bonaparte, *The Life and Works of Edgar Allan Poe: A Psycho-Analytic Interpretation*, trans. John Rodker [1949; New York: Humanities Press, 1971], pp. 688–689; emphasis added.)

A recent extensively reported example—in England—of the "missing" child Madeleine McCann is an instance where a (society-wide) much-longed-for closure has not been possible, with the result that the case is continually reconsidered and mulled over in the outlets of the mass media. It is the gap—the not knowing—that is anxiety-provoking. In the McCann case the status of the apartment where the supposed abduction took place (Apt. 5a, Mark Warner Ocean Club, Praia da Luz, Portugal) was not actually declared a crime scene until several weeks after the initial disappearance—that is, after all potential forensic evidence had been contaminated or destroyed.

100. The artist Susan Hiller (commenting on her 1994 artist installation at the Freud Museum, London) declared: "Everything in my collection is either something that's been thrown away or is rubbish, of no value. . . . I could say that Freud is an early modernist with antiquarian taste and my collection is obviously very postmodern—fragments and ruins and discards, appropriations, etc. . . . The objects I have collected are constant evocations of mortality and death, which of course could also be said of the objects in Freud's collection and perhaps in all collections." (Susan Hiller, *Thinking about Art* [Manchester: Manchester University Press, 1995], p. 228.)

The National Archive, rather than being a place of forgetting (repressing), is, of course, a place of remembering—one which has numerous parallels with another place of remembering: the cemetery (or garden of remembrance, etc.) Both are, for example, located on the outskirts of town—in places that are generally only glimpsed from a speeding car or train. Once there, the visitor tends to adopt a quiet, reverential tone: a reverence that is, either symbolically or literally, a reverence for the dead. After all, historians are obliged, like those who visit burial grounds, to acknowledge the dead.

101. In order to gain physical access to a file in the National Archive, each reader must first search a database and then order the file required. Three files may be ordered at any one time. It is interesting to note that in relation to DPP material, readers must conduct a search by entering the name of the person originally on trial—it is always the perpetrator's name that is indexed, not the victim's: the victim is always rendered "nameless," while the killer always becomes notorious/infamous.

102. A legally binding agreement to nondisclosure of any information that may compromise national security or the integrity of the nation, etc. All employees who work in sensitive areas such as intelligence have to abide by this law which is, obviously, a form of censorship.

103. Georges Bataille, "X Marks the Spot," in *Documents: Archéologie, Beaux-Arts, Ethnographie, Variétés*, July 1930. This reference relies on my own translation of this crucial passage, which I produced in collaboration with Iphigenia Tsingou and Jean-Philippe Vernes. In full, it reads:

This is the first photographic history of the Chicago Gangland warfare ever published. It begins with the murder of "Diamond Jim" Colosimo, at the dawn of Prohibition, and it continues from year to year, from corpse to corpse, up until the time when the Gangland killers finally went from murder to massacre—on Valentine's Day in 1929—and more recently to the "hit below the belt" against reporter Alfred "Jake" Lingle, who was treacherously murdered. The editor of this publication goes on to affirm his confidence in the moral value of giving publicity to criminal activity, and notably to the reproduction of photographs of corpses. "The publication of photographs of this kind," he says, "is becoming a more common occurrence day by day": "X Marks the Spot" contains no fewer than thirty-four such photographs in sixty-four pages [i.e., it contains copious illustrations].

This new practice, which seems to be emerging in Europe too, certainly marks a significant ethical shift in the public perception of violent death. It seems that in the end the wish to see triumphs over disgust or terror. So, as its publicity grew as much as it could, the American gangster warfare could have the social function known as "circus games" in ancient Rome (and bullfights in modern Spain). It would be all too easy to think that as a consequence gangsters would have the same fate as the Barbarians in Roman times—who, having been the delight of the civilized, then reversed that situation and destroyed everything [their rebellions against taxation that ultimately led to the end of ancient Rome as a functioning city]. Indeed, racket investments in American society seem no less astounding than the height of skyscrapers.

104. Hannigan, *New York Noir*; Buckland, *Shots in the Dark*; Phillips, *Police Pictures*; Sante, *Evidence*; Parry, *Crime Album Stories*. And, of course, this book that you hold in your hand. Do you not, for example, gentle reader, feel a little *dirty* as you browse the lurid images? You may also notice that my version of this conscious justification is that I present the photographs as part of a Freudo- Lacanian study.

105. Jacques Lacan, "Some Reflections on the Ego," *Journal of the Institute of Psycho-Analysis*, no. 34 (1951), p. 12. The opening dialogue in David Simon's study of daily life in the Baltimore Police Department—*Homicide: A Year on the Killing Streets* (London: Canongate, 2008, p. 1)—highlights precisely this familiar flippant attitude:

Pulling one hand from the warmth of a pocket, Jay Landsman squats down to grab the dead man's chin, pushing the head to one side until the wound becomes visible as a small, ovate hole, oozing red and white. "Here's your problem," he said. "He's got a slow leak."
"A leak?" says Pellegrini, picking up on it. "A slow one."
"You can fix those."
"Sure you can," Landsman agrees. "They got these home repair kits now."

106. Sean Tejaratchi, *Death Scenes* (Los Angeles: Feral House, 1996).

107. Bataille, "X Marks the Spot."

108. Sigmund Freud, "Negation" (1925), in *The Standard Edition of the Complete*

Psychological Works of Sigmund Freud, ed. James Strachey (London: Hogarth Press and the Institute of Psycho-Analysis, 1953–1973), vol. 19, p. 236.

109. Many of the case files that I consulted were not due to be made available for many years—some were marked with a sticker "Closed until 2038," for instance. However, numerous tranches of files were re-marked under a process of accelerated opening that was put in place at the National Archive in order to minimize any potential for lawsuits under the Freedom of Information Act, 2000: a law—which actually came into force in 2005—that guaranteed rights of access for members of the public, in relation to archival material held by public bodies, NGOs, and so forth. In the lead-up to the introduction of this law, many organizations rushed to bring their access policy into accordance with it.

Chapter 2

1. Roland Barthes, "The Photographic Message," in *Image, Music, Text*, trans. Stephen Heath (1961; London: Fontana, 2000), p. 22.

2. Bruce Fink, *A Clinical Introduction to Lacanian Psychoanalysis* (Cambridge, Mass.: Harvard University Press, 1997), p. 20.

3. Slavoj Žižek, "Two Ways to Avoid the Real of Desire," in *Looking Awry: An Introduction to Jacques Lacan through Popular Culture* (Cambridge, Mass.: MIT Press, 1991), pp. 53–54.

4. Michel de Certeau, *The Practice of Everyday Life* (1974; Berkeley: University of California Press, 1984), p. xxi.

5. Sigmund Freud, *The Interpretation of Dreams* (1900), in *The Basic Writings of Sigmund Freud*, ed. A. A. Brill (New York: Modern Library, 1995), pp. 287–288.

6. Sigmund Freud, *The Psychopathology of Everyday Life* (1901), in *The Basic Writings of Sigmund Freud*, pp. 50–51.

7. Svitlana Matviyenko, a Ph.D. candidate at University of Missouri-Columbia under the supervision of Ellie Ragand-Sullivan.

8. Mark Bracher, "Lacan's 'Civilization and Its Discontents,'" *Journal for the Psychoanalysis of Culture and Society* 17 (1998).

9. Jacques-Alain Miller, "An Introduction to Seminars I and II: Lacan's Orientation Prior to 1953," in Bruce Fink, Richard Feldstein, and Marie Jaanus, eds., *Reading Seminars I and II* (Albany: State University of New York Press, 1996), p. 11.

10. Jacques-Alain Miller, "On Perversion," in Fink, Feldstein, and Jaanus, *Reading Seminars I and II*, p. 317.

11. Joseph Wortis, *Fragments of an Analysis with Freud* (New York: Simon and Schuster, 1954), p. 159.

12. Fink, *A Clinical Introduction to Lacanian Psychoanalysis*, p. 17.

13. Jacques Lacan, *The Seminar, Book I: Freud's Papers on Technique* (1953–1954; New York: Norton, 1988), p. 262.

14. Jacques Lacan, *The Seminar, Book VII: The Ethics of Psychoanalysis* (1959–1960; London: Routledge, 1992), p. 69.

15. It is worth noting here that Lacan's *objet petit a*—which emerged following his 1959–1960 commentary on *das Ding*—has a similar, or parallel, status to Barthes's theorization of the photo-image's *obtuse* "Third Meaning" (itself a precursor to his later proposition of the *punctum*). For example: "the *obtuse* meaning is 'too many,' the supplement that my intellection cannot succeed in absorbing . . . [it] exceeds psychology, anecdote, function . . . [a meaning that] appears to extend outside culture, knowledge, information." (Barthes, "The Third Meaning" [1970], in *Image, Music, Text*, pp. 53–55.)

16. Lacan did not intend to reveal any doubt or hesitation as to the validity or significance of his conceptualizations during his lectures—thus the transcripts often have a tone that appears to be arrogant, impatient, aggressive, and dismissive.

17. Lacan, *The Seminar, Book VII: The Ethics of Psychoanalysis*, p. 132. The Thing—*das Ding*—is the forerunner of his conceptual domain of the Real—that is, the domain of the unsymbolizable ("the beyond of-the-signified").

18. Malcolm Bowie, *Jacques Lacan* (London: Fontana, 1991), p. 196.

19. This theme is also present in Poe, who described his Dupin stories as "tales of *ratiocination*," but his sense was not just "tales of reasoning"; for him, ratiocination also included the idea that he could confound the reader, give false clues, and so on. He intended that the reader would have to be proactive in their reading/reasoning process, not just a consumer.

20. Madan Sarup, *Jacques Lacan* (Hemel Hempstead: Harvester Wheatsheaf, 1992), p. 80.

21. See, for example, the supposedly unreliable Elisabeth Roudinesco, *Jacques Lacan and Co.* (London: Free Association Books, 1985). Many books set out the unruly mayhem that characterizes the early years of the psychoanalytic scene; see in particular Paul Roazen, *Brother Animal* (New York: Transaction, 1990).

22. In a recent conversation with two (anonymous) IPA candidates—i.e., trainee psychoanalysts—I was surprised to find that they are taught that Freud's work *is* highly significant, of course, but that his *oeuvre* should be understood as "something like a beautiful fairy tale." On the same subject, another trainee recently appealed to me: "But come on, so much else has happened in the last one hundred years [i.e., since Freud's time]."

23. In the context of this complex critical environment, I have sought out those Lacanian scholars who *have* been motivated to clarify and simplify Lacan's work, and have generated readings that are perhaps less nuanced than some, but nevertheless robust. It is upon the work of those commentators that I

have relied for clarification of the texts, including, in particular, Fink, Dor, Evans, and Miller. See Fink, *A Clinical Introduction to Lacanian Psychoanalysis*; Bruce Fink, *Lacan to the Letter: Reading Écrits Closely* (Minneapolis: University of Minnesota Press, 2004); Joël Dor, *The Clinical Lacan* (Northvale, N.J.: Jason Aronson, 1997); Joël Dor, *Introduction to the Reading of Lacan: The Unconscious Structured Like a Language*, trans. Susan Fairfield (New York: Other Press, 1998); Joël Dor, *Structure and Perversions*, trans. Susan Fairfield (New York: Other Press, 2001); Dylan Evans, *An Introductory Dictionary of Lacanian Psychoanalysis* (London: Routledge, 1996); Fink, Feldstein, and Jaanus, *Reading Seminars I and II*.

24. Fink, *Lacan to the Letter*, p. 6.

25. What constitutes early Lacan is probably as debatable as the date of the "invention" of photography. However, it was later—in the 1960s—that Lacan really elaborated the conceptual framework with which he is popularly associated.

26. Jacques Lacan, "A Theoretical Introduction to the Functions of Psychoanalysis in Criminology" (1950), in *Écrits* (New York: Norton, 2006), p. 121. The paper also includes memorable attacks on Krafft-Ebing's emphasis on human instincts, and Jung's proposal of a collective (society-wide) unconscious, which he characterizes as "untoward extrapolations." He also derides the characterization—within psychiatry—of Freudian clinical work as "depth psychology," pointedly noting that any supposed depth is apparent only because of the shallowness of what had gone before.

27. Renata Salecl, *(Per)versions of Love and Hate* (London: Verso, 1998), p. 50.

28. Miller, "On Perversion," p. 309.

29. Jacques Lacan, "On a Question Prior to Any Possible Treatment of Psychosis" (1958), in *Écrits*, p. 466. In his early texts Lacan favors describing the state of being *non compos mentis* as the condition of *irresponsabilité*. See, for example, Lacan, "A Theoretical Introduction to the Functions of Psychoanalysis in Criminology," p. 106.

30. Lacan, "On a Question Prior to Any Possible Treatment of Psychosis," p. 479.

31. Professor Bernard Burgoyne, lecturing on the master's course "The European Tradition in Psychoanalysis" (London: Middlesex University, October 2000).

32. Jacques Lacan, "The Function and Field of Speech and Language in Psycho-analysis" (1953), in *Écrits*, p. 215.

33. Freud, *The Psychopathology of Everyday Life*, p. 146.

34. John Douglas et al., eds., *Crime Classification Manual* (San Francisco: Jossey-Bass, 1992). This mode of investigating crime—popularized particularly by Thomas Harris in his novel *The Silence of the Lambs*—was generally attributed to Dr. James Brussel, who advised the New York Police Department in the 1960s; the investigations he worked on included that of the murders

perpetrated by Albert DeSalvo, the infamous "Boston Strangler." Brussel noted, for instance, the significance of the fact that DeSalvo often approached his victims *claiming to be a photographer looking for new models.* Following the success of Harris's book, both Robert Ressler and John Douglas have claimed to be the inspiration/model for the "brilliant" FBI agent portrayed therein. See James Brussel, *The Casebook of a Crime Psychiatrist* (New York: Bernard Geis Associates, 1968); Thomas Harris, *The Silence of the Lambs* (1991; London: St Martin's Press, 2006).

35. Robert Ressler and Tom Shachtman, *Whoever Fights Monsters* (New York: St. Martin's Press, 1992), p. 114.

36. The Lacanian structure of neurosis (repression) is equally identifiable in CCM, but runs across several of its classifications, such as those identified as *Conflict Murder*, *Argument Murder*, *Domestic Homicide*, and so on.

37. See American Psychiatric Association, *Diagnostic and Statistical Manual of Mental Disorders*, 4th ed. (Washington, D.C.: American Psychiatric Association, 2000). To the psychoanalyst this book is indicative of the challenge that lies ahead for Freudians—often the definitions, explanations, and assertions it contains are somewhat remote from the psychoanalytic perspective. For example—and highlighting one of the most disgraceful/shameful aspects of the history of this book—the editors (the self-styled "Task Force on DSM") removed homosexuality from their list of mental disorders only in 1972.

38. The CCM approach to studying a crime scene has recently been attacked and supposedly discredited, both by judges and in academic papers. As Dr. Laurence Alison, for example, argues: "[There is generally] a recognition that particular cases [of murder] cannot easily be assigned to 'types,' 'traits,' or discrete, non-overlapping entities. Instead each case needs to be considered as possessing certain potentially unique features . . . offenders cannot easily be classified in terms of labels in which lists of background characteristics can be derived. I argue that there is little evidence in support of the utility of trait based models of profiling." (Laurence Alison, *The Forensic Psychologist's Casebook* [Cullompton, Devon: Willan, 2005], p. 3.) However, I note here that this capitulation is in essence a consequence of the misuse—and misunderstanding—of the CCM by various police forces, and is by no means indicative of a flawed conceptual framework.

39. This optimistic wish that psychoanalytic theory be considered more seriously by law enforcement professionals, the FBI, etc., is most likely to remain unfulfilled. After all, Freud's brief commentary on the criminal's relationship to guilt, which could have had significant consequences—particularly for approaches to the incarceration of perpetrators—remains inexplicably overlooked by criminologists. See Sigmund Freud, "Some Character-Types Met with in Psycho-Analytic Work" (1916), in *The Standard Edition of the Complete Psychological Works of Sigmund Freud*, ed. James Strachey (London: Hogarth Press and the Institute of Psycho-Analysis, 1953–1973), vol. 14. There *is* a tradition of psychodynamic theory being utilized in the context of

offender management, but most often in counseling and therapy—e.g., in the probationary service—and not, I believe, widely studied or accepted by law enforcement operatives.

40. Victor Burgin, "Brecciated Time," in *In/Different Spaces* (Los Angeles: University of California Press, 1996), p. 122; emphasis added.

41. Griselda Pollock, *Vision and Difference* (London: Routledge, 1988); Parveen Adams, *The Emptiness of the Image* (London: Routledge, 1996). The motif of the gendered "male gaze" was originally asserted by Laura Mulvey in her essay "Visual Pleasure and Narrative Cinema." In that text the author misleadingly conflates a supposedly gendered "sexist" gaze with Lacan's conceptualization of the "gaze of the Other." This unhelpful confusion has also been noted by several other commentators, including Dylan Evans and Martin Jay. See Laura Mulvey, "Visual Pleasure and Narrative Cinema," in *Visual and Other Pleasures* (Basingstoke: Macmillan, 1975); Evans, *An Introductory Dictionary of Lacanian Psychoanalysis*; Martin Jay, *Downcast Eyes: The Denigration of Vision in Twentieth-Century French Thought* (Berkeley: University of California Press, 1993).

42. Annette Kuhn, "Thresholds: Film as Film and the Aesthetic Experience," *Screen* 46, no. 4 (2005), pp. 401–414.

43. Liz Wells and Derrick Price, *Photography: A Critical Introduction* (London: Routledge, 1996).

44. As if chastising a presumed blunt, unemotional directness in psychoanalytic theory—a supposed flaw that could perhaps be resolved if everyone were a little more *flexible*: saw both sides, negotiated a compromise, as diplomats must always do.

45. Lacan, "On a Question Prior to Any Possible Treatment of Psychosis," p. 485.

46. This point should be made vigorously: the assertion of the primacy of the Freudian unconscious is a non-negotiable factor. Often, those who attempt to incorporate Freud into the wider field of critical theory—e.g., the scene of comparative literature—have a tendency to apply his concepts only from time to time, or only where *relevant* (the so-called grocery-cart Freudians, who reach to pick his concepts off the shelf only when it is convenient), and such scholars would most probably find this study *too limited*.

47. There should be a warning note on the front cover of this book to that effect. And it is present for a reason: the casual viewer should be *prepared* for these brutal, visceral documents.

48. Susan Rubin Suleiman, *Subversive Intent* (Cambridge, Mass.: Harvard University Press, 1990), quoted in Sue Taylor, *Hans Bellmer: The Anatomy of Anxiety* (Cambridge, Mass.: MIT Press, 2000), p. 3.

49. Taylor, *Hans Bellmer*, p. 3.

50. Gayatri Chakravorty Spivak, "Displacement and the Discourse of Woman,"

in Mark Krupnick, ed., *Derrida and After* (Bloomington: Indiana University Press, 1983), p. 190.

51. Indeed, as Myers and Wright et al. have noted, it is precisely because their act of murder is so uncommon that women who kill become intensely mythologized—Myra Hindley, Rosemary West, and Ruth Ellis, for example. See Alice Myers and Sarah Wright, eds., *No Angels* (London: Pandora, 1996).

52. I think it is fair to assume that *unconsciously* my basic motivation was indeed a morbid fascination: what other explanation could there be? In my defense, may I note that I came to crime scene photography with little previous knowledge of overtly distressing imagery; my prior preoccupation has been the theme of the mundane/everyday, but particularly in relation to exhibitionism and voyeurism.

53. During the period of my Ph.D. research (where this book has its origins) I was very fortunate to have three female supervisors with whom I was able to discuss/share my feelings of shame and horror in some detail.

54. The experience of being surrounded by these bleak photographs for so long might be likened to ancient samurai students who were forced to abide by the exhortations of their teachers, who instructed them to *always keep death in mind.*

55. Lacan actually completely removes women from the conceptual/structural framework of perversion. Fink notes, for instance, that "Lacan goes so far as to say that 'female masochism is a male fantasy,' and qualifies lesbianism not as a perversion but as *hetero*sexuality: love for the Other sex—that is, women." (Fink, *A Clinical Introduction to Lacanian Psychoanalysis*, p. 173.)

56. Jacques Lacan is attributed—by the psychoanalyst Jean-Bertrand Pontalis, in his foreword to Sartre's *The Freud Scenario*—as making the following (supposedly half-remembered) statement: "There is a distraught side to every woman . . . and a ridiculous side to every man." See Jean-Bertrand Pontalis, "Editor's Foreword," in Jean-Paul Sartre, *The Freud Scenario* (1955; London: Verso, 1985), p. xi.

For a more complete account of the history of hysteria, see Janet Beizer, *Ventriloquized Bodies* (Ithaca: Cornell University Press, 1994).

Chapter 3
1. Roy Hazelwood interviewed by Katherine Ramsland (trutv.com, 2005) http://www.trutv.com/library/crime/criminal_mind/profiling/hazelwood/1 .html.

2. Robert Ressler and Tom Shachtman, *Whoever Fights Monsters* (New York: St. Martin's Press, 1992), p. 84.

3. American Psychiatric Association, *Diagnostic and Statistical Manual of Mental Disorders*, 4th ed. (Washington, D.C.: American Psychiatric Association, 2000), p. 568.

4. Gilles Deleuze, *Coldness and Cruelty* (1967; New York: Zone Books, 1991), p. 33.

5. The formulaic and distinctively mannered activity of the "perverse" BDSM scene—*bondage-domination-sadism-masochism*—is, also, ultimately concerned with ritualized behavior that is entirely pre-negotiated: replete with copious rules, regulations, and a "play-safe" etiquette. It is perhaps ironic, given their tantalizing moniker, that the participants generally share a fear of actually encountering a sociopath of the type I am considering here—such disruptive individuals are quickly isolated, and become *personae non gratae*. Like the seemingly endless rota of committee meetings that anarchists' groups regularly organize, the BDSM scene has to negotiate a kind of institutionalized transgression.

6. Thomas De Quincey, *On Murder Considered as One of the Fine Arts* (1827; Oxford: Oxford University Press, 2000), p. 10.

7. John Douglas, Robert Ressler, and Ann Burgess, *Sexual Homicide: Patterns and Motives* (New York: Free Press, 1992), p. 122.

8. Many such murderers do make photographs of *their* crime scene. The infamous serial killer Jeffrey Dahmer, for example, took numerous Polaroids of his victims and was eventually incriminated by them (a group of his photographs was noticed by a police officer who was attending Dahmer's home on an unrelated inquiry). See Brian Masters, *The Shrine of Jeffrey Dahmer* (London: Hodder and Stoughton, 1985).

 It is the intrinsically "filmic" or drama-like—seemingly aestheticized—staging of such murders that has been recognized by numerous visual artists, including Hans Bellmer and Walter Sickert. In the 1978 film *The Eyes of Laura Mars*, a murderer places his victims into poses that deliberately pastiche the glossy fashion photographs made by Laura Mars. See Irvin Kershner, *The Eyes of Laura Mars* (Los Angeles: Columbia, 1978). Also—in relation to this notion of staging—in the 1930s, Frances Glessner Lee produced a series of detailed and accurately scaled architectural-style models of some unsolved murders. See Corrine Botz, *Nutshell Studies of Unexplained Deaths* (New York: Monacelli Press, 2004). The theme of artists' interest in the aesthetics of the sexual murder has also been traced in great detail by Maria Tatar. See Maria Tatar, *Lustmord: Sexual Murder in Weimar Germany* (Princeton: Princeton University Press, 1995).

9. It was Richard von Krafft-Ebing's survey of sexually motivated crime which introduced the term "sadistic," which he characterizes as merely the pathological intensification of *normal conditions*: "Under normal conditions man meets obstacles which it is his part to overcome, and for which nature has given him an aggressive character. This aggressive character, however, under pathological conditions may likewise be excessively developed, and express itself in an impulse to subdue absolutely the object of desire, even to destroy or kill it. Sadism is thus nothing else than an excessive and monstrous pathological intensification of phenomena which accompany the psychical sexual life particularly in males." (Richard von Krafft-Ebing, *Psychopathia Sexualis: A Medico-Forensic Study* [1887; New York: Bell, 1965], p. 56.)

The notion of the perverse/sociopathic killing as sexually motivated was first considered by the FBI's serious crime unit in John Douglas and Roy Hazelwood, "The Lust Murderer," *FBI Law Enforcement Bulletin* 16 (April 1980). It was formalized in the CCM as: "*Type 131. Organized Sexual Homicide*": "These components [of evaluation] combine to form traits common to an organized offender: one who appears to plan his murders, who targets his victims, and who displays control at the crime scene. A methodical and ordered approach is reflected through all phases of the crime. . . . The act of killing may be eroticized, meaning death comes in a slow deliberate manner. An asphyxial modality is often noted. An example of this is the deliberate tightening and loosening of a rope around the victim's neck as he or she slips in and out of a conscious state. Sexual activity in which sexual acts are performed in conjunction with the act of killing may also be found." (John Douglas et al., eds., *Crime Classification Manual* [San Francisco: Jossey-Bass, 1992], pp. 123–125.) Also "*Type 134: Sadistic Murder*": "sexual gratification is obtained from torture involving excessive mental and physical means. The offender derives the greatest satisfaction from the victim's response to torture. Sexually sadistic fantasies in which sexual acts are paired with domination, degradation, and violence are translated into criminal action that results in death" (ibid., p. 136). See also Douglas, Ressler, and Burgess, *Sexual Homicide*.

10. Many post-Freudians have used this archaic spelling to refer to unconscious fantasy in order make the differentiation more overt. There is a fundamental difference between a consciously manufactured fantasy and a set of unconscious coordinates that usually remain entirely unrecognized by the subject.

11. Jean Clavreul, "The Perverse Couple," in Stuart Schneiderman, ed., *Returning to Freud* (1967; New Haven: Yale University Press, 1980), p. 227. This out-of-print and hard-to-find text is, in my opinion, one of the most profound in the psychoanalytic literature.

12. Slavoj Žižek, "Why Is Reality Always Multiple?," in *Enjoy Your Symptom* (London: Routledge, 2001), p. 202.

13. Clavreul, "The Perverse Couple," p. 226.

14. Central to Lacan's formulation of the structure of perversion is a relationship to what often gets called the "big Other," that is, a relationship to a symbolic Other that "generally refers to a person or institution serving a symbolic function—legislating, prohibiting, putting forward ideals, and so on." The purpose of this clunky terminology is to differentiate *Autre* or "A" from *autre* "a"—the *objet petit a* (the object cause of desire). See Bruce Fink, *A Clinical Introduction to Lacanian Psychoanalysis* (Cambridge, Mass.: Harvard University Press, 1997), p. 232.

15. The original phrase in full is: "Let every soul be subject unto the higher powers. For there is no power but of God: *The powers that be* are ordained of God." (National Council of the Churches of Christ in the United States of America, *Holy Bible: New Revised Standard Version* [Oxford: Oxford University Press, 1989], Romans 13:1; emphasis added.)

16. In a police investigation, apparent evidence of such knowledge may be some-
 what incriminating. For instance, an attempt to demonstrate the defendant's
 supposed *guilty knowledge* of the crime scene was a key aspect of the failed
 prosecution case against Colin Stagg in his trial for the murder of Rachel
 Nickell (see *R v Stagg*).

 One case—held at the National Archives—details a murder in which a
 perpetrator went into a police station in order to confess his guilt, only to be
 told to "prove" what he was asserting. He highlighted a detail of the killing:
 he had removed only one of the victim's socks—a detail that was immediately
 checked. Equally, it is for such reasons that the details of a crime scene are
 never revealed to journalists.

17. Clavreul, "The Perverse Couple," p. 222.

18. The themes of risk and a supposed audience recur in Ressler's consideration of
 the fallacy that *the criminal will always return to the scene of the crime*: "Berkowitz
 [a perverse serial killer] told me that on the nights when he couldn't find
 a proper victim or proper circumstances, he would drive back to the scenes
 of earlier murders he had committed and revel in the experience of being
 where he had formerly accomplished a shooting. It was an erotic experience
 for him to see the remains of bloodstains on the ground, a police chalk mark
 or two: seated in his car, he would often contemplate these grisly mementos
 and masturbate. . . . Yes, murderers did indeed return to the scene of their
 crimes, and we could try to catch future murderers on that basis. Equally as
 important, the world could now understand that this return to the scene
 of the crime arose not out of guilt . . . but because of the sexual nature of
 the murder. Returning to the murder site took on a connotation that Sherlock
 Holmes, Hercule Poirot, or even Sam Spade had never dared to suggest."
 (Ressler and Shachtman, *Whoever Fights Monsters*, p. 69.)

19. Photographs 3.6 and 3.7 parallel/recall the "staged" photographs of Hans
 Bellmer's macabre series of photographs *La Poupée* [The Doll], in which the
 artist specifically referenced/parodied sexual murder.

20. In film structure/language, the major function of the two-shot is to commu-
 nicate emotional reaction between subjects, or action/reaction.

21. This image of "house" also has the quality of a Jungian archetype—a commu-
 nal (society-wide) unconscious foreknowledge. For example, when young
 children draw, they often begin with a depiction of a face or a house—in front
 elevation—and these two images seem to coincide, with the mouth and eyes
 in the same formation as the windows and door.

 Lacan's consideration of the gaze begins with a commentary on Sartre's
 text; see Jacques Lacan, *The Seminar, Book XI: The Four Fundamental Concepts of
 Psychoanalysis* (1964; London: Karnac, 2004), pp. 84–94. For Sartre's example
 of the house, see Jean-Paul Sartre, *Being and Nothingness* (1943; London:
 Routledge, 2000), p. 243. For Merleau-Ponty's reference to the inside/outside
 of a house, see Maurice Merleau-Ponty, "The Visible and the Invisible," in
 Basic Writings (1968; London: Routledge, 2004), p. 249. For Žižek's example,
 see "Why Is Reality Always Multiple?," p. 201.

22. Sartre, *Being and Nothingness*, p. 252.

23. Ibid., p. 257. Sartre's text here goes on to conceptualize the voyeuristic look in relation to the "pure shame" of being watched/discovered: "Shame is shame of self; it is the recognition of the fact that I am indeed that object which the Other is looking at and judging. I can be ashamed only as my freedom escapes me in order to become a given object" (p. 261). Dylan Evans has suggested that the profound alienation between eye and gaze is not Sartre's purpose, but this passage does seem to foreshadow Lacan's later conceptualization: "We cannot perceive the world and at the same time apprehend a look fastened upon us; it must be one or the other. This is because to perceive is to look at, and to apprehend a look is not to apprehend a look-as-object in the world; it is to be conscious of being looked at" (Sartre, *Being and Nothingness*, p. 257). Beyond Sartre's commentary, Lacan also refers to Maurice Merleau-Ponty's "quale," a concept that Merleau-Ponty introduces in his own commentary on the gaze (unpublished at his death in 1959) published as *Le Visible et l'invisible* in 1964. For a fuller understanding of the fascinating and vexed evolution of the theme of "the gaze"/"the Other," I refer the reader to Martin Jay's ency-clopedic—but perhaps not entirely definitive—*Downcast Eyes*. See Martin Jay, *Downcast Eyes: The Denigration of Vision in Twentieth-Century French Thought* (Berkeley: University of California Press, 1993); Maurice Merleau-Ponty, *The Visible and the Invisible* (Evanston: Northwestern University Press, 1968); Sartre, *Being and Nothingness*.

24. Jacques Lacan, *The Seminar, Book I: Freud's Papers on Technique* (1953–1954; New York: Norton, 1988), p. 215.

25. Lacan's commentary on the gaze is developed in his *Seminar, Book XI: The Four Fundamental Concepts of Psychoanalysis*, pp. 67–119. Žižek, "Why Is Reality Always Multiple?," p. 201.

26. The term Senior Investigating Officer is the modern nomenclature for the person who is responsible for decisions that must be made in order to isolate a suspect and build a case against them that includes evidence of their *means, motive, and opportunity*. At some point—on the basis of the evidence—the SIO must offer the DPP an overview of the case, together with a recommendation to prosecute the suspect, and if so, for what crime. The actual trial and so-called "due process" are not part of the SIO's responsibility: everything that relates to the trial is the responsibility of the DPP. I should also note that the SIO's case report is only a recommendation. The DPP may decide that the evidence against a suspect is insufficient to stand a realistic chance of gaining a conviction, etc.

 In each of the cases I have considered, this report is attached to the photo-graphs, along with witness statements and so forth.

27. Georges Bataille, "The Use Value of D. A. F. de Sade" (1930), in *Visions of Excess*, ed. Allan Stoekl (Minneapolis: University of Minnesota Press, 1985), p. 93.

28. Clavreul, "The Perverse Couple," p. 217.

29. Of significance to a criminal investigation is the implication that the specific identity of the victim may—most likely—be disregarded: very often the victim was simply *in the wrong place at the wrong time*—the perverse killer's victim is selected to play a role in a preexisting script: they simply walk onto the "set" at an unfortunate moment. Hence the common belief that such killers kill without motive, or *at random*—and recall, too, the laconic descriptions exchanged by casting directors for walk-on parts in motion pictures: "girl with red hair" or "girl in bar," etc.

30. DPP 2/XXXX, SIO's report, p. 3. In order to retain anonymity I am unable to reference this—and other original material—more specifically, as it would compromise security and privacy, which I have tried to ensure. All the murder cases held at the National Archive, Kew, begin with the code DPP/2, followed by a four-figure number.

31. Jacques Lacan was the owner of this notorious painting at the time this murder was committed—he purchased it at auction in 1957. He also commissioned a slipcase for it—from André Masson—so that he, too, could "cover the exposure of the private parts." After his death in 1981 his estate gifted the painting to the Musée d'Orsay, Paris.

32. This "Murder on the Gatwick Express" echoes the setting of the classic Agatha Christie "whodunit?" murder mystery *Murder on the Orient Express*.

33. A layout that creates discrete units within a carriage and was commonplace on the British Rail system at that time. Such compartments were often reserved for *first-class* travelers, and it is relevant to note that they were subsequently *phased out* precisely because of security concerns.

34. See, for example, Richard Linklater's *Before Sunrise*. In that film the narrative follows the meeting of Jesse and Céline through just such a chance encounter, which leads to a heartfelt romance. Céline expresses this when she says: "I believe if there's any kind of God it wouldn't be in any of us, not you or me but just this little space in between. If there's any kind of magic in this world it must be in the attempt of understanding someone, sharing something." (Richard Linklater, *Before Sunrise* [Los Angeles: Castle Rock Entertainment, 1995].)

35. DPP 2/XXXX, SIO's report, p. 2.

36. The modus operandi (MO) is revealed in the exact way that the criminal carries on: the specific binding or knots used to restrain the victim, the types of injuries inflicted for example. Any factor that personalizes the crime is an aspect of the MO.

37. See, for example, Burkhard Riemschneider, ed., *100 Pin-up Girls* (New York: Taschen, 1999).

38. The legal definition of obscenity is precisely: "material that will tend to deprave or corrupt."

39. Lacan, *The Seminar, Book I: Freud's Papers on Technique*, pp. 217–218.

40. Steven Spielberg, *Close Encounters of the Third Kind* (Los Angeles: Columbia, 1978).

41. Clavreul, "The Perverse Couple," p. 227.

42. Douglas, Ressler, and Burgess, *Sexual Homicide*, p. 42.

43. See Sol LeWitt, "Sentences on Conceptual Art" (1969), in Gary Garrels, ed., *Sol LeWitt: A Retrospective* (New Haven: Yale University Press, 2000), p. 372.

44. This notion of producing obscene graffiti for an audience is a distinctive hall-mark of perversion that might also be deployed to produce a clinically based appraisal of the photographic works of Hans Bellmer, Helmut Newton, Araki, Serrano, etc.

The theme of a corrupting demonstration is recognizable in, for example, this comment from the—supposedly provocative—collaborative duo of visual artists Dinos and Jake Chapman, who reveal: "We are interested in recuperating every form of terrorism *in order to offer the viewer* the pleasure of a certain kind of horror, a certain kind of Bourgeois convulsion." (Uta Grosenick and Burkhard Riemschneider, *Art Now* [Berlin: Taschen, 2002], p. 94; emphasis added.) This remark recalls Fenichel's observation: "The 'threatening' type of exhibitionist [such as] the man who shows pornographic pictures to his 'innocent' partner, enjoys the powerlessness of the partner because it means 'I do not need to be afraid of him [or her].' . . . Sadists of this type, by threatening their objects, show that they are concerned with the idea that they themselves might be threatened." (Otto Fenichel, *The Psychoanalytic Theory of Neurosis* [1945; London: Routledge, 1995], p. 354.) Sue Taylor has explored this theme in some detail in *Hans Bellmer: The Anatomy of Anxiety* (Cambridge, Mass.: MIT Press, 2000).

45. Michael Powell, *Peeping Tom* (London: Michael Powell Theatrical, 1960).

46. This sense of being included or implicated in the criminal acts is also something that the viewer of these crime scene images must also bear: how frightening it would be for any viewer to experience—or accept—such an image as not just fascinating, but *arousing*.

The theme of the sociopath as both seductive and highly charismatic is explored in several studies and in literature: see, for example, Gianrico Carofiglio, *The Past Is Another Country* (London: Old Street, 2007); Patricia Highsmith, *The Talented Mr Ripley* (1955; London: Vintage, 1992); Pascal Froment, *Je te tue. Histoire vraie de Roberto Succo, assassin sans raison* (Paris: Gallimard, 1991).

In his book of recollections of the Rachel Nickell murder case, the—now retired—SIO Keith Pedder emphasizes that the presumed guilt of their chief suspect was reinforced by the fact that when he was shown the crime scene photographs during an interrogation he displayed obvious evidence of sexual arousal (i.e., he supposedly got an erection when looking at the sexually explicit crime scene pictures). See Keith Pedder, *The Rachel Files* (London: John Blake, 2001).

47. Marie Bonaparte, *The Life and Works of Edgar Allan Poe: A Psycho-Analytic Interpretation*, trans. John Rodker (1949; New York: Humanities Press, 1971), p. 467; emphasis added. The passage in full reads: "It is the discovery that a whole class of beings—girls and women—are in fact and forever deprived of penises that gives the castration threat its actuality and full horror. And, indeed, many years pass before the little boy will accept this difference in the sexes and 'believe his own eyes,' so painful does he find its acceptation. Even when he does he consoles himself by thinking that little girls grow penises in time, and goes on believing that grown women at least, and especially his mother, are so endowed. When, however, that last line of defense must be abandoned and his mother appears as a castrated being and he realizes that women, by way of the mother, once and for all prove him wrong, he revenges himself by hating and scorning women."

48. Otto Fenichel, "Some Infantile Sexual Theories" (1927), in *Collected Papers, First Series*, ed. Hanna Fenichel and David Rapaport (London: Routledge and Kegan Paul, 1954), p. 117.

49. Joël Dor, *The Clinical Lacan* (Northvale, N.J.: Jason Aronson, 1997), p. 42.

50. Ibid., p. 58.

51. Charles Baudelaire, "Le Peintre de la vie moderne" ("The Painter of Modern Life," 1859, in *Baudelaire: Selected Writings on Art and Literature*, ed. Robert Baldick, trans. P. E. Charvet [London: Penguin, 1972, p. 424). It is worth quoting this remarkable passage in full here: "No doubt Woman is sometimes a light, a glance, an invitation to happiness, sometimes just a word; but above all she is a general harmony, not only in her bearing and the way in which she moves and walks, but also in the muslins, the gauzes, the vast iridescent clouds of stuff in which she envelops herself, and which are as it were the attributes and the pedestal of her divinity; in the metal and the mineral which twist and turn around her arms and her neck, adding their sparks to the fire of her glance, or gently whispering at her ears. What poet, in sitting down to paint the pleasure caused by the sight of a beautiful woman, would venture to separate her from her costume?"

52. Bataille writes: "If she [a woman] strips naked she reveals the object of a man's desire, an individual and particular object to be prized . . . nakedness as opposed to the normal state is certainly a kind of negation. The naked woman is near the moment of fusion, her nakedness heralds it. Hers is the nakedness of a limited being." (Georges Bataille, *Eroticism* [1957; London: Marion Boyars, 1987], p. 131.)

53. Charles Baudelaire, "The Double Room," in *Paris Spleen* (1869; New York: New Directions, 1970), p. 5. Baudelaire is apposite, as his work and personality have been regularly characterized in relation to the theme of perversion. René Laforgue's reviled *psychobiography* of the author includes this passage, richly descriptive of the notion of infantile fantasy: "This homesickness, or, as Baudelaire called it, this 'spleen'—here is the source of the trouble. In order to understand it let us turn to psychoanalysis, or, quite simply, to

Baudelaire. The denial of life is often a symbol for remaining a child, close to the mother's breast—a child, to be sure, who preserves his impotence, his weakness, his puerility, but also his fantasies that make Gods out of parents, virgins out of cathedrals, giants out of mountains. Homesickness for the lost paradise—what is it but homesickness for lost childhood, for the exaltations and the passions of a time when the emotions, undisturbed by knowledge, could take complete possession of the heart." (René Laforgue, *The Defeat of Baudelaire*, trans. Herbert Agar [London: Hogarth Press, 1932], pp. 18–19.)

Baudelaire's allusion to perfume is also revealing: is it not the sense that in addition to some primary pleasant fragrance there is also present some other aroma that is *too* sweet, or even acrid—i.e., the glimpse of what is "hidden behind"—that is the *sine qua non* of any "intoxicating" perfume?

54. Jacques Lacan, "Kant with Sade" (1963), in *Écrits* (New York: Norton, 2006), p. 654.

55. Bonaparte, *The Life and Works of Edgar Allan Poe*, p. 471. Elsewhere Bonaparte provocatively comments: "No less frightful and repulsive, to certain men [than a scar or mutilation of the body] is the appearance or idea of the vulva which, unconsciously, is likened to some frightful wound, left from the severed penis" (p. 468).

56. The state also defines sadistic killers as the most dangerous of all criminals. Under English law, a sexual or sadistic murder requires that the judge impose the highest tariff of "whole life" in prison on the perpetrator (if the victim was a child) and a minimum of thirty years in prison (if an adult).

A murder case with an undoubted—and unsettling—parallel in the modus operandi is the notorious killing of Rachel Nickell (on Wimbledon Common, London, in 1992). In his later annotation of that case, the former SIO Keith Pedder introduces a possible narrative: "He [the killer] wants more than just her quick death. He pulls her jeans and pants down and either just before, or just as she dies, he forces a smooth object into her anus. This is not a sexual act in the ordinary sense, it's an act of violation. In his fantasy, sex is inextricably linked with degradation and the defiling of the woman. Rachel, by now, has fulfilled this role. Her body is left with her buttocks prominently displayed, so that anyone coming across her will see her in the most degrading position the killer could manage in the circumstances." (Pedder, *The Rachel Files*, p. 75.)

57. DPP 2/XXXX, SIO's report, p. 13.

58. Jean Genet, *The Thief's Journal* (1949; New York: Grove, 1964), p. 10.

59. Andrei Tarkovsky, *Stalker* (Moscow: Gambaroff-Chemier Interallianz, 1979); J. G. Ballard, *The Atrocity Exhibition*, rev. and annotated ed. (1969; London: Flamingo, 2001); Jan Staller, *On Planet Earth* (New York: Aperture, 1997).

60. James Glover, "Notes on an Unusual Form of Perversion," *International Journal of Psychoanalysis* (1927), pp. 10–24. In the case history Glover discusses, the most desirable woman is one wearing high heels, while the one with flat shoes is much less captivating.

61. Bataille, *Eroticism*, p. 145.

62. The notion of a carefully worked-over too-rigid tale is also known—coinci-
dentally—to characterize those who are testifying falsely in court, as Wellman
suggests: "It is often useful, as your first question, to ask him [or her] to
repeat his [or her] story. Usually he [or she] will repeat it in almost identically
the same words as before, showing he [or she] has learned it by heart." See
Francis Wellman, *The Art of Cross-Examination* (1903; New York: Touchstone,
1997), p. 67.

63. The garments, as they are draped this way, also seem to form a—now frozen—
image of a ghostlike diaphanous figure.

64. Clavreul, "The Perverse Couple," p. 224.

65. Baudelaire, "Le Peintre de la vie moderne," in *Selected Writings*, p. 427.

66. Sigmund Freud, "Splitting of the Ego in the Process of Defence" (1940), in
The Standard Edition of the Complete Psychological Works of Sigmund Freud, ed.
James Strachey (London: Hogarth Press and the Institute of Psycho-Analysis,
1953–1973), vol. 23, p. 277.

67. Clavreul, "The Perverse Couple," p. 223. Of course, Lacan's innovation was
to reconceptualize the phallus in relation to desire; he is less interested in
the idea of a physical penis replacement, which is a distinctly Freudian theme.
But it can be seen here that the two readings do not, in any case, contradict
each other.

68. Fernand Braudel, *The Structures of Everyday Life* (London: Phoenix Press,
1979), p. 282.

69. The history of the common superstition that bad luck will befall those who
put shoes on a table—particularly new shoes—is explored by Iona Opie and
Moira Tatem. See Iona Opie and Moira Tatem, eds., *A Dictionary of Superstitions*
(Oxford: Oxford University Press, 1989), p. 161.

70. American Psychiatric Association, *Diagnostic and Statistical Manual of Mental
Disorders*, p. 702.

71. Žižek, "Why Is Reality Always Multiple?," p. 229.

72. Bataille, *Eroticism*, p. 275.

73. Further evidence of the perverse in this murder scene is also present in a sign
which can be seen next to the body—not illustrated—and reads STORE IN A
COOL DRY PLACE: a "caption" that parallels Sue Taylor's observation concern-
ing the cover image on one issue of *Le Surréalisme, même* in which a model
[Unica Zurn] "reclines on a plaid blanket, seen from behind without head or
limbs, reduced to a pale lump of trussed meat. When it [the photograph]
was reproduced on the cover of *Le Surréalisme, même* in 1958, the necrophiliac
overtones of this photograph were acknowledged with the caption: 'Keep in
a cool dry place.'" (Taylor, *Hans Bellmer*, p. 186.)

74. After all, when searching this room, it would have been only a few minutes before the wardrobe would have been opened by those seeking the missing woman—as a decoy strategy alone, it would never have been effective.

75. DPP 2/XXXX, SIO's report, p. 7.

76. DPP 2/XXXX, SIO's report, p. 9.

77. DPP 2/XXXX, SIO's report, p. 4.

78. Genet, *The Thief's Journal*, pp. 20–22.

79. DPP 2/XXXX, SIO's report, pp. 3–4.

80. This factor also raises the question of the unconscious motivation of the victim of a crime—defined in law as *any reasonable creature*. For example, Gordon Burn records these comments from Carol Raine in his *Happy Like Murderers*: "In the immediate aftermath of this attack [an indecent assault in a public toilet by the serial killer Fred West] . . . Carol [Raine] started to have morbid thoughts about ending up in the papers as a murder victim; obsessively thinking that her picture would be on the front of some paper because she'd been found dead. 'I *know* I'm going to be famous,' she started telling friends after the incident in the park. 'But it's going to be for being a body.'" See Gordon Burn, *Happy Like Murderers* (London: Faber and Faber, 1998), p. 17. Of course, all victims are not *innocent* victims, but more than this there are those who are unconsciously determined to put themselves in the place of the victim—a theme the FBI discuss under the rubric "victimology." I do not propose to engage with this highly challenging subject area in this volume, but I do intend to explore this theme elsewhere.

81. Joël Dor, *Structure and Perversions* (New York: Other Press, 2001), p. 147.

82. Jacques Derrida, "Freud and the Scene of Writing," in *Writing and Difference*, trans. Alan Bass (1966; Chicago: University of Chicago Press, 1978). The key issue that prevails in any critical reapplication of Bataille's anarchic maxim "In the world of play, philosophy disintegrates" is that in addition to inspiring vital new modes of attack—e.g., Derridas's *Glas* (Lincoln: University of Nebraska Press, 1974), or Tim Clark's *The Sight of Death* (New Haven: Yale University Press, 2006)—it can also be deployed in a malevolent, destructive— that is, wholly Bataillian—manner, whereby any thesis is evasively postponed and requalified, the perverse protest insisting that every position is only a trial, an option, a possibility. The Deleuzian "zone of multiplicity" is replaced with daunting obfuscation that proposes an "unlimited range of possible readings." Dr. Clare Bishop makes a similar point in her consideration of the so-called "relational aesthetics" group of visual artists. See Clare Bishop, "Antagonism and Relational Aesthetics," *October* 110 (Fall 2004), pp. 51–79.

83. *Chinatown*, dir. Roman Polanski (Los Angeles: United Artists, 1977).

Chapter 4

1. Bruce Fink, *A Clinical Introduction to Lacanian Psychoanalysis* (Cambridge, Mass.: Harvard University Press, 1997), p. 94.

2. In CCM the schizophrenic killer is characterized specifically as disorganized. See John Douglas et al., eds., *Crime Classification Manual* (San Francisco: Jossey-Bass, 1992).

3. Jacques Lacan, *The Seminar, Book III: The Psychoses* (1955–1956; London: Routledge, 1993), p. 12.

4. Fink, *A Clinical Introduction to Lacanian Psychoanalysis*, p. 165.

5. Lacan, *The Seminar, Book III: The Psychoses*, p. 12.

6. Fink, *A Clinical Introduction to Lacanian Psychoanalysis*, p. 88.

7. Psychoanalyst Lindsay Watson, lecture given at Middlesex University Psychoanalysis MA on psychosis, 2000. A point also made by Dylan Evans: "[In psychosis there is] a constant slippage of the signified under the signifier, which is a disaster for signification." (Dylan Evans, *An Introductory Dictionary of Lacanian Psychoanalysis* [London: Routledge, 1996], p. 155.)

8. American Psychiatric Association, *Diagnostic and Statistical Manual of Mental Disorders*, 4th ed. (Washington, D.C.: American Psychiatric Association, 2000), pp. 297–300.

9. DPP 2/XXXX, SIO's report, pp. 13–14.

10. Gordon Burn, *Happy Like Murderers* (London: Faber and Faber, 1998), pp. 103–106.

11. DPP 2/XXXX, SIO's report, p. 13.

12. Fink, *A Clinical Introduction to Lacanian Psychoanalysis*, p. 98.

13. Sigmund Freud, "Three Contributions to the Theory of Sex" (1905), in *The Basic Writings of Sigmund Freud*, ed. A. A. Brill (New York: Modern Library, 1995), pp. 551–552.

14. Numerous such asides and comments are attributed to Mr. Davis, but it is not my intention to imply that Miles was *insane*. See, for example, Ian Carr, *Miles Davis* (London: HarperCollins, 1999); Miles Davis and Quincey Troupe, *Miles Davis: The Autobiography* (London: Picador, 1990).

15. Rosalind Krauss, "Corpus Delicti," in Krauss, ed., *L'Amour fou* (New York: Abbeville, 1985), pp. 64–65.

16. A proposition that returns once more to Lacan's submission that "the prohibition of incest is nothing other than the *sine qua non* of speech." (Jacques Lacan, *The Seminar, Book VII: The Ethics of Psychoanalysis* [1959–1960; London: Routledge, 1992], p. 69.)

17. This proposition of the *informe*/formless as a fundamentally *psychotic* phenomenon is one that I intend to develop further elsewhere.

18. Lacan, *The Seminar, Book III: The Psychoses*, p. 9.

19. Perhaps it is an experiment that pertained to reanimation which is documented here.

20. And the law concurs with this possibility: the absence or nonfunctioning of any moral sensibility renders the perpetrator beyond or without intention; there is no *mens rea* (guilty mind).

21. Karlheinz Stockhausen, *Kontra-Punkte* (1953; Vienna: Universal Editions, 1984), p. iii; emphasis added.

22. J. G. Ballard, *The Atrocity Exhibition*, rev. and annotated ed. (1969; London: Flamingo, 2001), p. 62.

23. DPP 2/XXXX, SIO's report, p. 74.

24. This notion of the quasi-revolutionary or transformational quality of psychosis is a key theme in Deleuze and Guattari's *Anti-Oedipus*. See Gilles Deleuze and Félix Guattari, *Anti-Oedipus: Capitalism and Schizophrenia* (Minneapolis: University of Minnesota Press, 1983).

25. I am thinking in particular of the work of Gunter Bruss. Many of the original photographs of his performances are reproduced in Pilar Parcerisas, Hubert Klocker, and Daniele Roussel's excellent *Viennese Actionism* (Barcelona: Actar, 2008). Also, certain of the works of two US-based artists also seem relevant: Vito Acconci and Chris Burden—Burden's *Icarus* (1973), in particular.

26. Recall also Peter Stillman, who in Paul Auster's *City of Glass* cannot write anything down so instead spells out letters in his footsteps as he walks. See Paul Auster, *City of Glass*, in *New York Trilogy* (1985; London: Faber, 1993).

27. Lacan, *The Seminar, Book III: The Psychoses*, p. 53.

28. Lindsay Watson, case material seminar, Middlesex University; Psychoanalysis MA, December 2000.

29. Jacques Lacan, "On a Question Prior to Any Possible Treatment of Psychosis" (1958), in *Écrits* (New York: Norton, 2006), p. 481; emphasis added.

30. Fink, *A Clinical Introduction to Lacanian Psychoanalysis*, pp. 84–85.

31. Friedrich Nietzsche, "Beyond Good and Evil" (1886), in *Basic Writings of Nietzsche*, ed. Walter Kaufmann (New York: Modern Library, 1967), p. 258.

32. Robert Ressler and Tom Shachtman, *Whoever Fights Monsters* (New York: St. Martin's Press, 1992), p. 128.

33. Daniel Paul Schreber, *Memoirs of My Nervous Illness* (1903; New York: New York

Review Books, 2000), p. 26. Schreber's manuscript remains one of the most complete records of a psychotic's delusional constructions, and has been annotated by Deleuze and Canetti, as well as Freud and Lacan. It is significant too that his recollections—memoirs—are currently published by a literary house: the parallel world is developed so vividly. His image of the human soul as a physical mass of iridescent vibrating filaments—each of which is connected to a nerve in the body—is indelible. Schreber is, undoubtedly, an example of the creative reimaginings of perception that the surrealists—and Bataille—revered.

In George Orwell's *1984*, such linguistic inversion is, of course, known as *Newspeak*. But such disorientations are also common enough outside of fiction, e.g., the name Taliban—the brutally cruel and oppressive quasi-government imposed by a loosely organized group of sharia fundamentalists (who *de facto* ruled Afghanistan in the 1990s) who *banned all education* for women means, literally: *Those Who Are Seeking*. See George Orwell [Eric Blair], *1984* (1948; London: Penguin, 2003).

34. The negative or "neg" is seen less frequently since the demise of traditional wet processing. The color negative is an exact inversion of the tonal range of the familiar positive print.

35. Ressler and Shachtman, *Whoever Fights Monsters*, p. 17. Another example cited by Ressler places emphasis on the criminal's erroneous interpretation/understanding of the significance of an unlocked door: "He [the serial killer Richard Chase] had been hearing voices that told him to take a life [auditory hallucinations], and he just went down the street rattling doors. If a door was locked, he wouldn't go in. If it was open he went in. I asked him why he hadn't simply broken down a door if he wanted to go inside. 'Oh,' he said, 'if the door is locked, that means you're not welcome.'" (Ibid., p. 18.)

36. Leader acknowledges that the emergence of such a logic may seem to calm or placate—the implication being that the subject is somehow *relieved*: "Reports claimed that [the 'cannibal' serial killer Peter Bryan] 'fooled' social workers and 'conned' prison staff into believing that he was now less dangerous, but why assume he was trying to fool anyone? On the contrary, when someone arrives at a delusional logic, they may become calmer and less volatile. They now know what they have to do in life." (Darian Leader, "Peter Bryan Cannibal," *Times* [London], March 19, 2005.)

37. See Jakob and Wilhelm Grimm, *The Complete Fairy Tales* (1812; London: Vintage, 2007), p. 535.

38. Andy Robinson, "CSI: London," *Nikon Pro Magazine*, April 2007, p. 36.

39. So too is the equivalent in speech: the holophrase.

40. DPP 2/XXXX, SIO's report, p. 2.

41. DPP 2/XXXX, SIO's report, p. 3. The killer's comment that she is "not the least bit insane" is indicative of a lack of doubt: an important theme, as I have outlined.

42. Ormerod notes—from an English law case—an instance that is quite the reverse of this important, necessary act: a delusional man who "cut his victim's throat believing he was [merely] cutting a loaf of bread." See David Ormerod, *Smith and Hogan: Criminal Law* (Oxford: Oxford University Press, 2008), p. 285.

43. Quoted by Nicole Ward Jouve, *"The Streetcleaner": The Yorkshire Ripper Case on Trial* (London: Marion Boyars, 1986), pp. 47–49.

44. Berin Golonu, *To Protect and Serve: The LAPD Archives* (Los Angeles: Yerba Buena Center), unpaginated press material.

45. The well-known video games available on several formats including Microsoft Xbox 360 and Sony Playstation 3. The zombie genre of horror films focuses on malevolent characters that are putative reanimated corpses—the "undead."

46. Schreber, *Memoirs of My Nervous Illness*, p. 18.

47. The "comp" is photo industry jargon for a *composite image* that would once have been made by literally cutting and pasting several different photographs—an effect that is now typically achieved using Photoshop's "Layers" functionality. See Otto Rank, *The Double [Der Doppelgänger]* (1925; London: Karnac, 1989).

48. In factories—as in prisons—the workers'/inmates' *code of silence* demands that problems are resolved without recourse to any imposed authority. Approaching the management "behind your back" is utterly unacceptable, and it is a golden rule of such environments that workers do not "grass" or "snitch" on co-workers or fellow inmates.

49. Lacan, *The Seminar, Book III: The Psychoses*, p. 202.

50. Schreber, *Memoirs of My Nervous Illness*, p. 16.

51. Christopher Nolan, *Memento* (Los Angeles: Newmarket Capital Group, 2000).

52. Schreber, *Memoirs of My Nervous Illness*; Franz Kafka, *The Trial* (1925; New York: Schocken Books, 1998). The irony of Schreber's account is that Professor Flechsig, one of Judge Schreber's most feared tormentors in his delusional world, is—Burroughs-like—*in reality* the director of the asylum (secure unit) at which he is held.

53. William Burroughs, *The Naked Lunch* (1959; London: Flamingo Classics, 1993), p. 57; emphasis added. Burroughs is, of course, parodying the Hippocratic Oath that all doctors must abide by, which states: "All that may come to my knowledge in the exercise of my profession or in daily commerce with men, which ought not to be spread abroad, I will keep secret and will never reveal." See Geoffrey Lloyd, ed., *Hippocratic Writings* (London: Penguin, 1983), p. 67.

54. Lacan, "On a Question Prior to Any Possible Treatment of Psychosis," pp. 466–481.

55. A meltdown occurs if the core of a nuclear reactor can no longer be cooled effectively: the required cooling water must *never* stop pumping; if it does, the consequence is not a reactor breakdown—i.e., it merely ceases to function—but the rapid disintegration of the entire installation.

56. Lacan says, in relation to Schreber: "What is at stake is a message that does not come from a subject beyond language, but from speech beyond the subject" (Lacan, "On a Question Prior to Any Possible Treatment of Psychosis," p. 479).

57. Just such a "psychotic conspiracy theory" is explored—for comic effect—in the film *The Truman Show*, in which the protagonist *really is* on a huge film set that is indeed controlled by unseen *powers that be*. See Peter Weir, *The Truman Show* (Los Angeles: Paramount, 1998).

58. Lacan, *The Seminar, Book III: The Psychoses*, p. 13.

59. DPP 2/XXXX, SIO's report, p. 3.

60. An example of the type of crime scene material that Bataille commented on in his celebrated review of the book *X Marks the Spot*. See Georges Bataille, "X Marks the Spot," in *Documents: Archéologie, Beaux-Arts, Ethnographie, Variétés*, July 1930.

Chapter 5

1. Sigmund Freud, "Screen Memories" (1899), in *The Standard Edition of the Complete Psychological Works of Sigmund Freud*, ed. James Strachey (London: Hogarth Press and the Institute of Psycho-Analysis, 1953–1973), vol. 3, p. 308. Freud's purpose in this text is made clearer when Strachey's chosen *screen* (as "partition") is stripped away and replaced by the more obvious and correct English translation of the German *Deckerinnerungen: cover* memories. Freud's notion that memories of slight, arbitrary, and supposedly insignificant experiences are often put in place to cover other more disturbing childhood memories (a mechanism of repression) might also be used to reconsider a repetitive theme of this project: the traumatizing corpse is often ignored in favour of developing a reading of a far less terrifying detail (but one that is nevertheless a consequence of, and directly dependent upon, the original "unacceptable" reality). Children who witness a murder often recall, initially, only minor details—they may be able to describe, say, the pattern of the wallpaper in the room where the attack happened much more reliably than the events of the execrable act. This important theme of the Freudian *Deckerinnerungen* I intend to develop in more detail elsewhere.

2. Dr. Darian Leader, "Lecture on Anxiety," Centre for Freudian Analysis and Research public lecture (University of London Union, University of London), February 4, 2006.

3. Jacques Lacan, "Aggressiveness in Psychoanalysis" (1948), in *Écrits* (New York: Norton, 2006), pp. 78–79.

4. Jacques Lacan, "A Theoretical Introduction to the Functions of Psychoanalysis in Criminology" (1950), in *Écrits*, p. 106.

5. The so-called Cold War that was fought between the allied Western democracies and those ideologically allied to Soviet Communism. The same overstated threat can—perhaps more controversially—be recognized in the constant warnings and states of "Amber Alert" and "Heightened Threat Level" that are regularly issued to the public during the current, so-called, War on Terror.

6. For example, this exchange recorded by Wellman:

 COUNSEL: What medical name, doctor, would you give to the plaintiff's present ailment?
 DOCTOR: He has what is known as "traumatic neurosis."
 COUNSEL: Neurosis, doctor? That means, does it not, the habit, or disease as you may call it, of making much of ailments that an ordinary healthy man would pass by as of no account?
 DOCTOR: That is right, sir.

 See Francis Wellman, *The Art of Cross-Examination* (1903; New York: Touchstone, 1997), p. 67.

7. Neurosis is the only one of these three mental "structures" that clinical psychoanalysis can hope to have any effect upon—in a process that Freud described as a slow dismantling of the superego.

8. Karen Horney, *The Neurotic Personality of Our Time* (1937; New York: Norton, 2000), pp. 22–23.

9. Jean Laplanche and Jean-Bertrand Pontalis, *The Language of Psycho-Analysis* (London: Karnac, 1973), p. 398. The seemingly devious unconscious is captured indelibly by William Burroughs in his short story "The Discipline of DE," in which he notes: "As soon as you attempt to put DE [the discipline of Do Easy] into practice you will find that you have an opponent very clever and persistent and resourceful with detailed knowledge of your weaknesses and above all expert in diverting your attention for the moment necessary to drop a plate on the kitchen floor. Who or what is this opponent that makes you spill drop and fumble slip and fall? Groddeck and Freud called it the IT a built-in self-destructive mechanism. Mr Hubbard calls it the Reactive Mind" (William Burroughs, "The Discipline of DE," in *Exterminator!* [London: Calder and Boyars, 1974], p. 66).

10. American Psychiatric Association, *Diagnostic and Statistical Manual of Mental Disorders*, 4th ed. (Washington, D.C.: American Psychiatric Association, 2000), p. 457.

11. Juan-David Nasio, *Hysteria from Freud to Lacan* (New York: Other Press, 1998), p. 17.

12. Neurotics are often *captured* in a vexing paradox—they are drawn into an increasingly intimate relationship *with the very thing that they claim to despise or fear*. As Laplanche and Pontalis ask: "Does not the housewife who is obsessed with cleanliness end up by concentrating her whole existence on

dust and dirt?" (Laplanche and Pontalis, *The Language of Psycho-Analysis*, p. 378.) That is, obsessive cleaning rituals bring the neurotically conscientious person into an ever-closer relationship with the supposedly polluting and corrupting dirt (or *invisible* bacteria) that the repetitive wiping and scrubbing activities are designed to eradicate.

13. George Orwell [Eric Blair], "The Decline of the English Murder" (1946), in *Essays* (London: Penguin, 2000), p. 345.

14. Wilhelm Stekel, "Criminal Impulses," in *Compulsion and Doubt* (London: Peter Nevill, 1950), p. 157.

15. Fish and Chips—*Fish 'n' Chips*—is a meal sold in specific—usually to-go-only—restaurants. The fish is deep-fried in batter, and the chips are thick-cut. This meal is as distinctively English as, say, roast beef, the full English breakfast, and so on. Until an EU directive made the practice illegal—due to the supposed toxicity of printer's ink—this meal was traditionally wrapped in old newspaper pages for the customer to carry home.

16. Stekel, "Criminal Impulses," p. 144.

17. Alfred Harmsworth (later Lord Northcliffe) supposedly gave this order to the journalists in the early days of his newspaper, which began daily publication in 1896. Harmsworth's assumption was that including news about recent murder cases would give the paper popular appeal. Of course, his supposition was correct: such stories remain a basic staple not just for the *Daily Mail* but across newspapers generally.

18. Harold "Kim" Philby eventually defected in January 1963—a few months after the murder depicted here—to the Soviet Union, where it was confirmed that he was indeed "the Third Man."

19. Sigmund Freud, *The Psychopathology of Everyday Life* (1901), in *The Basic Writings of Sigmund Freud*, ed. A. A. Brill (New York: Modern Library, 1995), p. 99.

20. Sigmund Freud, "Obsessive Actions and Religious Practices" (1907), in *The Standard Edition of the Complete Psychological Works of Sigmund Freud*, vol. 9, p. 119.

 Of course, it is the power of the neurotic's "private religion" that Lacan sought to derail and degrade with his introduction of the much-debated variable-length psychoanalytic session, his proposition being that the standard fifty-minute session inevitably becomes ritual-like. Conversely, in the variable-length session the speaker's monologue may be broken off very unexpectedly, even mid-sentence, with a consequence that Bernard Burgoyne has described: "[For Lacan] brokenness evokes the broken relations of the Oedipal loves of the child. Brokenness automatically creates transference. Brokenness promotes/amplifies a recognition of lack. In analysis it is this mechanism that pushes the analysis forward." (Professor Bernard Burgoyne lecturing on the Master's course "The European Tradition in Psychoanalysis" [London: Middlesex University, October 2000]. This quotation was taken

down longhand during a seminar. I trust that my rendition does justice to the speaker's intended sense.)

21. I am thinking of books by such authors as Nicci French, David Baldacci, Jeffrey Deaver, Maeve Binchey, and so forth.

22. Behavioral therapy is currently a popular choice for treating one-off neurotic symptoms that are presented to a GP (General Practitioner, or medical doctor) within the National Health Service (NHS) in England. The doctor can refer the patient to a therapy course which is designed to deal with a single *stand-alone* symptom—particularly eating disorders, or addictions such as smoking, gambling, or phobias. The patient is basically taught/trained (in a similar manner to Pavlovian conditioning) to think about *something else* when the craving is encountered. This approach to neurotic symptoms is similar to another recent fashion: hypnotherapy. The basic problem with both approaches—from the psychoanalytic perspective—is, as Freud was acutely aware, that neurotic symptoms are "dynamic," that is, they morph. If a symptom is reduced or removed through such a therapeutic course, it is likely that—if it is treated only in this way—the neurosis will simply produce other new/different symptoms in place of the one which is now supposedly "cured."

23. DPP 2/XXXX, SIO's case report, p. 3.

24. DPP 2/XXXX, SIO's case report, p. 7.

25. Wilhelm Stekel, "The Doubt," in *Compulsion and Doubt*, p. 91.

26. Sigmund Freud, "Notes upon a Case of Obsessional Neurosis ['The Rat Man']" (1909), in *The Standard Edition of the Complete Psychological Works of Sigmund Freud*, vol. 10, p. 190.

27. Samuel Beckett, "The Expelled," in *No's Knife* (London: John Calder, 1967), p. 9.

28. Jacques Lacan, "Some Reflections on the Ego," *Journal of the Institute of Psycho-Analysis*, no. 34 (1951), pp. 11–12.

29. A theme that is explored, for example, in the film *American Beauty*, in which the dénouement is precisely the revelation that an extremely homophobic character—Ricky's father—attempts a homosexual seduction. (*American Beauty*, dir. Sam Mendes [Los Angeles: DreamWorks SKG, 1999].)

30. Laplanche and Pontalis, *The Language of Psycho-Analysis*, p. 376.

31. Dr. Darian Leader, "Lecture on Citibank Prize Finalists," *Gallery Talks* (Photographer's Gallery, London, March 23, 2000). See my comment at chapter 1, note 65, above.

32. DPP 2/XXXX, SIO's case report, p. 7.

33. As Braudel noted: "Luxury is an elusive, complex and contradictory concept, by definition constantly changing: it can never be identified once and for

all." (Fernand Braudel, *The Structures of Everyday Life* [London: Phoenix Press, 1979], p. 183.)

34. Rationing of basic foodstuffs continued after World War II—until 1954 for some.

35. *Blue Velvet*, dir. David Lynch (Los Angeles: Dino de Laurentis Group, 1986). The phrase slow-motion is synonymous with *digital time stretching*, which may be a more familiar nomenclature to some.

36. Beyond individual instances of pathological states is the more generalized notion that our society is built upon this fundamentally neurotic model; this is, of course, Freud's main argument in *Civilization and Its Discontents*, in which he states that "it is impossible to overlook the extent to which civilization is built up on renunciation, how much it presupposes the non-satisfaction of powerful drives—by suppression, repression or some other means." (Sigmund Freud, *Civilization and Its Discontents* [1930], in *The Standard Edition of the Complete Psychological Works of Sigmund Freud*, vol. 21, p. 44.) Equally, a basic psychoanalytic critique/explanation of consumerist society is outlined by the Freudian Karen Horney: "[Unconscious] feelings of inferiority and inadequacy are characteristics that never fail [to be recognized in neurosis] . . . they may be covered up by compensating needs for self-aggrandizement, by a compulsive propensity to show off, to impress others and oneself with all sorts of attributes that lend prestige in our culture, such as money, possession of old pictures, old furniture, women, social contacts with prominent people, travel or superior knowledge." (Horney, *The Neurotic Personality of Our Time*, p. 38.)

37. Jacques Lacan, *The Seminar, Book VII: The Ethics of Psychoanalysis* (1959–1960; London: Routledge, 1992), pp. 231–232.

38. This theme is also represented the text of one of Richard Prince's paintings from his *Jokes* series, which appropriate cartoons originally published in the *New Yorker*: "Do you know what it means to come home at night to a woman that will give you a little love, a little affection, a little tenderness? It means you're in the wrong home, that's what it means."

39. Hélène Toussaint, *Courbet* (London: Arts Council of Great Britain, 1978), p. 166.

40. Edgar Degas, *La Coiffure* [Combing the Hair], 1896 (National Gallery, London).

41. Otto Fenichel, *The Psychoanalytic Theory of Neurosis* (London: Routledge, 1995), p. 151. In Lacanian terms the charitable act and the aggressive unconscious motive are thus indivisible: "Only saints are sufficiently detached from the deepest of our shared passions to avoid the aggressive repercussions of charity. In any case, such [hostile reactions in psychoanalysis] should hardly surprise us analysts, we who expose the aggressive motives behind all so-called philanthropic activity." (Lacan, "Aggressiveness in Psychoanalysis," p. 87.)

42. This was to have been the girl's first day back at school (DPP 2/XXXX, SIO's report, p. 3).

43. DPP 2/XXXX, SIO's report, p. 1.

44. Particularly in reference to the theme of acting out—elaborated below— I note here that, in this case, the killer left the scene of the crime, walked calmly to the nearest police station, and upon arrival simply stated: "I am here to report a murder." (DPP 2/XXXX, SIO's report, p. 7.)

45. René Laforgue, *The Defeat of Baudelaire* (London: Hogarth Press, 1932), p. 32.

46. Horney, *The Neurotic Personality of Our Time*, pp. 66–67.

47. DPP 2/XXXX, SIO's report, p. 6.

48. A motif that recalls Michael Craig-Martin's *An Oak Tree*, a work of art that also refuses to comply with the viewer's logical expectations: his sculpture comprises only a half-full glass of water on a shelf, accompanied by a text concerning interpretation and perception.

49. DPP 2/XXXX, SIO's report, p. 5.

50. An example of Freud's famous assertion: "These two discoveries (that the life of our sexual instincts cannot be wholly tamed, and that mental processes are in themselves unconscious, and [thus] only reach the ego and come under its control through incomplete and untrustworthy perceptions) amount to a statement that the ego is not master in its own house. . . . No wonder, then, that the ego does not look favourably upon psychoanalysis and obstinately refuses to believe in it." (Sigmund Freud, "A Difficulty in the Path of Psycho-Analysis" [1917], in *The Standard Edition of the Complete Psychological Works of Sigmund Freud*, vol. 17, p. 143.)

51. John Douglas et al., eds., *Crime Classification Manual* (San Francisco: Jossey-Bass, 1992), p. 200.

52. This is the portmanteau noun proposed by Philip Kaufmann as an appropriate English equivalent for the German *Fehlleistung*, which is used by Freud throughout the text of *The Psychopathology of Everyday Life* and does indeed seem to be more relevant than either Strachey's chosen "parapraxes," or Brill's "erroneously carried-out actions." See Walter Kaufmann, *Freud, Adler, and Jung* (1980; New York: McGraw-Hill, 1992), p. 24.

53. Laplanche and Pontalis, *The Language of Psycho-Analysis*, p. 4.

54. Freud also relates an instance of a misachievement: an inexplicable *return to the scene of a crime* which he describes in "The 'Uncanny'": "Nothing but painted women [heavily made-up prostitutes] were to be seen at the windows of the small houses, and I hastened to leave the narrow street at the next turning. But after having wandered about for a time without enquiring my way, I suddenly found myself back in the same street, where my presence was now beginning to excite attention. I hurried away once more, only to arrive

by another *détour* at the same place yet a third time. Now, however, a feeling overcame me which I can only describe as uncanny, and I was glad to find myself back at the piazza I had left a short while before, without any further voyages of discovery." Although Freud does not offer an explanation for this bizarre behavior, there can be no doubt as to the *real* reason for his repeated return to the same street of prostitutes. (Sigmund Freud, "The 'Uncanny'" [1919], in *The Standard Edition of the Complete Psychological Works of Sigmund Freud*, vol. 17, p. 237.)

55. David Ormerod, *Smith and Hogan: Criminal Law* (Oxford: Oxford University Press, 2008), p. 295.

56. In Sigmund Freud, "Some Character-Types Met with in Psycho-Analytic Work" (1916), in *The Standard Edition of the Complete Psychological Works of Sigmund Freud*, vol. 14, p. 332.

57. Truman Capote, *Other Voices, Other Rooms* (1948; London: Penguin, 2004), p. 36.

58. DPP 2/XXXX, SIO's report, p. 4.

59. DPP 2/XXXX, SIO's report, p. 5.

60. Horney, *The Neurotic Personality of Our Time*, p. 71.

61. Ibid., p. 70.

62. Lacan, of course, emphasizes not only a dimension of automatism in violence but also an automatism in desire. As Žižek notes: "[In Lacan] the automatism of love is set in motion when some contingent, ultimately indifferent— libidinal—object [*objet petit a*] finds itself occupying a pre-given fantasy place." (Slavoj Žižek, "Fantasy," in Dany Nobus, ed., *Key Concepts of Lacanian Psychoanalysis* [New York: Other Press, 1998], p. 214.)

Afterword

1. John Walker, "Context as a Determinant of Photographic Meaning" (1980), in Jessica Evans, ed., *The Camerawork Essays* (London: Rivers Oram Press, 1997), p. 54.

2. Walker's original in full reads: "Consider a wedding photograph, and then the variety of contexts in which such an image could be encountered: in a family album; framed on the mantelpiece in a living room; in the window of a local commercial photographer's shop; in a local newspaper; in a national newspaper; in a fashion magazine; in a women's journal; in an advertisement on a street hoarding; in an art gallery; in a social history museum; in a television series on photography; inside another photograph . . . with each shift of location the photograph is recontextualized and as the context changes so does the meaning." (Walker, "Context as a Determinant of Photographic Meaning," p. 54.)

3. One further layer of distance—in this *chain of evidence*—is the imposition of a *dot screen* that is used to enable formerly half-tone black-and-white images (continuous tones of gray) to be printed with black ink alone—as in this book. Full-color reproduction involves making four dot screens that must then be aligned to achieve the color image, i.e., cyan, yellow, magenta, and black.

4. *Blow-Up*, dir. Michelangelo Antonioni (London: Bridge Films, 1966).

5. Slavoj Žižek, "Courtly Love, or, Woman as Thing," in *The Metastases of Enjoyment* (London: Verso, 1994), p. 95.

6. See also Joel Sternfeld, *On This Site* (San Francisco: Chronicle, 1996). Sternfeld's study concentrates on this distinctive quality of the crime scene: it is a location or site that is privileged, but only temporarily. The series documents various crime sites months and sometimes years after the execrable events: the photographs often reveal a "scene" that is an unremarkable view— it has been returned to the quotidian.

7. John Roberts, "Surrealism, Photography and the Everyday," in *The Art of Interruption* (Manchester: Manchester University Press, 1998), p. 109.

8. Simone de Beauvoir, "Must We Burn Sade [Faut-il brûler Sade]?," in *Marquis de Sade*, ed. Paul Dinnage (New York: Grove Press, 1953), pp. 80–82.

9. John Taylor, *Body Horror: Photojournalism, Catastrophe and War* (Manchester: Manchester University Press, 1998), p. 194.

10. Beauvoir, "Must We Burn Sade?," p. 79.

11. The CCD is the light-sensitive pixel array that has all but replaced celluloid film. It is the overall mode of presentation that has altered: in the case materials I worked with, the photographer typically presented only three or four 10"x 8" black-and-white prints in a card-bound and treasury-tagged booklet, with a few terse handwritten inscriptions.

12. I note the recent appearance of two scholarly articles that also engage with crime scene photography: Linda Steer, "Surreal Encounters: Science, Surrealism and the Re-circulation of a Crime-Scene Photograph," *History of Photography* 32, no. 2 (2008), pp. 110–122; Domietta Toriasco, "Undoing the Scene of the Crime: Perspective and the Vanishing of the Spectator," *Camera Obscura* 22, no. 1 (2007), pp. 77–111.

13. Ralph Rugoff, "On Forensic Photography," in *Circus Americanus* (London: Verso, 1995), p. 184.

14. Friedrich Nietzsche, "Beyond Good and Evil" (1886), in *Basic Writings of Nietzsche*, ed. Walter Kaufmann (New York: Modern Library, 1967), p. 279.

15. Taylor, *Body Horror*, p. 13.

The Perverse Crime Scene

3.1

3.2

3.3

3.4

3.5

3.6

3.7

3.8

3.9

3.10

3.11

3.12

3.13

3.14

3.15

3.16

3.17

3.18

3.19

3.20

3.21

3.22

3.23

3.24

3.25

3.26

3.27

3.28

3.29

3.30

The Psychotic Crime Scene

4.1 4.2 4.3 4.4 4.5

4.6 4.7 4.8 4.9 4.10

4.11 4.12 4.13 4.14 4.15

4.16 4.17 4.18 4.19 4.20

4.21 4.22 4.23 4.24

The Neurotic Crime Scene

5.1

5.2

5.3

5.4

5.5

5.6

5.7

5.8

5.9

5.10

5.11

5.12

5.13

5.14

5.15

5.16

5.17

5.18

5.19

5.20

5.21

5.22

5.23

5.24

5.25

INDEX